Women Together/ Women Apart

TIRZA TRUE LATIMER

Women Together/ Women Apart

Portraits of Lesbian Paris

Rutgers University Press
New Brunswick, New Jersey, and London

Library of Congress Cataloging-in-Publication Data

Latimer, Tirza True.
 Women together, women apart : portraits of lesbian Paris /
Tirza True Latimer.
 p. cm.
 Includes bibliographical references and index.
 ISBN 0-8135-3594-8 (hardcover : alk. paper)—ISBN 0-8135-3595-6
(pbk. : alk. paper)
 1. Lesbian artists—France—Paris—Biography. 2. Lesbians—France—Paris—
Biography. 3. Arts, French—France—Paris—20th century. 4. Paris (France)—
Intellectual life—20th century. I. Title.
 NX164.L4738 2005
 704'.086'6430944361—dc22

2004023479

A British Cataloging-in-Publication record for this book is available from the
British Library

Design by Karolina Harris

Manufactured in the United States of America

Pour l'amour des femmes

CONTENTS

ACKNOWLEDGMENTS

This book bears only one signature yet it bears the imprint of many hands, hearts, and minds. Kindred spirits, close friends, members of the tribe have urged me forward and accompanied me during the time it took to complete this work. I appreciate most of all the help and encouragement I received from this community but prefer to thank its members individually in person.

As a scholar, I am deeply grateful to the mentors who have shaped my thinking and played a part in the evolution of this book. To Wanda Corn, who has never steered me wrong, and to those who served on my dissertation committee—Pamela Lee, Richard Meyer, Mary Louise Roberts, and Peggy Phelan—all of whom have influenced my work and altered my vision, my thanks and recognition. This project is also beholden to a scholar whom I consider an honorary adviser: Whitney Chadwick. Additionally, conversations with Leah Dickerman, Dianne Macleod, William MacGregor, Moira Roth, Jennifer Shaw, Abigail-Solomon Godeau, and Alla Efimova enlivened this investigation as it evolved from a dissertation into a book.

During my several stays in Paris, a number of people offered me their hospitality, resources, advice, moral support, editorial comments, and the occasional coup de main, among them Christine Bard, Cathy Bernheim, Nicole Lise Bernheim, Chantal Bigot, Corinne Bouchoux, Isabelle Cahn, Mireille Cardot, Catherine Gonnard, Elisabeth Lebovici, Laure Murat, Evelyne Rochdereux, and Virginia Zabriskie. François Leperlier shared his enthusiasm and his expertise on Claude Cahun. Adrien and Lucette Ostier-Barbier shared their time, their consideration, their living room, and

their collections with me, as did Arlette Albert-Birot. Françoise Flamant supported this project in countless ways, large and small, from start to finish.

I am indebted to the curators, librarians, and staff members of a number of institutions for their cooperation and assistance. I name only some of them here but offer my thanks to those not named as well: to Virginia Mecklenburg and Katherine Manthorne for serving as my advisers at the Smithsonian American Art Museum, Washington, D.C., and for making Brooks's paintings, drawings, and correspondence related to the collection available to me; to Cecilia Chin and Pat Lynagh, among other librarians at the American Art Museum/National Portrait Gallery; to Judy Throm at the Archives of American Art, Smithsonian, for greatly facilitating the study of Brooks's papers; to Beth Alvarez, curator of literary manuscripts at the McKeldin Rare Books Library, University of Maryland, for permitting me to consult Djuna Barnes's papers; to the librarians at the Beinecke Rare Book and Manuscript Library, Yale University, for making my research on Brooks and her circle both pleasant and productive; to Louise Downey and Val Nelson at the Jersey Museum, Channel Island of Jersey, for, on several occasions, sharing their time, their office space, and the museum's rich holdings from the estate of Claude Cahun and Marcel Moore; to the members of the staff at the Château-Musée in Haut-de-Cagnes, where Suzy Solidor's portraits and papers are conserved, and especially to Claudie Godelle, whose assistance proved invaluable; to the archivists at Radio-France for making tapes of Solidor's broadcasts available to me; to those of Solidor's admirers, protégés, and peers who shared their knowledge and memories with me: the late Marcelle Frass-Routier, Michel Gaudet, Doris Lemaire, Michèle Melikov, and Michèle Venture; to Vincent Rousseau, curator of the Musée des Beaux-Arts de Nantes, who introduced me to the collections there; to the librarians and curators at the Bibliothèque Municipale de Nantes; to the librarians and staff members at Paris's Bibliothèque de l'Arsenal, Bibliothèque Forney, Bibliothèque Historique de la Ville de Paris, Bibliothèque de l'Opéra, Bibliothèque Marguerite Durand, Institut Mémoires de l'Édition Contemporaine (IMEC), and Bibliothèque Nationale, Richelieu; to the curators of the Natalie Clifford Barney Papers at the Bibliothèque Littéraire Jacques Doucet, Paris, and to François Chapon for authorizing access to Barney's letters; and to Alex Ross and Peter Blank among the many librarians and staff members who have facilitated my research at the Art Library and Green Library, Stanford. To all of you I express my enduring gratitude and respect.

A series of grants, large and small—all of them generous—enabled my research both in Paris and in the United States. Early on, I benefited from the support of the Department of Art and Art History and the Institute for Research on Women and Gender at Stanford University. My research on Brooks at the American Art Museum was made possible by a fellowship from the Smithsonian, Washington, D.C. The George Lurcy Foundation financed a year of research in France on Cahun, Moore, and Solidor.

My affiliation with the Beatrice Bain Research Group at the University of California, Berkeley, and my association with the Berkeley Art Museum and the Judah L. Magnes Museum, Berkeley, enabled me to introduce this project into new and transformative forums.

In conclusion, I acknowledge the editorial and production team at Rutgers University Press, the anonymous reader who commented so constructively on my manuscript, my copyeditor Kathryn Gohl, and especially Leslie Mitchner, editor in chief, for her commitment to *Women Together/Women Apart*; I also recognize my "imaginary collaborators"— Romaine Brooks, Natalie Barney, Claude Cahun, Marcel Moore, and Suzy Solidor—who provided such rich food for thought.

Women Together/ Women Apart

Introduction

Mythology is history.

—Charlotte Wolff,
Love Between Women

his book began as the story of one portrait—Romaine Brooks's
Self-Portrait of 1923—which has both personal and professional
significance to me (fig.1). My awareness of alternatives to the sce-
narios of marriage and motherhood that shaped a woman's destiny when
I was growing up in my sheltered Connecticut suburb owes an enormous
debt to a very limited repertoire of images, images that sparked in me a
sense of recognition, unnamed potential, unimagined horizons of possi-
bility. Brooks's *Self-Portrait* is one such image. I first stood face to face with
this near life-scale portrait at the Smithsonian American Art Museum in
Washington, D.C., over thirty years ago, when I was a college student. As
my eyes took in the artist's daring statement of self—the defiant stance,
the sober costume with its rakishly turned collar, the unyielding set of the
chin, eyes ablaze from the shade of an outsized top hat—I experienced a
shock of recognition: *She's my kind of woman*, I said to myself, not need-
ing confirmation from the wall text (which offered none in any event). As
it happens I was reading the visual cues correctly, although I was unaware
at that time of either the complexity or the history of the codes that under-
wrote the portrait's legibility to me as a statement of lesbian identity, of
autonomy and active desire—and as such, a statement of emancipation from
the bounds of femininity. That was the beginning of my attraction to and
curiosity about Paris of the 1920s. It was also the beginning of my own
ability to imagine myself, to see myself, not just as a woman who loved
women but as a member of a visual (if not always visible) community—

and thus to participate in a visual culture whose history can be traced back to the Paris of Brooks's era.

What Romaine Brooks's self-portrait meant to me in 1971, and later, in the 1990s, when I began to study her portraiture within lesbian-feminist theoretical frameworks, had little to do, however, with what it meant to her in 1923. What, after all, did "lesbian identity" mean in Paris at that time, when the closet (a figure central to identity politics movements of the later twentieth century) and its subjects of enclosure were still under construction?[1] This is only one of many questions we must ask in order to begin to understand what this portrait signified for Brooks and her audiences in 1923 Paris, London, and New York.

One critic, taking inventory of "the black hat, quite tall, the regard in the shadow of a brim that advances slightly, the pallid face, lips . . . colored, a little black blazer with a red ribbon on the lapel providing the only note of contrast," describes Brooks's likeness as "a being invisible to our eyes."[2] Why invisible? The artist, on occasion, introduced her painting as

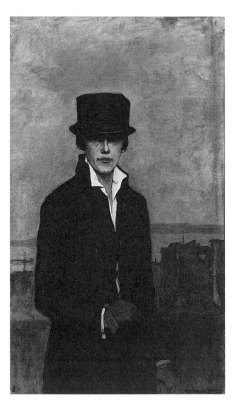

Fig. 1. Romaine Brooks, *Self-Portrait*, 1923.
*Smithsonian American Art Museum,
Gift of the Artist*

"un portrait psychologique."[3] What does that mean? At what point do invisibility and psychology meet? Are today's categories of identity, with their contingency on the politics of visibility, useful in an analysis of texts produced in Paris between World War I and World War II? What sense does it make to invoke the phrase *lesbian identity*—even in the format of a question such as this—in relation to the self-representational initiatives of Brooks and her contemporaries? What do I mean by *lesbian* anyway?

Let me address the last question first. By *lesbian*, I mean, first and foremost, the female subject of homoerotic desire. I take erotic desire to mean both intense physical attraction and passionate emotional investment. While embracing lesbianism as an identity has been, for women of my generation, both collectively and individually empowering, the term *lesbianism* itself—at once too discursively mercurial, too historically connotative, and too semantically absolute—fails to do justice to the rich spectrum of erotic practices and identities that it presumes to describe in a word. Admittedly, to unite same-sex relationships and cultures of the contemporary era—let alone those of 1920s and 1930s Paris—under a single rubric is to create an illusion of coherence and uniformity where inconsistency and diversity are indicated.

This said, I choose to use *lesbian* throughout this book as a sort of free-floating signifier.[4] In doing so, I do not mean to imply a singular, historically or culturally transcendent erotic or affective orientation but the various alternatives to normative (patriarchal) relational and social models imagined by women together and apart in Paris between the wars. Some of the women I investigate here would not have described themselves as lesbians, or would have described themselves as such under certain circumstances and not others, or at given moments in their lives and not at others. I use the word loosely, therefore, but not without deliberation, as a rhetorical device capable of evoking the subject of female homoerotic desire, the broader if more precarious notion of cultural identity, and the implicit theme of feminine autonomy.

I prefer *lesbian*, for its gender specificity, to *homosexual*—and employ the word synonymously with period vocabulary such as the more poetic *sapphist* (which articulates a cultural heritage as well as an explicit sexual practice) or the more clinical *invert*. Although the women-loving women I discuss typically disdained categorizing labels, those who invented the descriptive vocabulary of sexual identity (sexologists, psychologists, novelists, poets, journalists, and the like) employed a range of terms more or less interchangeably. For instance, Havelock Ellis, whose work was praised

by several of the Paris lesbians I discuss, alternately uses the terms *lesbian*, *female invert*, and *female homosexual*. Ellis, what is more, routinely cited eyewitness observations, first-person testimonials, expert case studies, and literary sources from both Europe and America, expanding the vocabulary exponentially.[5] Research in this radical new field, what is more, often benefited from rapid translation and circulated soon after publication within the international scientific community. German, Italian, French, Swiss, and American confreres referenced each other's publications as a matter of course both to demonstrate erudition and to position themselves professionally. The vocabulary of homosexuality that evolved, as a result, had an international character. French terms like *inverti*, *uranien*, *homosexuel*, *lesbienne*, and *saphiste* had phonetic and conceptual equivalents in other European languages.

If, in this study of the visual culture of lesbian Paris, I draw verbal and pictorial images of lesbianism from far-flung sources and diverse orders of representation, I do so to show the extent to which different modes of expression and sites of interrogation shared a common currency. One might, indeed, expose the roots of sexological theory in literature, or even popular culture, but that is not my project. Nevertheless, the migration of images and ideas from fictional to factual registers—the extent to which one "contaminated" the other (revealing the representational status of both)—is so evident in the writings of important theorists like Ellis as to foreordain an eclectic, thickly descriptive approach.

Like Ellis, sexology's popularizers in France (Dr. Pierre Vachet, *L'Inquiétude sexuelle*, 1927; Dr. Henri Drouin, *Femmes damnées*, 1929), the authors of erotic novels (Pierre Mac Orlan, *La Semaine de Sapho*, 1929), pulp fiction (Victor Margueritte, *La Garçonne*, 1928), travel guides (*Pour s'amuser: Guide du viveur à Paris*), advice books, exposés, and gossip columns (Marise Querlin, *Femmes sans hommes: Choses vues*, 1931; Maryse Choisy, "Dames seules," 1932) employed language that was densely layered with connotation. The lexicon of terms commonly used to describe independent, strong, ambitious, or accomplished women, what is more, overlapped with those insinuating lesbianism and included everything from the relatively neutral *modern woman*, to the more colorful *amazon*, to out-and-out pejoratives like *virago*.[6] By the late 1920s, few women who exercised authority in any walk of Parisian public life were exempt from the perception of lesbianism (or the anticipation of that perception).[7] Journalists such as Maryse Choisy routinely collapsed the economic and sexual autonomy of women into a single, global cliché: "In

Athens, as in Paris, as in New York, this 'lesbisme' [*sic*] . . . is born of the woman who works, the woman who is no longer a madonna, but not yet the comrade whose independence men of breeding will respect."[8] Sappho, described in nineteenth-century French literature as the prototypical lesbian, was redefined by Choisy and her readers as "the Eve of liberated women."[9]

As must be clear by now, parsing out sapphic signifiers among their many possible subjects of signification interests me less than the broader implications of what I identify as the *lesbian effect*—a phantasm, a limit case, a constellation of ambiguous visual codes that puts several related representational systems to the test. The modern Sappho, whose image saturated Parisian popular and visual culture during the first decades of the twentieth century, was both a sign and a site of symbolic disruption, a placeholder for the unnamable, the unheard of, the unthinkable, representing not just *l'amour impossible entre deux femmes* but also, and more importantly, the emancipation of women from the constraints of gender— and, by extension, the restructuration, or even deconstruction, of Western civilization's foundational hierarchy.

I begin this investigation by asking how, why, when, and where specific representations of female same-sex desire achieved cultural intelligibility and social significance. Taking a leaf out of Valerie Traub's book *The Renaissance of Lesbianism in Early Modern England*, I too ask in this book "what it means for women to inhabit specific categories of representation at particular moments in time."[10] Traub demonstrates that, in seventeenth-century England, the rise of public theater, the secularization of the art economy, the emergence of illustrated books, and the increase of female literacy contributed to an efflorescence of representations of sapphic love. Joan DeJean, in her ambitious *Fictions of Sappho, 1546–1937*, relates representations of Sappho in French and German literature to period- and place-specific sexual political regimes. *Women Together/Women Apart*, although more modest in scope, considers how the circulation of texts across national and cultural frontiers during the early twentieth century enabled the subjects of sapphic representation to imagine and image themselves for the first time on an international scale. The vehicles of transmission included corporeal texts, literary and theoretical texts, and—of particular interest to those of us who, if marginalized, do not constitute "visible minorities"—visual texts.

I maintain that by marking themselves and their work in ways that certain observers (contemporary and future) would read as lesbian, artists

like Brooks and her peers willfully engaged in the process of defining new social, cultural, professional, and relational possibilities for all women. These artists participated, at the same time, in both the definition of the neologism *lesbian* and the elaboration of the visual codes and strategies that enabled modern lesbians to recognize each other. Choisy might have had Brooks in mind when she wrote, "There is no point in looking for Sappho in Mytilene. She is an artist. Therefore she moved to Paris."[11] Paris lesbians helped to shape contemporary ideas about the poles of femininity and masculinity, about the possibility of intermediary positions, and about that which eludes or exceeds the implied continuum.

The self-representational statements of lesbian artists working in Paris between the wars inevitably reflect on, and bear on, questions of national as well as sexual identity. Even American expatriates like Brooks, who lived their entire lives in Europe, were shaped if only *en creux* by national heritage. Whether they migrated to Paris from abroad or from the provinces, however, Brooks and her contemporaries explored identifications and attempted to create communities that cohered around something other than national origin. Some, like Cahun and Moore, yearned for an egalitarian society of kindred spirits; others, like Brooks, believed that they belonged to a "peculiar aristocracy . . . of the higher mental and artistic element."[12] In any case, they were drawn to Paris, and thrived there, in part because of the capital's cosmopolitan character.

In the 1970s, lesbians of my generation looked back to Brooks and the influential population of woman-loving women who converged on Paris in the 1920s and 1930s for traces of our history, our cultural origins. This remains important in a context that continues to offer lesbians few positive models, little affirmation of our existence, and thus renders self-recognition and self-representation problematic. In the 1920s, the preoccupations of Brooks and her contemporaries were not entirely different. They too sought to affirm a notion of genealogy that would empower lesbians in their own and future generations, and their artistic statements reclaimed specific cultural and historical traditions (the Sapphic legacy, for instance). Yet these two pivotal moments in the history of both lesbianism and feminism, the 1970s and the 1920s, shaped the initiatives of my generation and those of Brooks's generation in significantly different ways.

Obviously, historical and cultural factors also shape our agendas as scholars, our perspectives as students of history, and our faculties as interpreters of visual culture. In order to penetrate the logic of visual codes forged by lesbians in an era that Barney dubbed "our belle époque,"[13] it is necessary

to turn away from the light of our day and burrow deeply into such cultural-historical residue as is preserved in libraries, archives, private collections, and the kiosks of vendors specializing in *livres anciens et vieux papiers*, with the (admittedly quixotic) ambition of developing a period eye and cultivating a period mentality.

Although my research plan in France originally entailed tracing a specific genealogy of twentieth-century lesbian visual culture, the evidence with which I was confronted indicated that the constraints facing Brooks and the lesbian artists, writers, decorators, performers, publishers, and patrons who formed her entourage in 1920s and 1930s Paris related more narrowly to gender than to sexual identity. "I only wish that to grow up and become a woman weren't synonymous with the loss of freedom," the juvenile Mireille Havet confided to her journal in 1919.[14] Despite the fact that Paris offered unparalleled educational and professional opportunities in the arts to women from around the world, French law denied most civil rights to women. The Napoleonic Code, whose gendered terms had changed only slightly since its inception in 1804, continued to define women as "incompetent," on a par with children and the insane. In 1929, the magazine *Vu* devoted a special issue to "the status of woman: what woman cannot do in France, what woman can do in the world."[15] An article by Odette Simon, an appeals court lawyer, resumed:

> Cannot do: vote in any election, obtain a passport without authorization, enter the stock exchange, hold a high bureaucratic position, leave her husband, dress in men's clothing (ordinance of 7 Nov. 1800), serve as judge. Without the authorization of her husband, the woman/wife cannot sign a valid contract [or] make a purchase or sale. . . . It is also impossible for her to accept an inheritance, even one from her own mother, to initiate legal proceedings or defend herself legally, to make a charitable donation, to assume financial responsibility for a dependant, to be a member of a family council or an executor of a will, without the consent of her husband.[16]

In sum, the male head of household exercised the authority equally over his wife and his children. Subordinated in private life, women in 1929 had little or no official voice in the public sphere under the legal code. In practice, however, women's lives had changed considerably since the beginning of the Great War.

The imperatives of warfare and reconstruction accelerated a shift in the

nature of the country's economic base from rural/agrarian to urban/industrial, and a shift in the character of the labor force as well. By 1929, the urban sector edged into the majority, accounting for 51 percent of France's population. During the same decade, new feminine subject categories emerged, categories not anticipated by the law or accommodated by the language (where the word for woman, *femme,* shares an identity with the word for wife). Unmarried adult women, celibates, bachelors, lesbians—in short, women without men—cut an increasingly visible figure on the urban scene. The wartime decimation of France's male citizenry threw this new populace of "single" women into high relief.[17] Broadly speaking, the as-yet-undefined category of women-without-men represented a sort of gray area, a loophole in a restrictive social, economic, and representational system. And this loophole opened up new opportunities for women in all professional spheres in France, including the arts. In one way or another, the women whom I have chosen to investigate were transformed by the watershed of the Great War.

For the subjects of my case studies, and many other lesbians working in Paris during the interwar period, opting out of the heterosexual contract—and with it, received ideas about what it meant to be a woman—was the precondition of both personal and professional fulfillment. Natalie Barney claimed to "belong to a category of beings that may flourish once the traditional earthly couple has been definitively discredited, permitting each of us to preserve or rediscover her integrity as an entity."[18] As Barney was well aware, this feminine "society of the future" had yet to cohere as a social reality.[19] Yet lesbians in post–World War I Paris witnessed and contributed to significant shifts in the representation (if not the experience) of gendered power relations. As a result, Brooks and many of her contemporaries in Paris believed that they could succeed not despite but *because of* their lesbianism.[20] Lesbianism released them from predetermined schemas of femininity and engaged them in a creative process that Barney described as "perpetual becoming."[21]

In Paris of the interwar period, feminine stereotypes stigmatized women as intellectually limited, morally and physically weak, capricious, and derivative, while characterizations of lesbians (even by detractors) often emphasized their exceptional intellectual prowess, independence, strength, reliability, creativity, and qualities of leadership. The multinational roster of talented lesbians portrayed by Brooks—many of whom were described in Compton Mackenzie's best-selling 1928 novel *Extraordinary Women*—used their "extraordinary" status as self-promotional

leverage and parlayed their successes, in a circular manner, into proof of lesbian superiority.[22] "Is it sapphism that nourishes her intelligence, or is it intelligence that makes her a lesbian?" Jean Royère wondered about the redoubtable Barney.[23]

This generation of lesbians created frameworks that offered them, if not an escape, at least some play within the representational bounds of femininity. They inscribed themselves within genres such as biography, autobiography, and portraiture—genres in which the codes of identity and social status have traditionally taken form. Lesbians modified the conventions of these genres in radical ways.

A trend that Janet Flanner (thinking of Colette) referred to as "auto-biographic novelizing," for instance, gained currency among Paris's literati.[24] Colette's *Le Pur et l'impur*, Radclyffe Hall's *The Well of Loneliness*, Lucie Delarue-Mardrus's *L'Ange et les pervers*, Djuna Barnes's *Nightwood*, H.D.'s trilogy *Paint It Today*, *Asphodel*, and *HER*, Bryher's two novels, *Development* and *Two Selves*, and Gertrude Stein's *The Autobiography of Alice B. Toklas* were all produced between World War I and World War II and inventoried in bookshops frequented by Paris lesbians (notably the shops of Sylvia Beach and Adrienne Monnier). "Novelizing" allowed lesbian authors to articulate previously unspeakable aspects of their personal and social experience, and to invent alternate versions of their personal narratives. Perhaps even more radically, autobiographical novels by lesbian authors memorialized the lives of individuals who would have otherwise remained without historical profile. A similar claim could be made about the initiatives of the visual and performing artists I discuss in this volume, who (whether self-seriously, in parody, or with cynical calculation) used portraiture as well as autobiographical writing to "mythologize" their own histories.

Literary studies about writers of lesbian-historical significance have demonstrated that sexual identity, like gender, is not only what Joan Scott calls "a useful category of historical analysis" but also a determining factor in the production and reception of culture.[25] In contrast, scholarship on visual modes of early twentieth-century lesbian cultural production is at a primary stage of development. Although it is true that the question of sexual identity preoccupies contemporary historians of fashion, performance, and the decorative arts,[26] lesbian identity remains largely uninterrogated within studies (including feminist studies) devoted to traditional high-art genres such as portraiture.

Feminist art historians privileging gender (and therefore heterosexual

power relations) as an interpretive axis have all but neglected the equally crucial problematic of sexual identity. Indeed, as Judith Butler has thoroughly demonstrated, feminist analysis too often unwittingly reproduces heterocentric patterns of thought that thwart the recognition of relational, social, and interpretive alternatives.[27] A decade before the publication of Butler's *Gender Trouble* shifted the terms of feminist analysis in America and Europe, Monique Wittig provoked controversy in feminist circles by challenging the relevance of gender—a patriarchal construct— to lesbian experience. "The refusal to become (or to remain) heterosexual," Wittig argued at the Modern Language Association conference of 1978, "always meant to refuse to become man or woman, conscious or not. For a lesbian, this goes further than the refusal of the *role* 'woman.' It is the refusal of the economic, ideological, and political power of a man . . . the designated category (lesbian) is *not* a woman."[28] The same logic applies, Wittig added, to any female who is not personally dependant on a man.

This radical proposition, which animated feminist debates throughout the 1980s, pivots on a distinction that many lesbians of 1920s Paris tacitly acknowledged. Making space for conceptual play within the categorical terms of social subjectivity, as they did (and as I do in my analysis of their practices), alters the lay of the historical landscape. Unfamiliar features stand out upon a cultural terrain already traversed by countless historians of Paris modernism and charted anew by feminist scholars of the 1980s and 1990s, from Shari Benstock (*Women of the Left Bank*) to Mary Louise Roberts.[29] A decade ago, Roberts could produce an insightful and apparently exhaustive cultural-historical study bearing the title *Civilization without Sexes: Reconstructing Gender in Postwar France, 1917–1927* without mentioning the word *lesbian* once in the body of the text. The fact that a feminist scholar of her stature could take gender politics in Paris between the wars as a focus and fail to examine the quite prominent lesbian dimension indicates not a personal blind spot but structural barriers in the operative methodological frameworks.

Since the publication of Roberts's book, scholars establishing disciplinary footholds in the fields of gay and lesbian studies, gender studies, queer studies, and cultural studies have opened new avenues of historical investigation, drawing on previously untapped resources and archives. The parallel elaboration of new approaches to social and cultural analysis in the 1990s by paradigm-shifters such as Teresa de Lauretis and Judith Butler contributed to the formation of a constellation known as "queer

theory" that literally altered the terms of this investigation.[30] Queer theory challenged prevailing methodologies to expose underlying heterosexist biases while providing the basis for a profoundly radical critique of discourses that construct categories of normativity and deviance, particularly categories of gender and sexual identity. I have benefited enormously from these developments, which open new perspectives on my period's historical topography. It becomes apparent, for example, that previously invisible or nonexistent categories of women—women independent of men (bachelors, celibates, widows, and lesbians)—demarcated the interwar Parisian scene from the social panorama of preceding decades. From these perspectives, the enclaves that sheltered Paris's nascent sexual subcultures, the itineraries that led Paris lesbians into the visible and discursive world, become not only visible but difficult to overlook. My emphasis on this population's significance distinguishes *Women Together/Women Apart: Portraits of Lesbian Paris* from earlier studies. My analysis draws energy from the tension between feminist theory, which throws the gender biases of the historical record into relief, and queer theory, which exposes the representational status of both gender and sex (and thus the instability of these socially regulatory categories).

The title of the book itself is riven with tension. It evokes the tension between the historic struggles of women acting together and the necessity of deconstructing the enabling premise, of taking *women* apart. It also refers to the tensions within discourses about gender and sexual identity, discourses that shaped the self-images of the artists I introduce here—the tension, for instance, between lesbianism conceived as a coupled identity (a matter of object choice) and lesbianism conceived as an inherently individual orientation (a congenital "condition"). *Women together*, what is more, evokes broader discursive frameworks (judicial codes, for instance) pertaining to women as a class within which lesbians (*women apart*) represent exceptions to the rule. Finally, the title, like my case studies, acknowledges both the collective and individual survival strategies of modern women in Paris of the 1920s and 1930s, then the capital of Western visual culture.

The problematic of visibility lies at the heart of this book. It is a book about lesbian self-representation—particularly, although not exclusively, about self-portraiture. It is a book about self-images projected by a category of subjects characterized historically as both invisible and unrepresentable.[31] In the process of formulating image-making strategies capable

of both communicating and dissimulating same-sex desire, lesbians of the early twentieth century confronted a number of interrelated dilemmas bearing on what Annamarie Jagose has described as "the ambivalent relationship between the lesbian and the field of vision."[32] Jagose, among other scholars, maintains that the lesbian—in society, culture, and history—represents not so much an absence as "a presence that can't be seen."[33] Lesbian presence *can* be seen, of course, but often—and this certainly pertains to Brooks and her portrait subjects—only by those who know how (and where) to look.

This "visible invisibility" has played a strategic role in the survival of lesbian relationships and cultures under historical circumstances that range from paternalistically hospitable to hostile. Visible invisibility, by the same token, has played a significant role in the maintenance of sexual hierarchies. Yet out-and-out visibility creates a disturbingly similar set of dilemmas, as the punch line of a cartoon featured in the trendy 1920s magazine *Fantasio* suggests (fig. 2). A couple of women—smoking, sporting the latest fashions, sharing an *apéritif* at a sidewalk café—are approached by an alluring third party (a women). The cartoon's heading, "L'Eternel ménage à trois," identifies the theme, while it's caption, "Mais les éléments ne sont plus les mêmes," comments wryly on the variation. "But what does it matter," the satirist seems to ask, "who plays the parts, as long as the roles themselves don't change?" On the one hand, as Martha Gever has shown in a recent study of lesbian celebrity, "visibility may disrupt or contradict received ideas and accepted beliefs. It may propose new kinds of social categories or inject new meanings into old ones. On the other hand, such contests often extend the reach of dominant forces." In other words, the theater of the visible is where dominance premiers and where it casts its subjects.[34]

Women Together/Women Apart considers the modes and methods employed by four Paris-based artists who, through various acts of self-representation, confronted the double binds of visibility and invisibility: Romaine Brooks, Claude Cahun, Marcel Moore, and Suzy Solidor. All well known in their era and all openly avowing erotic relationships with women, these artists visualized alternatives to the man's world in which they performed. While each of them lent substance to a social crisis that early twentieth-century polemicists referred to as "the woman problem," the four artists featured here are not "typical" in any way. They represent a range of artistic practices, a variety of political, social, and cultural profiles.

Brooks—an American heiress, raised in Europe—showed her work in

Paris's most prestigious venues and staked out her turf in the city's most elegant neighborhoods. Cahun and Moore, connected by family ties to Paris's intelligentsia and by conviction to the city's artistic and literary vanguard, hailed from the provincial capital of Nantes, where Cahun's father had shaped the character of regional journalism and Moore's had practiced medicine. Neither Cahun nor Moore ever had to earn a living, or stint on the time that they devoted to obscure theater companies, struggling bookstores, political activism, and edgy artistic practices. Solidor, in stark contrast, was the illegitimate daughter of a Saint-Malo charwoman. She arrived in Paris penniless after the Armistice, survived by her wits and her good looks, and fashioned herself into the toast of Parisian nightlife.

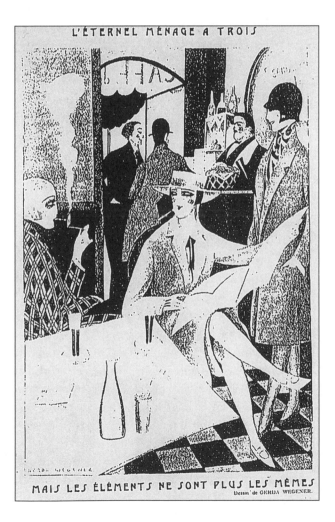

Fig. 2. Gerda Wegner, "L'Eternel Ménage à trois." *Published in* Fantasia, *ca. 1920*

All four women reinvented identities by adopting stage names, pen names, *noms d'artiste* that distanced them from their biological family origins. All four fled their ancestral homes for Paris, and all four claimed places at the center of their chosen spheres of artistic activity, while accentuating an underlying sense of displacement with respect to the larger society. They were, to paraphrase an expression used by Barney, "women apart." Yet their dreams, desires, tastes, practices, and itineraries overlapped and intersected with those of other women converging in Paris between the wars to establish the terms of on-going debates about representation, sexuality, and the politics of gender.

In the past decade, a number of publications emphasizing visual modes of cultural production have enriched the fields of art history and gender studies and effected a rapprochement between them.[35] These studies, which have informed and inspired my own investigation of lesbian identity formation and cultural production, regard the histories of art and homosexuality from predominantly male perspectives. My own emphasis on lesbian artists distinguishes the current project from its precursors in the field of art history. The focus on visual culture—from the fine arts to fashion, caricature, and commercial graphics—builds on earlier initiatives, such as those I have mentioned, in which questions of identity politics in early twentieth-century Europe figure. I have particularly benefited from, and converse with, Laura Doan's *Fashioning Sapphism: The Origins of Modern English Lesbian Culture*, which posits the relevance of visual culture to the emergence of lesbianism as an axis of social identity in 1920s England. *Women Together/Women Apart* reflects on lesbianism and visual culture in Paris during this pivotal period and begins to map the imaginary terrain that Paris lesbians shared with their contemporaries across the Channel and across the Atlantic.

To this end, I attend closely to the ways in which the artistic statements of interwar Paris lesbians engage with discourses on gender and sexual identity in Europe and America at this time. I introduce material from various domains (including cinema, fashion, decoration, literature, performance, journalism, fine art, advertising, and popular music), reserving a place of prominence for sexology. This said, I do not deny the persuasiveness of recent work that challenges sexology's primacy within histories of homosexuality, especially lesbianism. Terry Castle has, for instance, written authoritatively about literary representations of female same-sex desire before the emergence of sexology as a specialized field in the nineteenth

century.[36] Doan, arguing from another position, cautions that nineteenth-century theories and terminology relating to lesbianism would not yet have been commonly understood in 1920s England, even among members of the educated, ruling classes.[37] I concede that those pursuing knowledge about same-sex desire between women did not necessarily seek or find satisfaction in nineteenth-century sexological literature, supposing they had access to it. Ellis himself recognized that "the chief monographs on the subject [of homosexuality] devote but little space to women."[38] What is more, the explanations of lesbianism proffered by Ellis—one of the most accessible and lesbian-conscious authors in the field—are at best confusing.

Be that as it may, sexologists like Ellis, who drew on research material submitted by correspondents from across Europe and America, contributed greatly to the dissemination, homogenization, and popularization of theories of congenital (male and female) homosexuality. Homosexuals had implicated themselves in the elaboration and interpretation of such theories from the beginning, believing in the science's emancipatory potential. To wit, Karl Ulrichs, Magnus Hirschfeld, Edward Carpenter, André Raffalovich, and Ellis's collaborator John Addington Symonds all considered themselves authorities in a field of investigation that took their own sexual practices and psychic attributes as its focus.

Paris lesbians, although never the authors of such texts, were motivated to read, discuss, circulate, translate, critique, and occasionally ridicule them. There is little doubt that when, in *Ladies Almanack*, Djuna Barnes describes her heroine as a female "developed in the Womb of her most gentle Mother to be a Boy, . . . [who] came forth an Inch or so less than this [yet] paid no Heed to the Error," she meant to mock not only Barney, the most celebrated lesbian in Paris, but also the canonical works of sexual science.[39] André Rouveyre, a writer and illustrator who regularly attended Barney's salon, published a sketch of his hostess in *Mercure de France* that similarly ridicules theories describing the lesbian sorority as an intermediate species bearing male and female characteristics (fig. 3). The caricature emphasizes Barney's flowing feminine locks, which clash with a contrasting crop of masculine chin whiskers. Both Barnes's references to "the third sex" and Rouveyre's sketch imply that at least some of the readers of *Mercure*, and undoubtedly most of the readers of *Ladies Almanack*, were conversant with studies that strove to define sexuality in congenital terms.

Indeed, discussion at Barney's salon (which the editor of *Mercure*,

Rachilde, also attended), and at the literary gatherings presided over by Beach and Monnier, periodically turned to the latest writings and translations in the fields of psychology and sexology. Monnier's ledger marks the entry of works by Ellis into the inventory of La Maison des Amis des Livres, and Beach placed her own complete six-volume set of his *Studies in the Psychology of Sex* at the disposition of Shakespeare and Company's clients.[40] These two influential book dealers considered Ellis a personal friend, and his portrait, sketched by Monnier's brother-in-law Paul-Emile Bécat, occupied a place of prominence on the wall of Beach's shop.[41] Across the channel, feminist subscribers to the journal *Freewoman* (and its successors, *New Freewoman* and *The Egoist*) formed reading groups in which sexological texts were shared and discussed. They prevailed on leading theorists (Ellis, for one) to participate in the debates and lectures for which they provided a forum.[42]

That the scientific study of sexual behavior had emerged during the second half of the nineteenth century in step with the first organized feminist movements in France, England, and the United States was no coincidence. Feminist challenges to the so-called doctrine of separate spheres (domestic/feminine, public/masculine) unsettled the division of labor within traditional bourgeois family units. This, in turn, put enormous pressure

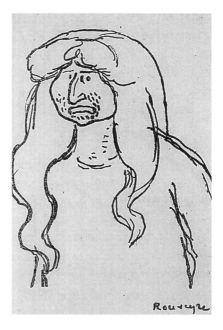

Fig. 3. André Rouveyre, caricature of
Natalie Barney.
Published in Mercure de France,
January–February 1913

on the conventions of gender and notions of sexual normality. The new sciences, with their reverse but intimately linked focus on sexual abnormality, created frameworks within which social order could be either re-established or differently conceived.[43]

In the 1920s, educated lesbians all over Europe carried on open dialogues with the scientific literature on sexual behavior and took positions in public debates about homosexual rights. Exceptionally, they intervened from within the professional ranks of the scientific community;[44] more typically, however, they demonstrated their literacy with respect to the sexual sciences and modified the character of this discourse via their various cultural practices. Radclyffe Hall, for example, asked Ellis to write a prologue for her pathbreaking 1928 novel *The Well of Loneliness*, in which the main character discovers her "true nature" in the texts of Krafft-Ebing. Ellis's endorsement boosted the credibility of a book that may otherwise have been dismissed as a "woman's novel," and a perverse one at that. The censorship proceedings against Hall's book offer evidence that the English courts, at least, took the novel seriously. In 1931, the English heiress Nancy Cunard, founder of Hours Press in Paris, printed an edition of Ellis's *The Revaluation of Obscenity* to protest this censure.[45]

Cahun, who translated Ellis's work for publication in French in 1929, acknowledged in a letter to Adrienne Monnier the impact of the sexologist's writings on her own intellectual development.[46] Ellis's *Studies in the Psychology of Sex*, which Cahun may well have discovered while volunteering at Beach's bookshop, enriched both the literary and visual dimensions of her oeuvre and inspired her to rethink key concepts (such as narcissism and transvestism) from a lesbian perspective.

Beyond these urban enclaves of highly motivated readers, access to research in the field of sexology remained limited, by and large, to a specialist public in the early 1920s. Ellis, for one, would have liked to see the work circulate more freely; he made certain publication decisions to this end, as at least one reviewer noted:

When Mr. Ellis's book was sent to us for review, we did not review it, and our reason for this neglect of the work of the Editor of the "Contemporary Science Series" was not connected with its theme or wholly with the manner of its presentment. What decided us not to notice the book was its method of publication. Why was it not published through a house able to take proper measures for introducing it as a scientific book to a scientific audience? . . . We considered

the circumstances attendant upon its issue suspicious. We believed
that the book would fall into the hands of readers totally unable to
derive benefit from it as a work of science and very ready to draw
evil lessons from its necessarily disgusting passages.[47]

Not surprisingly, Hall, in *The Well of Loneliness*, represents this kind
of scientific knowledge as privileged, something kept by the learned few
under lock and key, literally. Vita Sackville-West (whose biography was
"novelized" by Virginia Woolf in *Orlando*) sequestered her own sexolog-
ical literature in a tower room to which she alone had access. Decades
after their original publication, works like Ellis's *Studies in the Psychol-
ogy of Sex* circulated principally in academic and professional contexts,
and lay readers often went to what we would today consider extraordi-
nary lengths to procure them.

Bryher (Winifred Ellerman), an important patron of Beach's Shake-
speare and Company, approached Ellis through Beach's good offices to
obtain a complete set of the *Studies* for her personal library. Throughout
a decade in which Bryher produced two autobiographical novels, *Devel-
opment* (1920) and *Two Selves* (1923), the film *Borderline*, and her mag-
azine *Close Up* (to which Ellis contributed), she corresponded with the
sexologist on the average of twice a month. Ellis tested his hypotheses on
"the puzzling question" of cross-dressing on Bryher and steered her to
related readings by Freud, Rank, Adler, and Hirschfeld. Bryher upbraided
Ellis for discussing women's travesty in theater, cross-dressing to facilitate
travel or to exercise a traditionally male métier, and lesbian transvestism
in the same breath, earning Ellis's respect. He repeatedly solicited Bryher's
point of view on his "little contributions" to this field of knowledge, ask-
ing her to vet several of his essays before submitting them for publica-
tion.[48] "If . . . you find any points in them of special interest, I shall be
glad if you can throw any further light on them," he confessed. "When I
wrote to you in the first place about women disguised as men I was in the
dark as to what you might already know on the subject."[49] Bryher—with
her direct influence on Ellis, and his upon her—represents something of
an extreme example. However, like Bryher, the lesbians whose case stud-
ies form the basis for this book used artistic practice as a platform from
which to inflect the debates about gender and sexual identity that domi-
nated the decades after the Great War.

The arts promised these women something that the realms of science,
industry, and politics still denied them: self-determination. Although the

lesbians I discuss here shared little else—certainly no common vision of what it meant to be either a woman-loving woman or a woman-without-a-man in the 1920s and 1930s—they shared a set of social, cultural, and psychological conditions adhering to gender. If, within the web of enterprises created by women working in Paris between the wars, lesbianism opened up new fields of opportunity, it was because this identification finessed the historical limitations (and historical "privileges") of femininity.

ONE

Lesbian Paris Between the Wars

Pour apporter quelque chose,
il faut venir d'ailleurs.

—Natalie Clifford Barney,
Traits et portraits

espite the reactionary thrust of campaigns to restore order to post-war French society in the wake of the First World War, many of the lesbians who had achieved recognition for their professional activities during the war years maintained positions of prominence during the reconstruction period. Adrienne Monnier, founder of La Maison des Amis des Livres, a hub of literary Paris, made the uneasy admission that women entrepreneurs like herself who had launched businesses or assumed new vocations between 1914 and 1918 had been "favored by the terrible Goddess" of war.[1] Undeniably, the recruitment of six million able-bodied French men between 1914 and 1918 had opened unparalleled opportunities for women in every professional sector. The war raised the profile of the lesbians whose work provides the focus of this book and others with whom they interacted.

Suzy Solidor, for instance, escaped a career track of domestic service in Brittany to become, at the age of seventeen, a mechanic and driver in the ambulance corps.[2] During the same period, Lucie Schwob and Suzanne Malherbe assumed the gender-ambiguous pen names Claude Cahun and Marcel Moore, along with a share of editorial responsibility for the cultural pages of their family's newspaper and literary journal in Nantes.[3] The American expatriate Romaine Brooks, already established in the Paris art world, accepted the Croix de Chevalier de la Légion d'Honneur for fund-raising efforts on behalf of the Red Cross.[4] Her painting *La*

France croisée of 1914—which depicts a Red Cross nurse against a backdrop of smoke and flames—promoted a new vision of "the weaker sex" by putting a feminine face on heroism (fig. 4).

Like Brooks, many lesbians from abroad earned respect for their work, alongside French women, in the war relief effort. Sylvia Beach was one of the thousands of Americans who responded to the call for Red Cross workers. In all, some 25,000 British and American women (expatriates and temporary residents alike) joined volunteer relief organizations in France during the Great War. Among them, Gertrude Stein and Alice Toklas lent their services (and their Ford automobile) to the American Fund for the French Wounded (AFFW), dispensing donated supplies to hospitals and distressed civilians behind the lines in Alsace; they received the Médaille de la Reconnaissance Française for these activities. Dorothy Arzner, the only American woman to achieve prominence as a film director during Hollywood's golden era, also took the wheel of an AFFW vehicle.

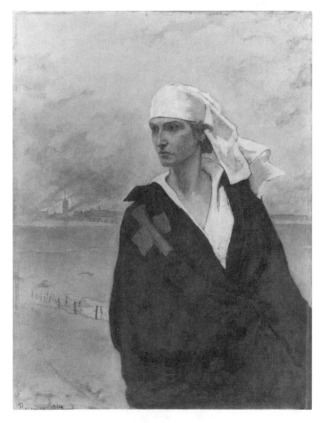

Fig. 4. Romaine Brooks, *La France croisée*, 1914. *Smithsonian American Art Museum, Gift of the Artist*

The American banking heiress Anne Morgan served as the first treasurer of the AFFW and established a convalescent hospital for French wounded in the Versailles home that she shared with the other two members of her so-called triumvirate, Elsie de Wolfe and Elizabeth Marbury. Marbury, an impresario and literary agent, and Wolfe, an interior decorator, joined the AFFW corps of volunteer ambulance drivers.[5] The designer Eileen Gray and her companion Evelyn Wyld, a renowned cellist, served as drivers in a fleet of relief vehicles assembled by the writer and influential patron of the arts Elisabeth de Gramont. Oscar Wilde's niece, Dolly Wilde, foreswore her vocation as a London debutante to join these legions "of girls in uniform," as Natalie Barney described them.[6] Barney, a confirmed pacifist, claimed to be the only American woman in Paris not driving an ambulance.[7]

Anne Morgan and her partner, Anne Murray Dike, both previously decorated, earned promotions to Officier de la Légion d'Honneur for founding the Comité Américain pour les Régions Dévastées (CARD), an all-women volunteer organization. Morgan and Dike recruited 350 American women to staff a fleet of sixty-five vehicles and conduct civilian relief operations in Picardy.[8] Just behind the battle lines, the "heiress corps" labored under the same conditions as the troops. "The mud is ten inches deep here," one recruit wrote home to Boston, "and after four hours under my car making repairs, I am literally unrecognizable."[9] Yet the women volunteers clearly recognized something of themselves in these active roles for which they knew no historical precedent.

This corps of wartime volunteers attracted what feminists would later describe as women-identified women, and those who did not conform to this profile were sometimes targeted by their comrades. Marion Bartol complained, for instance, that a fellow CARD volunteer, a certain Mrs. Wilson, was "strictly a man's woman. I can't just make out why," Bartol puzzled, "she is with the Committee as she does not seem to me the kind they usually select."[10] "Mrs. Wilson" notwithstanding, the CARDS typically referred to each other, as soldiers might, by last name—Bartol, Farr, Van Ressenlaer—or by dashing monikers like Tommy, Kit, and Jessie.[11] These daring women, and their comrades in the hundreds of analogous volunteer organizations that sprang up in France during the conflict, won voices in the social and cultural debates of the post-war years. As they returned to England and America from France, they also accelerated the cross-pollination of the new ideals and images of womanhood forged within their wartime sorority.

Elizabeth (Bessie) Marbury, in her memoirs of the war years, noted a widespread fascination among women volunteers "with the idea of inventing and wearing uniforms."[12] Mireille Havet had a crush on a woman whom she described in her journal as "fancy-free, dressed in an elegant khaki driver's uniform, embellished with the quite ravishing blazon of the Croix de Guerre and ensigns honoring her as a wounded soldier. She wears her hair very short, and, naturally, courts all the pretty women."[13] The khaki uniform, reversing its customary function as a leveling device, set these women of action apart, made them appear extraordinary.

The wartime appropriation of male vestments by this cadre of women in active duty heralded trends in post-war fashions. Sylvia Beach recalled admiring the boyish figure cut by her client Bryher as she perused the books at Shakespeare and Company turned out in a "tailormade suit— or what my British friends would call a 'costume.'"[14] Throughout the 1920s, legions of newly empowered women converged upon Paris from far and wide to assume vocations left in abeyance by the male population because of the war; a visible minority of these (now demobilized but no longer immobilized) women adopted the regalia of civilian male authority. Artists, photographers, novelists, journalists, advertisers, and caricaturists fixated upon "the pseudo-male with starched collar, shaved neck, and strictly tailored clothes," the woman with license to take the wheel, investing her with emblematic status.[15] These new female roles were not only performed but also reproduced by women. In 1929, for instance, the female editor of the trend-setting German periodical *Die Dame* commissioned a self-portrait for the magazine's cover from Tamara de Lempicka, picturing the fashionable Parisian artist at the wheel of an Italian sports car (fig. 5).[16] The glassiness of the driver's eyes, the metallic highlights of her racing costume and vehicle, the compositional stress placed upon her hand at the wheel, as well as the artist's monogram inscribed just above the handle of the driver's door mark Lempicka's identification with the sleek machine. The vehicle's partiality and diagonal relationship to the confines of frame suggest an excess of power and dynamism, as does the pilot's compression within the space of the cab. Such images of female power and mobility heralded a new species: the so-called modern woman.

The modern woman's attributes—male haberdashery and accessories, cropped hair, cigarettes—occasionally doubled as signifiers of lesbian identity, as the name of Montparnasse's premier lesbian nightclub, Le Monocle, suggests. Georges Brassaï spotlighted Le Monocle—both the watering hole and the fashion trend—when, in 1932, he published photos of the

club's cross-dressing clientele in an album bearing the title *Paris de nuit* (fig. 6). Although the lesbians who posed in fancy dress for Brassaï modified sartorial codes current in male homosexual culture, donning the costume of the sailor or the dandy-aesthete upon exceptional occasion, a few lesbians in the public eye adopted such attire on a habitual basis, sporting, for instance, the monocle as an everyday accoutrement. This hallmark enabled readers of Djuna Barnes's 1928 satire of lesbian Paris, *Ladies Almanack*, to identify Una Troubridge as the inspiration for the character Lady Buck-and-Balk, who "sported a Monocle and believed in Spirits."[17]

Romaine Brooks's portrait of Troubridge, painted in 1924, features the monocle as a signifier of both the sitter and her (aristocratic, lesbian) milieu (fig. 7). Two dachshunds—as equally matched as a same-sex couple—form the baseline upon which Brooks builds an image of their mistress, as long and sleek as a dachshund herself. The dog collar through which Troubridge hooks a restraining thumb rhymes with the man's stock wrapped tightly around her own throat, linking conjugal and canine bondage: the dogs were a gift to Troubridge from her lover Radclyffe Hall.

Troubridge—with her man-tailored eveningwear, her bobbed hair, her erect stance, and monocle clenched in a riveting eye—presents a striking

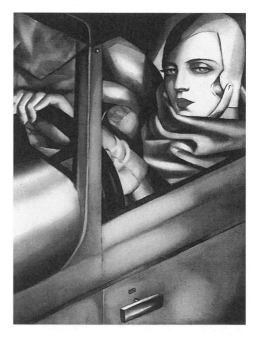

Fig. 5. Tamara de Lempicka,
Self-Portrait, 1929.
© 2004 Artists Rights Society
(ARS), New York/ADAGP, Paris

contrast to the feminine subjects of the portraits exhibited by Brooks before the First World War, such as *La Débutante* of 1910–1911 (fig. 8). Tellingly, the titles of such pre-war portraits tend to evoke the sitter's feminine costume or feminine role (*Le Chapeau à fleurs*, 1907; *Dame en deuil*, 1910), whereas the post-war portraits bear proper names. Women, in the interval, had become distinct individuals, personages. And fashion, once thoroughly imbricated in the system of constraints that kept women in their place (witness the isolation and immobility of the debutante), played, during the war and in the decades following the Armistice, a more liberating role.

"My costume says to the male: I am your equal. . . . If those who wear short hair and starched shirt collars have all the freedom, all the power, well then! I too will wear short hair and a starched shirt collar," exclaimed the feminist psychiatrist Madeleine Pelletier.[18] Nineteenth-century laws that prohibited women from wearing trousers in public were episodically enforced, and often the women targeted took the opportunity to defend their transgressions in the press. A journalist quoted the race-car driver Violette Morris as saying that she looked "less indecent in trousers than in a dress," for instance.[19] Wearing trousers, though, was for the

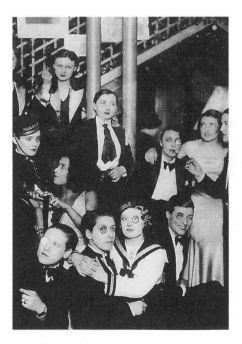

Fig. 6. Georges Brassaï, untitled (*Le Monocle*), ca. 1930.
© *Brassaï Estate—RMN*

daring and/or privileged few, and many career women opted for the com-
promise of wearing a man-styled jacket and tie with a skirt, not pants.

If cross-dressing affected a relative few, boyish hair styles caught on
within a broad cross-section of Paris's female population. The tresses of
the fin de siècle fell to the floor in households of working-class women
and the wealthy alike, a sign of the changing status of women across the
boards. Paul Morand reports, in his *Journal d'un attaché d'ambassade,
1916–1917*, that "the very latest fashion craze is for women to cut their
hair short. Everyone is doing it: . . . Coco Chanel at the head of this
list."[20] The provocative Claude Cahun appeared in public with her pate
completely shaved (in the manner of a prison or asylum inmate) as early
as 1916. Maryse Choisy, members of her fan club noted, first cut her hair

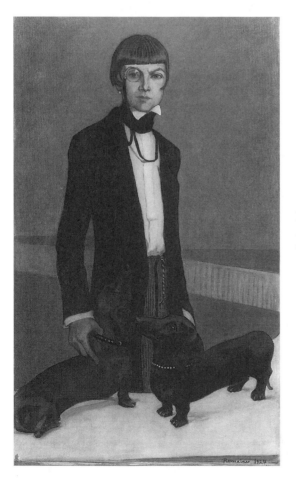

Fig. 7. Romaine Brooks, *Una,
Lady Troubridge*, 1924.
*Smithsonian American Art Museum,
Gift of the Artist*

in a preliminary bob in the early 1920s and then shaved her head "à la mode prisonnière" later in the decade.[21] Journalists reporting on the filmmaker Germaine Dulac rarely fail to note her cropped hair as well as the ever-present cigarette and man's cravat.[22]

By the late 1920s, Gertrude Stein wrote in *The Autobiography of Alice B. Toklas* that she and Elisabeth de Gramont, the duchesse de Clermont-Tonnerre,

> were the only two women . . . who still had long hair. . . . Madame de Clermont-Tonnerre came in very late to one of the parties, almost every one had gone, and her hair was cut. Do you like it, said Madame de Clermont-Tonnerre. I do, said Gertrude Stein. . . . That night Gertrude Stein said . . . I guess I will have to too. Cut it off

Fig. 8. Romaine Brooks,
La Débutante, 1910–1911.
Smithsonian American Art Museum,
Gift of the Artist

[Stein commanded Toklas], and I did. . . . I was still cutting the next evening.[23]

From our contemporary vantage point, it is tempting to interpret such sartorial statements as distinctively lesbian. The fact that a nightclub called Le Monocle catered to a predominantly lesbian clientele and that a Berlin magazine appearing under the banner of *La Garçonne* targeted lesbian subscribers suggests that European lesbians of the interwar era invested these fashions with subcultural significance. I agree with Laura Doan, however, that the mannish fashions of the 1920s may be more productively viewed as representing something larger, perhaps, as she says, "something Modern."[24] Certainly, the responsiveness of female consumers in Paris, London, and Berlin to the tailored suits and no-frills sportswear pictured in magazines such as *Vu*, *Vogue*, *Fémina*, *Ladies Pictorial*, *Die Dame*, and *La Garçonne* lends credence this claim. The *mode garçonne*, cropped hair and mannish clothing, may have provided cover for an "hommesse" like Stein, but it also proposed new liberties, both literally and figuratively, to an entire generation of women. Such fashions constituted "a visual language of liberation" from restrictive conventions of femininity and, as such, challenged the political and social status quo.[25] What I am suggesting here is not that most women wearing man-tailored clothing or aspiring to positions traditionally held by men were lesbians, but that the lesbian, like the garçonne, was emblematic of modernity. The lesbian embodied modernity's most radical promises (notably, the promise of feminine autonomy) as well as modernity's most radical threats (notably, the *threat* of feminine autonomy).

The novelist Victor Margueritte, in his best-selling novel *La Garçonne* (a title that feminizes the French word for boy), contributed to a mounting debate about these controversial fashions and their social implications. In 1922, Margueritte introduced the consumers of pulp fiction to Monique Lerbier, a character who, according to the author, incarnated "a woman's right to sexual equality in love."[26] Although Margueritte did not innovate, he certainly popularized "a new feminine type," as more than one reviewer observed.[27] His illustrator, the society painter Kees van Dongen, gave form to this type, picturing the novel's jazz-age protagonist dancing in the embrace of her lesbian lover, oblivious to the regard of male suitors. The book's vignettes of trendy impropriety provoked such controversy that the moral authorities pursued Margueritte for "outrage aux bonnes moeurs" and had his name expunged from the roles of the

Legion of Honor. "All publicity is good publicity," according to a capitalist maxim, and the controversy caused sales of the book to spike. At a time when the average print run for a popular novel was under 15,000, *La Garçonne* sold 20,000 within the first weeks of its publication, inducing Margueritte to embroider upon the adventures of Monique Lerbier and her fast-living crowd in two sequels.[28] He packaged the set as a trilogy, *La Femme en chemin*.[29]

Those who condemned Victor Margueritte misunderstood the overarching message of this modern epic: women who wear masculine clothing and display boyish hairstyles, women who reclaim masculine prerogatives (including economic and sexual autonomy), are destined to lead unhappy, unfulfilled, and "barren" lives. Feminism and lesbianism, for Margueritte, were but waypoints along the same path to perdition. Despite all the wartime demonstrations of women's competence and valor, being an independent woman in the 1920s remained "a very, very thin line to toe, a very, very frail wire to do a tight-rope act on," as Bryher's lover, the poet H.D. (Hilda Doolittle), affirms in her fictionalized memoir, *Bid Me to Live*.[30]

H.D.'s conclusion—that in the battle between the sexes, "the demarcations remained what they always had been" despite a temporary wartime retrenchment—strains credibility though.[31] Highly publicized censorship hearings throughout the 1920s provoked public responses from women of cultural influence. Cahun, Bryher, and Virginia Woolf, for instance, spoke out against bans on Maud Allan's revival of Wilde's play *Salomé*, sexually explicit films, and Hall's novel *The Well of Loneliness*, respectively. These controversies dramatized the volatility of post-war sexual and social relations. Personalities from every walk of life participated in debates about gender and sexuality, convinced that the future of Western civilization was at stake. Even the French president Léon Blum (whose book about marriage is the object of a drawing-room dispute in Margueritte's novel) weighed in on the subject.

In the meantime, experts from a range of intellectual disciplines grappled with the turn of historical and evolutionary events that threatened to advance women to the cultural forefront. Some, such as Otto Weininger, whose 1903 book *Sex and Character* was much praised by Gertrude Stein, interpreted the ascendance of women on the social, cultural, and political scenes of the new century as an effect of the masculinization of the feminine sector. "A woman's demand," he insisted, "for emancipation and her qualification for it, are in direct proportion to the amount of maleness in her."[32] The more progressive sexual theorists, though, linked women's

growing social, cultural, and political influence not to their degree of mas-
culinity but to their independence from men. Both Carpenter and Ellis,
furthermore, acknowledged the feminist movement as a natural site of
lesbian germination, because, as Ellis put it, "the congenital anomaly [of
lesbianism] occurs with special frequency in women of high intelligence
who, voluntarily or involuntarily, influence others."[33] Female educational
institutions were viewed by Ellis's more conservative colleagues as "great
breeding grounds" of lesbianism.[34] Indeed, in countries where colleges for
women existed, euphemisms for same-sex relations between women—
such as Wellesley marriage or Newnham friendship—frequently incorpo-
rated the names of women's schools.[35]

In reality, the rapport between feminism and lesbianism was problem-
atic. Negative characterizations of "the female possessed of masculine
ideas of independence" that placed the feminist in "the same class [of]
degenerates" with "that disgusting antisocial being, the female sexual per-
vert" caused many militant suffragists in France, England, and America
to avoid public demonstration of solidarity with avowed lesbians.[36] Al-
though Natalie Barney preserved the name of Emmeline Pankhurst in her
memoirs, the English feminist did not openly admit to her own connec-
tion with Paris's outspoken lesbian advocate, for instance. Even feminists
who publicly acknowledged the freedom that they themselves found in
same-sex relationships were often forced by expediency to tone down
their homosocial rhetoric.[37]

If the arena of political activism did not, in point of fact, lend itself to
the formation of lesbian social identity or lesbian community, the arenas
of higher education and professionalism did. Professionalism in the arts,
more specifically, offered women the symbolic means of self-representation
with which to negotiate their social, sexual, and political emancipation.
The college or professional school, the art academy, the gallery, the por-
trait studio, the illustrated journal, the small press, the book store, the
literary review, the theater, the cinema, the fashion house, the interior dec-
oration enterprise—among other sites—offered women seeking indepen-
dence in the 1920s footholds in a historically man's world. These sites
were of particular significance to lesbians, though, for within such
enclaves they made not only their livelihoods but their lives.

The ranks of enterprising women infiltrating professional spheres in Paris
during the interwar years provided an inexhaustible source of copy for
the popular press, including the magazines to which they contributed and

subscribed. Hervé Baille, to name just one of many popular caricaturists and cartoonists, created a profitable niche poking fun at the harbingers of women's liberation: women drivers; women artists; women journalists; women gaining purchase on the means of production and representation by entering the workforce, entering politics, taking to the streets. Baille's drawings appeared regularly in 1920s journals such as *Fémina* and *Revue Française,* whose subscription departments courted the very readership that such caricatures mocked. Among the feminine icons that Baille ridiculed, the woman driver stands out. In sketch after sketch, from the smallest page break to the most prominent header, the *chauffeuse* preens to present her best profile, dressed to the nines in the garçonne style. In one drawing from a series satirizing "la jeune fille américaine," for instance, the self-assured driver grips the wheel in her right hand, waves a cigarette ostentatiously with her free hand, and averts her gaze coyly away from the viewer (and the road) (fig. 9).[38] The office worker provided another easy target, uniformed in Chanel's revolutionary "little black dress," elongated fingers flying over the keyboard of her Underwood as if it were a concert piano (fig. 10). "Tch, tch," the illustrators of the women's pages scold, with or without resorting to captions, "mustn't take ourselves too seriously." These flippant satirical drawings indicate an editorial trend in the women's press generally during its emergent period.

In addition to caricaturists, journalists, and pulp novelists, popular psychologists editorialized on the phenomenon of women in the workplace. The remarks of Dr. Henri Drouin, the author of *Femmes damnées,* a popular study in feminine psychology, shed light on mainstream perceptions of working women: "As a fatal consequence of women's accession to careers traditionally reserved for men, a new type has appeared: *the businesswoman.* In matters of business, women have demonstrated that they could go as far as we."[39] Drouin points to the notorious lesbian *femme d'affaire,* Marthe Hanau, as a prime example of this "unnatural type," even though her nickname, *La* Banquière, marks the singularity—not the typicality—of this particular woman's accomplishment. The doctor's choice of examples, however, makes a more significant point: it links professionalism and lesbianism, implying that a woman's accomplishment in the professional sphere is symptomatic of an equally disturbing psychosexual disorder.

While Hanau's success in the world of high finance remained exceptional, women pursuing artistic vocations between the wars earned acclaim in escalating numbers. The visibility of women as both the brokers and

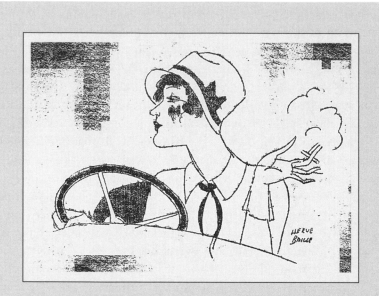

Fig. 9. Hervé Baille, caricature of "la jeune fille américaine au volant."
Published in Revue Française, *3 June 1928*

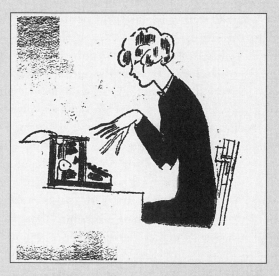

Fig. 10. Hervé Baille, caricature of "la juene fille américaine."
Published in Revue Française, *3 June 1928*

producers of modern culture was indeed one of the period's distinguishing traits. Drouin described these pioneers, a category of "femmes damnées forgotten by Baudelaire," as "strangers to their sex" and perceived "at the basis of their artistic accomplishments, a sensual void."[40] As paradigmatic of "this type . . . for whom artistic creation constitutes a refuge from the disappointments of love," Drouin offers two examples: first, the brilliant Mme de Sévigné, who never would have left us her phenomenal legacy "if she had been fulfilled as a wife and happy as a mother"; and second, that "insatiable virago" George Sand, whose genius issued, by Drouin's reckoning, from sexual frigidity.[41]

The extraordinary accomplishments of authors such as George Sand, George Eliot, Elizabeth Barrett Browning, and Jane Austin helped to make literature the "freest of all professions for women," according to Virginia Woolf.[42] Literary women of Woolf's generation both effected transformations to their local cultural environments and enlivened debates about art, gender, and sexual identity internationally. Lesbians engaged in activities from writing, journalism, and publishing to book illustration, book lending, and book selling weave in and out of the origin narrative that I am in the process of composing, as must by now be apparent.

Parallel to this accommodation within the literary professions, the interrelated domains of the theater and the visual arts also offered women economic alternatives to marriage, if not relief from the protocols of bourgeois gender relations. Although the theater continued to provide institutional cover for the most conventional of sexual transactions, at least—as Mary Louise Roberts has shown with respect to Sarah Bernhardt—eccentricity in sexual matters was the rule, not the exception, within this milieu.[43] The putatively bohemian society of visual artists, which engaged with the theatrical community in Paris to their mutual enrichment throughout the 1920s, attracted its share of lesbian artists and models. Pursuant to the sexual desegregation of private as well as state-sponsored academies in France in the late nineteenth and early twentieth centuries, women from all over France and, indeed, the world had come to Paris to study. Many—like those providing the focus of this study—remained to establish careers in the artistic capital. The professional forums that they created—from galleries like that of Berthe Weill to exhibition societies such as the Femmes Artistes Modernes—introduced a new cast of players to the international cultural scene.

One visual métier, photography, offered these newcomers the opportunity to master an emerging technology whose practices and conventions

remained open to elaboration from fresh perspectives. As the interwar photographer Germaine Krull observed, "the same world, seen through different eyes, is not exactly the same."[44] Indeed, seeing the world differently could make a world of difference. When Jean Cocteau exclaimed to Krull, "you are a reforming mirror. You and the camera obscura obtain a new world," he clearly identified the camera as the instrument of revolutionary social vision.[45]

The redemptive potential of this new technology positioned photography in the forefront of the most radical cultural movements of the early twentieth century. Photography's ignoble status in relation to the traditional arts, it's reputation as "the last refuge of failed painters,"[46] made it attractive to cultural provocateurs and available (by default) to marginalized practitioners, including women. Indeed, women entering the field of photography had a hand in shaping alternatives to existing (predominantly masculine) profiles of artistic and professional accomplishment. Berenice Abbott—an American expatriate whose portrait studio attracted, in the 1920s, an intercontinental clientele—visualized, through the camera's lens, the feminine face of Paris's intellectual and artistic vanguard. Abbott trained her lens almost exclusively, during this phase of her career, on figures of cultural distinction: Adrienne Monnier, Sylvia Beach, Janet Flanner, Djuna Barnes, and Marie Laurencin, among them. Speaking of her professional investment in the genre of portraiture during the years between the wars, Abbott claimed that "people were more *people* then," before the post-war social masks had hardened.[47]

Portraiture, implicated from its inception in processes of social evolution, experienced a resurgence during the 1920s, when Abbott lived and worked in Paris.[48] This resurgence helped to make people "more people then." Photographic portraiture mediated the creation of new social images, new social subjects, prototypes, alive with an intensity not yet dulled by the very repetition that photographic technology made possible. Abbott and others of her generation believed that the camera did not "color the image it records with remembered images of other times and places."[49] Camera vision could emancipate the eye from habits of sight and the mind from oppressive stereotypes.

To understand this line of thinking, it is necessary to imagine a world in which advertising had not yet achieved industrial primacy, a society in which the photographic image had not yet been definitively enslaved by commercial interests. In such a world, Lucien Vogel, editor of the photographically illustrated journal *Vu*, could boast with impunity of his intention

to "bring to France a new format: [photographically] illustrated coverage of news from around the world. In the pages of *Vu*," he emphasized, "advertising will occupy the place it deserves, in proportion to the place that it occupies in modern life."[50] Vogel believed that modern technology and commerce promised a better informed, less brutalized, more democratic future. Photographically illustrated magazines like *Vu* and *Vogue* constituted an open-ended catalogue of widely accessible visual references that included new images of women.[51]

In this world, the movie camera too promised to open vistas for women; cinema's potential inspired theatrical personalities such as Colette, Sarah Bernhardt, Musidora, and Loïe Fuller, directors such as Alice Guy, Germaine Dulac, and Dorothy Arzner, and producers such as Bryher, to name just a few. When H.D.—watching Bryher's image projected on the motion picture screen—exclaimed, "You are myself being free," she captured a feeling shared by many of her contemporaries.[52] A priori, filmmaking, like photography, represented a gender-neutral practice that enabled women to visualize a world free of constraining gender prejudices. In the 1920s, before the "talkies" outmoded the "silents," the so-called seventh art provided what Bryher described as "a single language across Europe" and established a frame of reference that could be shared across cultural and political borders.[53] Bryher's magazine *Close Up*, the first international journal devoted to film, included contributions from correspondents based in Paris, London, Berlin, Geneva, Hollywood, New York, Moscow, and Vienna.[54] Bryher's fluency in several languages positioned her to serve as both editor and translator. Under her direction, *Close Up* represented every nation that had been traumatized by the Great War and provided a site of dialogue in which historical enmities (whether between men and women, heterosexuals and homosexuals, blacks and whites, rich and poor, or nation-states) had no place. The title *Close Up*, like the quintessentially cinematic viewing angle to which it refers, speaks of this desire for rapprochement. Neutrality, mutual respect, the free exchange of ideas— these were the editorial principals to which *Close Up* adhered, and according to the journal's contributors, these very qualities shaped the character of the new medium.

Not surprisingly, women professionals in the fields of cinema and photography often balked when asked to discuss their work from a "woman's" perspective. In interviews, Berenice Abbott impatiently brushed aside questions about gender and sexual identity, stressing instead her aesthetic and technical accomplishments. In this way, she denied representational space,

within the public record, to narratives of victimization (or, for that matter, favoritism). Professionalism, she believed, held out the promise of evaluation based uniquely on merit.[55]

Despite their incursions into new professional territory, however, "independent women" of the 1920s still had, as the American expatriate H.D. put it, "no special place on the map."[56] Understandably, lesbians who had the means (such as H.D. and her lover Bryher) often chose to expatriate, to live as cosmopolitan nomads, or to retreat to some remote terrain of exile, beyond the range of family and state. Bryher, for one, took up residence in multinational Switzerland, leaving her prominent English family with nothing more than the address of Sylvia Beach's Paris bookshop as a point of contact. On the most profound level, of course, as Virginia Woolf justly observed, this territorial disinvestment characterized women everywhere, whether lesbian or not, at this time. As a "Society of Outsiders," women of the pre-suffrage era were statutory foreigners even in their place of birth.[57] Although the lesbian seemed a misfit not only with respect to citizenship but also with respect to kinship, she had nevertheless been structured by these frameworks. She "is and is not outcast, is and is not a social alien, is and is not a normal human being, she is," H.D. resumed, "borderline."[58]

If H.D. expressed ambivalence about the states of social and territorial liminality in which she and her lover were destined to live, Bryher took a more positive stance. Bryher shared Edward Carpenter's belief that the borderline position occupied by members of the "intermediate sex" represented an ideal middle ground—not completely estranged from nor completely implicated in the prevailing social schema—where polarized factions (racial, sexual, or political) might be led to make peace. According to Carpenter, "the frank, free nature of the [intermediate] female, her masculine independence and strength wedded to thoroughly feminine grace of form and manner, may be said to give [her], through [her] double nature, command of life in all its phases, and a certain freemasonry of the secrets of the two sexes," which enabled her to function as a "reconciler" and "interpreter."[59]

This logic informs a silent movie titled *Borderline*, which was produced by Bryher in 1930, with her husband-of-convenience Kenneth MacPherson operating the camera. Paul and Eslanda Robeson made their screen debuts in *Borderline*, attracting the attention of reviewers from England, Germany, France, and Italy. Bryher cast herself, aptly, in the role of innkeeper. The inn, a transitional accommodation located on the frontier

between politically neutral Switzerland and Germany, served as the setting for Bryher's politically and formally progressive film.

For lesbians of this pivotal generation, the question of territory itself was never neutral though, as Bryher realized. While she and H.D. chose to settle permanently in Switzerland (the birthplace of the Red Cross and a haven for conscientious objectors and deserters from both camps during the First World War), hundreds of their lesbian contemporaries adopted France as a permanent or long-term homeland. A privileged few attempted to establish outposts in spots such as Capri, where Brooks sojourned, or Mytilene, where Natalie Barney and Renée Vivien dreamed of laying claim to the mythological terrain of lesbian origins.

Terms such as *sapphist* and *lesbian* located this originary terrain in the distant reaches of the cultural imagination. The euphemism *amazon*, too, conjured up a race that dwelled, according to stories told well before the time of Homer, at the borderline of the known world. Classical narratives pushed the habitat of these women warriors farther and farther to the east as the ancient world, and its charted territories, expanded.

Had the Amazons been a real matriarchal tribe? Or were they merely the poetic incarnation of feminine resistance to patriarchal oppression? Classical scholars, poets, anthropologists, and political philosophers of the early twentieth century argued this point among themselves.[60] "It is of no consequence," wrote Charlotte Wolff in 1971, when a new generation of lesbians resumed the interrogation, "whether the matriarchate existed as a definite period of history . . . or in mythology only. Mythology is history."[61] A number of Paris lesbians at the turn of the century held the same opinion. It was of some consequence, for instance, that Vivien (née Pauline Tarn) taught herself Greek to translate Sappho's verses for French publication in 1903, just a year after Barney completed her *Cinq Petits Dialogues grecs*.[62] Vivien and Barney—two native English speakers whose literary pursuits unfurled and intertwined in French, the "language of love"—brought Sappho and sapphism together under the banner of a bilingual cultural movement.[63] For these two expatriate poets, the mythical territory of Lesbos—a settlement founded, according to legend, by Amazons—represented a heritage more legitimate (because freely chosen) than any determined by bloodlines or national origin. Legends of Sappho's reign on the island during matriarchy's golden era recommended Mytilene as a modern-day refuge for literary lesbians. Barney's *Cinq Dialogues* represent sapphism as a unifying literary, spiritual, and sexual alternative to patriarchal norms, as the following passage makes plain:

Then the Unknown Woman, persuasive and formidable, terrible and gentle, says to me: If you love me, you will forget your family and your husband and your country and your children and you will come to live with me. / If you love me, you will leave everything you cherish and the places where you remember yourself . . . and your memories and your hopes will become nothing more than the desire for me. . . . / And I answered her sobbing: I love you.[64]

Barney's Aegean "colony" foundered, as did her romance with Vivien. Undeterred, however, she went on to establish an urban Lesbos in Paris, where she solicited the support of influential comrades. Barney founded a weekly literary salon in 1909 and thereafter the *pavillon* on the rue Jacob, with its enclosed garden, served as the staging ground for a veritable Sapphic revival.[65] There, the pageants performed, the poetic narratives discussed and recited—penned by Barney herself, Vivien, H.D., and other writers known to them—celebrated heroines, goddesses, and queens liberated from the pages of Western culture's foundational myths. Two of Barney's lovers, Colette and Eva Palmer, performed a dialogue extolling "l'amour grec" written by Pierre Louÿs in the classical mode. The poet Lucie Delarue-Mardrus dedicated her 1917 play *Sapho désesperée* to Barney. Ida Rubinstein coveted the role, but in the end Delarue-Mardrus herself interpreted Sappho for the inauguration of the Théâtre Fémina.[66] Such lesbian initiatives glossed a classical revival that had been gathering momentum within male homosexual communities for decades.[67] More broadly speaking, the Sapphic revival claimed space for autonomous women upon the contested terrain of Western cultural origins while projecting a new cultural and relational paradigm into the future.

The cover of Djuna Barnes's sardonic paean to Barney and her salon, *Ladies Almanack*, pictures the literary hostess as a modern Amazon. Astride her steed, sword raised, Barney leads the charge against the patriarchy at the gallop, backed by a small army of female admirers (fig. 11). Barnes, in her foreword to the *Almanack*, locates this lighthearted saga at "neap-tide to the Proustian chronicle." The phrase situates the lesbian Paris known to Barnes and Barney in relation to homosexual society as viewed by one of its most celebrated male chroniclers, Marcel Proust.[68]

Proust, in *À la Recherche du temps perdu*, elaborates on the themes of territorial alienation familiar in early twentieth-century accounts of sexual deviance. Take, for instance, the woman-loving Albertine (travesty of

Albert, a homosexual chauffer in Proust's employ); Proust portrays this lesbian character as "a spy," who "betrays her most profound humanity, in that she doesn't belong to the human community, but to an alien race that infiltrates this society, hides itself therein, never to assimilate."[69] *Ladies Almanack*, in contrast, describes lesbianism as an imperious rather than insidious mode of operation. Instead of infiltrating society (in the tradition of cross-dressing traitors such as the legendary Chevalier d'Eon), Barney, identified by Barnes as the queen of Amazon Paris, makes conquests, rescues hostages held in marriage, and restores them to "the shores of Mytilene."[70] Mytilene, in Barnes's account, is not a land of exile, an alien territory, but a reclaimed motherland.

Barney, who financed the first edition of *Ladies Almanack* in 1928, schematized Paris-Lesbos, this land of promise, for the frontispiece of her self-published memoirs, *Aventures de l'esprit* (fig. 12).[71] The shifting perspectival and representational systems of Barney's *Le Temple de l'amitié et ses familiers* disorient the viewer. Is it a blueprint, a map, a guest list,

Fig. 11. Djuna Barnes, cover illustration, *Ladies Almanack*, 1928. © *The Authors League Fund, as literary executor of the Estate of Djuna Barnes*

a social register, a genealogy? An interior floor plan artlessly defines a domestic space within which Barney has scribbled the names of those who attended her weekly salon: guests of both sexes from a variety of artistic, social, and geographic climes. The role intermingles still celebrated names—Colette, André Gide, H.D., Sarah Bernhardt, Janet Flanner, Rainer Maria Rilke, Sinclair Lewis, Louis Aragon, Radclyffe Hall, Rachilde, Marcel Schwob, Marie Laurencin, Georges Antheil, Greta Garbo, Mercedes de Acosta, Marguerite Yourcenar, Gertrude Stein—with forgotten ones. The names, like the guests themselves no doubt, appear grouped by free association, observing no pronounced taxonomy. Brooks occupies a central spot near the tea table, surrounded by personalities whom history has since obscured. Here and there we find the names of those who sat for Brooks's portraits: Una Troubridge, Elisabeth de Gramont, the novelist Paul Morand, the pianist Renata Borgatti. A few (illegible) names occupy a space in the margins, on the perimeter of the salon.

Barney reserves the top of the page for her most honored guests. Upon this echelon, decadents of the old school—Pierre Louÿs, Comte Robert de Montesquiou, Rilke, Edouard de Max, Apollinaire, Proust—rub shoulders with the suffragist Emmeline Pankhurst, the dancer Isadora Duncan, and poet Renée Vivien. Before an elevation of the temple consecrated "à l'Amitié" (focal point of this drawing, Barney's garden, and her career), we find Remy de Gourmont, originator of the epithet "l'Amazone des lettres," by which Barney was known.

A fine, meandering line traces the hostess's trajectory through a parlor full of guests representing no less than a dozen nations, out the garden door, and up to the threshold of this Temple of Friendship. Barney labels the line, like a river on a map, "l'Amazone," mixing cartographic with architectural idioms. She adopts this fluvial trope repeatedly in her memoirs, comparing herself, for instance, to an American "tidal wave that runs against the current of the Seine and jostles the small boats that are too tightly attached to the banks."[72] Barney's drawing purposefully represents an allegorical place—"now a landscape, now a room," words once used by Walter Benjamin to describe the city of Paris.[73] It evokes the trajectories of friendships, of love affairs, of rivalries, and hit-and-miss encounters staged within the semiprivate space of Barney's salon: a special place on the map for independent women.

Like Romaine Brooks's portrait oeuvre, Barney's schematic drawing, and the salon itself, represents the desire for community more than the fact of community; the characters named here never acted in concert on

the same stage at the same time. Some of them may never even have set foot on Barney's premises; others may have done so with reluctance. Radclyffe Hall, for one, viewed Paris-Lesbos as a "no-man's land—the most desolate country in all creation," and neither Barney's charms nor the brilliance of her salon changed this perception.[74] Renée Vivien experienced her short life in that country as a form of exile, lamenting, "everywhere I go I repeat: '*I do not belong here.*'"[75] Similarly, the protagonist of H.D.'s autobiographical novel, *Paint It Today*, protests that she and her lover have been "cast out of the mass of the living."[76]

Some lesbians, on the other hand, wore their alienated status like a badge of distinction. "In order to bring something, it is necessary to come

Fig. 12. Natalie Barney, *Le Temple à l'amitié et ses familiers*, frontispiece for *Aventures de l'esprit*, 1929.

from elsewhere," Barney prefaced the collection of literary portraits that she created of this estranged population.[77] Brooks adopted an aesthete's stance, that of an artiste who "belongs to no time, to no country, to no milieu."[78] And those—like Bryher or Cahun and Moore—who decried chauvinism for its logic of domination, seized on the utopian potential of alienation.

Whether experienced as an affliction, a strategy, or a distinction, this lesbian culture of estrangement inflected expatriation in specific ways. As Sandra Gilbert and Susan Gubar have observed, "Neither an emigrant nor an immigrant, the expatriate defines herself in resistance to both the first country in which she was born and the second country where she resides." The expatriate standing of the lesbians who settled in Paris symbolized the rejection of nation and family as the cornerstones of identity. The citizens of Paris-Lesbos might well have conceived of lesbianism itself "as a perpetual, ontological expatriation."[79] Expatriation, by these lights, equally describes the venture of lesbians who migrated to Paris from the provinces, many of whom (like Claude Cahun and Marcel Moore, or Suzy Solidor) abandoned their family names en route.

If Paris was, as Barney claimed, "the only city where you can live and express yourself as you please,"[80] this was because those who sought alternatives there envisioned and lived it as such. By behaving and speaking differently—by articulating what the *Ladies Almanack* described as "the anomaly that calls the hidden name"—lesbians of this era aimed to redefine the boundaries of both the known and the imagined world.[81]

Two

Romaine Brooks

PORTRAITS THAT LOOK BACK

A new star makes a new heaven.

—Natalie Clifford Barney,
The One Who Is Legion

The lesbian society portraitist Romaine Brooks, an outstanding member of Paris's growing population of modern women, cut a striking figure on the European cultural scene during the 1910s and 1920s. Her dashing fashions, raven hair, pale complexion, and penetrating eyes invested the painter with an aura of romance. Mireille Havet described Brooks, amid a select group of admirers, as wrapped in "the perverse and disquieting mystery of her spacious black living room, with its off-white and vermilion accents, gold cushions, lacquer ware, mirrors, geometrically patterned rugs, and grand fireplace." The only natural touch, "a rude and untamable fire," threw light on the "admirable, hermetic face" of the hostess, with her "sad smile, that of a disappointed child, and an authoritarian and ardent regard that caresses and questions."[1] Brooks staged her professional and social interactions within contexts, like the mise-en-scène that Havet described, of her own devising.

The artist's decor, like her demeanor, was of a piece with the dark and somewhat disquieting paintings that claimed pride of place in the overall scheme. "Ça, c'est moi," Brooks would declare to her guests, gesturing dramatically toward the 1923 self-portrait. The critic Albert Flament recorded his impression of this expatriate's "joyous accent thrown like a veil over the void of her solitude." Flament had no sooner stepped across the painter's threshold when Brooks introduced him to a "portrait

psychologique" (the 1923 self-portrait) that she had propped on an easel by the windows. Flament noted the effect of this dual encounter: "'Un portrait psychologique'. . . ! In the three-faced psyche glass I perceive the real face of Mrs. Brooks, who has just made herself up with that ochre powder she loves so much. . . . And I shift my eyes back to that other visage, severe and pale, a being invisible to our eyes that [the artist] has rendered on canvas . . . , a solitary wanderer, at large within a devastated habitat."[2] Flament represents the 1923 self-portrait as a sort of uncanny double, a manifestation of the subject's unconscious (singular, invisible, private) essence. Brooks's early supporter Robert de Montesquiou, in his article "Cambrioleurs d'ames," acknowledged the uncanny effect of Brooks's portraiture more generally. It was as if, he observed, these paintings had the power to usurp the essence of their sitters, the power to "steal their souls."

Montesquiou, model for the neurasthenic protagonist of Joris-Karl Huysmans's fin-de-siècle classic À Rebours (Against nature), recognized Brooks as a kindred spirit; he called attention to her work on the occasions when she saw fit to release it from her salon for display in exhibitions or galleries. The portraits demonstrated a degree of panache and savoir faire that some believed ill suited to a woman painter, a wealthy one who painted only what and when she pleased. A number of critics remarked that Brooks's portraits derived their strength from the models who posed for her more than from the artist herself. Certainly the works produced by Brooks during the 1920s, in particular, dramatize a sense of entitlement shared by the artist and her sitters—that is, the upper echelons of Paris's cosmopolitan lesbian society.

These portraits "look back" in more ways than one. Most obviously, the independent women represented by Brooks—commanding equal footing with the artist-heiress—confidently return the gaze of the observer. At the same time, these portraits revise and revitalize an iconography of distinction codified in the previous century. Elite figures such as the dandy and the flâneur, for instance, emerge anew in and through Brooks's portrait oeuvre. Characterized by extreme refinement, meticulous attention to surface appearances, and indifference to commercial expediency, dandyism offered an alternative to the ethos of masculine sobriety that prevailed in Baudelaire's era. Via costume and gesture, the dandy set himself apart from the sober legions of businessmen and statesmen responsible for building the great financial and colonial empires of nineteenth-century Europe. In the writings of Baudelaire and his contemporaries, another privileged

male character, the flâneur, also stood apart from the industrious fray of capitalist expansion to savor the special pleasures of modern urban life. While, on the one hand, the dandy created a public spectacle of himself, the flâneur took up the less conspicuous station of an anonymous and detached observer. Both the figure of the dandy and that of the flâneur continued to resonate in the 1920s Paris art world and continued to accrue new social meanings.

Brooks, as recent scholarship demonstrates, elaborated those meanings in her monograph, memoirs, and letters, in her decorative schemes, her photographs, her fashions, and, above all, in her portraits of modern women.[3] Brooks's tour-de-force self-portrait of 1923 offers a striking example of the artist's feminine—and more specifically, lesbian—revision of dandy-aestheticism and of the figure of the flâneur (fig. 13). With this self-portrait, and with her fashion and aesthetic choices generally, Brooks not only envisioned a new kind of elite subject but also contributed to the resignification of a pastiche of visual cues that enabled upper-class lesbians to identify and to acknowledge one another.[4] In the same stroke, Brooks tailored the mantle of artistic genius to suit an entirely new profile: that of a woman.

This bifurcated identification (with the flâneur, the observer, and with the dandy, the observed) was the first solution that Brooks worked out to two significant problems facing her when she began her painting career in the 1890s. Both problems related to the larger question of the status women in European societies, the so-called woman question. First, how could an artist represent a feminine subject in ways that acknowledged strength of character, powers of intellect, and the capacity to assume active roles? Second, how could Brooks, as a woman, represent herself as a serious (and potentially canonical) artist?

In a survey of French Salon painting of the 1890s, the critic Camille Mauclair attempted to come to terms with a new type of female iconography put into circulation by artists to whom he referred as "the painters of the 'New Women.'" He speculated that *la femme nouvelle*—self-reliant, educated, and ambitious—would cause artists to rethink the gendered conventions of portraiture.[5] Throughout the nineteenth century, he noted, the pictorial goals of male and female portraiture had rarely converged. Feminine portraiture offered the artist an opportunity to demonstrate technical virtuosity, to craft the decorative surfaces of the sitter's costume, coiffure, and body as of one piece with her resplendent surroundings;

portraits of male subjects, on the other hand, allowed the artist to translate individual character and psychic depth into marks of paint. Because of the emergence of a new kind of feminine subject at the turn of the century, Mauclair observed, "a new concept of women's portraits has begun to emerge. Her decorative and nonconscious aspects will probably fade. A new woman is being elaborated, a pensive and active being to which a new form of painting will have to correspond."[6] If Mauclair had witnessed the arrival, upon his own historical horizon, of a new form of portraiture that corresponded to this new kind of feminine subject, he still imagined that "the painters of the New Women" would be male. New Women who desired to represent themselves had first to contend with yet another rhetorical figure, that of the *femme peintre*.

In the first decades of the new century, an expanding community of women artists emerged from the professional academies whose doors they

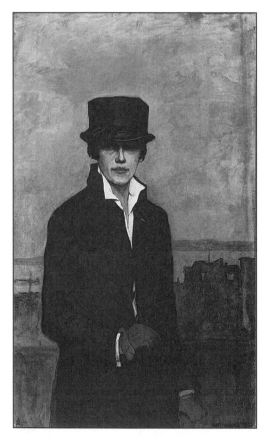

Fig. 13. Romaine Brooks, *Self-Portrait*, 1923. *Smithsonian American Art Museum, Gift of the Artist*

had forced open in the 1880s and 1890s to expose their work in the prestigious annual Salons. The proliferation of work by women at the Salon provoked a spate of polemical critical writings about the artistic and professional capabilities of the "gentle sex." Louis Vauxcelles, for instance, devoted a chapter of his 1922 survey of French art to what he described as the era's "copious blossoming" of a new art-world figure, the femme peintre. The distinctions he made between art produced by women and art produced by men surfaced time and again in critical responses (whether supportive or dismissive) to incursions by women into this historically male cultural arena. "What many female painters and sketchers call art," Vauxcelles concluded, "is often merely an art of pleasure. . . . Rare are those women artists who have understood that art is not merely an agreeable lie, but that through it one should express the most profound, the most intimate part of oneself, the sad and lofty dreams that one cannot pursue in life."[7]

The fashionable Parisian society painter Kees van Dongen chose the "lady painter" as the subject of a painting he exhibited at the Galerie Bernheim in 1921 (fig. 14).[8] The title *Passe-temps honnête* encapsulates the assumptions about women that inform the critical writings of Vauxcelles and his contemporaries as well as this painting. The cliché of the "honest pastime" acknowledges, on the one hand, the amateur status of most women artists of van Dongen's era and, on the other, the opportunities that women of the post-war generation might have had to indulge in *dishonest* pastimes. The title also sets a complicit tone for the dialogue between the painter and the viewer, a jocular exchange mediated by the painting itself.

Van Dongen pictures a stylish woman perched on perilously high-heeled shoes before an easel erected in the middle of her elegantly apportioned living room. The domestic setting tells us just as plainly as the painting's title that art is only a hobby for this woman, not a profession. The dilettante dabbles at her palette while chatting with a fashionably dressed female companion (perhaps the sitter for the painting within the painting?), who poses at the cusp of an over-mantel mirror, head propped up on her elbow to convey a cultivated blend of amusement and boredom. The sheltered, domestic setting, the claustrophobic enclosure of the two women within the picture's frame, and the narcissistic circuit of the feminine gaze framed and reframed here by both mirror imagery and portraiture-within-portraiture effectively evoke the limited horizons of both the female painter and the female subject more generally. The woman

painter's vision, under these circumstances, can be neither "lofty" nor "profound." As if to literally materialize the frivolity of this woman's artistic pretensions, the printed fabric out of which the painter's smock is fashioned features brightly colored circus clowns. Her foolish smock not only marks her as an amateur but also compensates for her incursion into the unwomanly sphere of cultural production.

This stereotype of the lady who paints, like all stereotypes, contains a kernel of truth. Most women who painted at the beginning of the twentieth century were indeed "ladies" — in so far as their backgrounds almost always assured them financial security, if not independence. Until well into the twentieth century, art academies in Paris held segregated life-drawing classes and provided separate studios for female students; female students paid twice what male students paid for classes and studio space.[9]

Fig. 14. Kees van Dongen, *Passe-temps honnête*, 1921.
© *2004 Artists Rights Society (ARS), New York/ADAGP, Paris*

Under the circumstances, the upper-crust profile of the majority of women pursuing careers in the visual arts in the late nineteenth and early twentieth century is hardly surprising. Class privilege, what is more, often rendered the distinction between amateur and professional somewhat fluid. Women who wanted to be considered professional necessarily took pains to safeguard their reputations against the stigma of amateurism—by avoiding, for instance, media associated with hobbyists (such as watercolors) or steering clear of lesser genres (such as the still life).

Yet the aspersion of amateurism was, as they well understood, merely symptomatic of a more fundamental prejudice concerning the innate inferiority of women. The sexologist Guglielmo Ferrero linked the secondary role played by women in the arts, their inferior aesthetic faculties, to the peculiar character of their biological imperatives—in particular the putatively whimsical nature of female sexual desire.[10] Brooks aspired to the status of the rare exception with respect to both aesthetics and sexuality. She refused to be considered a woman painter. As a result, she chose not to show her work in the all-women shows organized by the association of Femmes Artistes Modernes, to which several of her colleagues (such as Marie Laurencin and Tamara de Lempicka) adhered.[11] The paternalistic tone of the critical coverage that these exhibitions received permits us to understand, if not applaud, Brooks's position. Guillaume Apollinaire, writing about the Femmes Artistes Modernes, pronounced that although work by "les peintresses" was not original or innovative, at least it married "good taste . . . with delicacy." He described paintings by Marie Laurencin (then his lover and a regular contributor to F.A.M. exhibitions) as "lighthearted" rather than sober, "intuitive" rather than cerebral.[12]

In contrast, Brooks's paintings—such as her haunting nude *Azalées blanches* of 1910—garnered more serious consideration. As characterized by Montesquiou, Brooks seduced the viewer not with innocence and charm but with a more powerful allure, dark and decadent, "akin to that of belladonna" (fig. 15).[13] In his review "Cambrioleurs d'ames," Montesquiou took pains to countermand the presumption of amateurism that handicapped so many of Brooks's women colleagues. Without offering a corrective to this stereotype, he concluded: "In this time of unfettered amateurism, the quality of her work classes her among those whose products . . . serious, severe, bitter, even . . . have nothing to do (no, nothing whatsoever) with the trendy art objects we see exhibited annually."[14] From the very beginning of her career, critical responses to Brooks's work stressed qualities more typically associated with masculinity, describing

her work as "original," "innovative," "vigorous," "penetrating," "cerebral," "precise," "affirmed," "sober," "rigorous," and "masterful."[15]

Vauxcelles, although skeptical about the suitability of women to artistic careers generally, seemed to view Brooks's lesbianism as a distinguishing feature, and one that differentiated her work from traditional patterns of feminine practice. "The nature of the artist [Brooks] is singular," he alerted the reader, "marked by a cold perversity, a bit literary. Her drawing is firm, muscular, the composition always willful."[16] A reviewer for the *Commentator*, a London paper, described the aura of Brooks's paintings as "curious, cold, salty," "artificial," "insidious," and "highly self-conscious." "In Mr.—or is it Miss?—Brooks's art," this reviewer acknowledged a "touch of decadence" that he found "languorous," somehow, in a "rather new, Northern kind of way" and "not wholly unpleasant."[17]

These critics were responding to the female portraits and nudes that Brooks exhibited at her first solo show, organized by Paris's prestigious Durand-Ruel Gallery in 1910, and a spin-off exhibition held the following year at London's Goupil Gallery. In works like *Azalées blanches*, the expressive distortion of scale, the disturbing lassitude of the figure, the calculated combination of perspectival systems, and the funereal color scheme contradicted received ideas about the prettiness of the feminine

Fig. 15. Romaine Brooks, *Azalées blanches*, 1910.
Smithsonian American Art Museum, Gift of the Artist

artistic sensibility and presented an alternative to the (traditionally fecund and voluptuous) female nude. With paintings like *Azalées blanches*, Brooks began to tackle the questions of how to represent women differently and how to represent herself as a different kind of woman artist.[18]

The solution to these interrelated problems did not crystallize, however, until the following decade—after the war—when Brooks conceived of the paintings that Natalie Barney labeled a "series of modern women."[19] The series, which Brooks and Barney together took pains to circulate, redressed the less-dignified images of modern women that proliferated in the print media internationally during the post–World War I reconstruction period. The portraits—whose bold outlines, monochromatic coloration, and simplified formal vocabulary facilitated photographic replication— were so frequently and widely reproduced in publications that Brooks had to engage no fewer than four clipping services (one in England, one in the United States, and at least two in France) to keep her 1920s press book current.

Brooks's *Self-Portrait* of 1923, although not the first in this series of modern women, epitomizes the artist's post-Armistice project. She chose to feature the self-portrait on the cover of the exhibition catalogue for a major solo show at London's Alpine Gallery in 1925. Reviews of the show in art journals on both sides of the channel, and indeed on both sides of the Atlantic, cameoed her self-portrait. The painting was, and continues to be, the most widely exhibited and widely reproduced of Brooks's works, serving, from its inception, as a kind of logo for the painter. In this self-portrait, Brooks figures the modern feminine subject (herself) as an entirely autonomous agent. She holds her own within the space of the painting and within the space we occupy as viewers, leveling her gaze at us from the shade of that brimmed top hat. The critic Claude Roger-Marx was struck by the ways in which this portrait played with codes of gender and sexual identity: "This top hat that overshadows a feminine face, these gloved hands, this virile costume recalls the most daring descriptions in [Proust's] *À la Recherche du temps perdu*, while the melancholy with which the artist has invested her regard makes one dream of the heroines so tenderly described by Colette in *Ces Plaisirs*."[20] Despite Brooks's adoption of expressive practices (from her palette to her costume) that harked back to late nineteenth-century aesthetes like James Abbott McNeill Whistler and Oscar Wilde, critics persistently identified Brooks as an artist who was, like Proust and Colette, "adamantly of her times."[21]

Modifying nineteenth-century conventions (of both gender and representation), Brooks aimed to establish her lineage as a notable artist while visualizing new social and cultural horizons for women of her disposition and standing. In this portrait of the artist, among other works, Brooks renegotiates a heavily coded geographical and social space. She poses on what appears to be a balcony or terrace—a transitional space linking the interior (perhaps of the artist's studio or home) to the outside world, a world in ruins. The balcony also links innovations in the realm of portraiture to past conventions of feminine representation, situating the artist at the threshold of a promising new era. In sharp contrast with the "girl wistfully wondering at life," as one critic described the subject of an earlier balcony portrait titled *La Vie passe sans moi*, the feminine subject represented by Brooks in 1923 does not wistfully overlook a world to which she has only limited access.[22] Instead, Brooks appears to dominate the cityscape behind her. Her form breaks the horizon, cutting a black silhouette against the troubled sky. In the background, the facade of a ruined building doubles the artist's silhouette like a haunting leitmotif.[23] The windows of the hollowed-out building, like Brooks's own introverted regard, seem to simultaneously invite and ward off visual access.

While balcony portraits like this one by Brooks from the 1910s deploy representational strategies used by impressionist-era painters to map the constraints of bourgeois femininity onto the architecture and geography of the modern city, the 1923 self-portrait presents a radically different model of feminine subjectivity.[24] The feminine subject here takes on the aspect of a flâneur, a subject identified with, rather than "sheltered" from, the city. Indeed, the balcony seems to figure the flâneur's gaze, overlooking not a literal place but an allegorical city, like the city evoked in the contemporaneous writings of Walter Benjamin.[25] The artist's perch does not overlook the Champs de Mars at the heart of Paris, which provides a backdrop for another one of Brooks's earlier balcony portraits, *Jean Cocteau à l'époque de la grande roue* (Jean Cocteau in the era of the Ferris wheel) of 1912. In contrast to the quintessentially Parisian spectacle that Brooks associates with Cocteau, she has chosen to situate herself within a less identifiable urban geography—it could be Paris, it could be Whistler's London—where land and water interpenetrate in the half light. Before our eyes, as before those of the flâneur described by Benjamin, "the city dilates to become landscape."[26] The misalignment of the architectural and topographical features bracketing the subject contributes to the troubling ambiguity of this setting. Unresolved but evocative, the

background seems to formalize the artist's own liminal status as an expatriate, a woman artist, and representative of the so-called intermediate sex. Like the flâneur, she poses "on the threshold, of the city as of the bourgeois class. Neither has yet engulfed [her]; in neither is [she] at home."[27]

Elisabeth de Gramont, *femme de lettres*, describes Brooks in terms that affirm this image of the artist as a privileged outsider, above the fray, "indifferent to honors and testimonials of recognition" and destined "to remain a stranger wherever she goes."[28] Echoing Baudelaire's romantic notion of the poet, Gramont pictures Brooks as a painter who, by dint of her marginality (sexual marginality included), remains completely free, at home both nowhere and everywhere, "like a roving soul in search of a body" (and entitled to take any body she chose).[29]

This sense of entitlement shapes the image that Brooks presents in her self-portrait. Striking a proprietary pose vis-à-vis the urban scene behind her, she directs her attention away from the exterior public world, toward the private interior, where she situates the viewer. In so doing, she herself remains remote while identifying the viewer not as a member of the wider, outside public but as an intimate, an "insider." Before this *invitée*, the portrait subject stands slightly torqued and perfectly erect at the very limit of the picture plane, impinging upon the viewing space that she has defined, as if, "emancipated from coteries and human society in general, it pleases her simply to observe those around her."[30]

Just as the portrait figures a subject who commands the space behind (metaphorically, the past, away from which she pivots) as well as what lies ahead (in both time and space), it presents us with a feminine subject who masters her own representation. The worked-over surfaces of the portrait subject's face and garments, in contrast to the relative sketchiness of the setting, establish the primacy of this subject, while the expressive brushwork celebrates and memorializes the artist's hand. The asymmetry of the composition, the reduction of form, the deft outlining, signal the painter's modernity and visual sophistication. The half circles underscoring the eyes emphasize her appraising gaze, while the shadow cast by the hat fends off the searching eyes of the viewer. Vauxcelles, struck by the intensity of this effect, remarked, "Madame Brooks does not paint the eyes, but the regard"[31]—in this case, the artist's self-regard, her regard for others, and the regard of others for her all come into play.

If this emphasis on the shaded eyes suggests a privileged subject who—like the flâneur—observes without being observed, the emphasis also

entwines the aesthetic experience with that of desire. Benjamin could have had this painting in mind when he wrote, explaining the charismatic power (or "aura") of the original art work, that "the painting we look at reflects back at us that of which our eyes will never have their fill. What it contains that fulfills the original desire would be the very same stuff on which the desire continually feeds."[32] In attempting to exchange regards with the painting, the viewer experiences a pleasure in desiring—the simultaneous sensation of fulfillment and lack that constitutes the peculiarly intimate thrill of aesthetic experience.[33] Yet the gender dynamics of desire set in play here do not conform to normative (subject/object, male/female) binaries. This painting (this woman) not only looks back; she looks first. Indeed, we find it impossible to return her gaze. Our eyes are turned away, disregarded; deflected downward by the vertical line of the portrait subject's nose, they come to rest on a pair of startlingly red lips.

The bright lip rouge and thickly powdered face mark the portrait subject as a woman, and a fashion-conscious one at that, despite her male attire. The vermilion lipstick calls forth the only other touch of color in the painting—the hero's ribbon that adorns the artist's lapel—to invoke a feminine subject who, like the Baudelairian artist, is both modern and heroic.[34] The artist has highlighted the musculature surrounding the portrait subject's mouth, suggesting a capacity for expression that the sealed lips pictured here belie. We might linger upon these lips, trying to read meaning into the impassive set of this mouth and jaw, were it not for the arrowlike white collar and throat that lead our eyes away, down the button-line of the subject's jacket (which buttons man-wise, right to left). The jacket gaps slightly to receive the thumb of a gloved right hand. The subject's forearm, nearly perpendicular to her torso, cuts off our eye's descent and invites us to pause and appreciate her articulated and articulate hand: the painting hand.

The subject's glove—its turned-back cuff, its seams, its suggestive position—invites exegesis. As an attribute, the glove has a long history in visual representation. In feminine portraiture (such as *La Femme au gant*, 1869, by Brooks's one-time instructor Carolus-Duran) the glove—dropped like a hint in the woman's wake—participates in a coy mise-en-scène of heterosexual seduction. In masculine portraiture (Velázquez's portraits of the Spanish nobility, for instance) the glove serves, instead, as a marker of aristocratic privilege and authority.[35] A central visual prop of diplomacy, the glove removed signals a disposition to negotiate, the glove thrown down, a provocation. From the seventeenth century forward, breviaries

outlining the rudiments of genteel behavior informed aspiring bourgeois gentlemen that the removal of one glove indicated genuine "ease."

What does it mean that Brooks, in this self-portrait, has not removed one glove? Is this a way of indicating, in dialogue with the breviaries on genteel comportment, that she is somehow not entirely at ease? Not quite genteel, *pas vraiment gentil*—not quite nice? Or is it that she is not disposed to negotiate? Or does the fact that she retains both gloves suggest, in defiance of the conventions of feminine portraiture, that this subject is not sexually available to men? In any or all cases, Brooks, like her male dandy predecessors, clearly deploys fashion here as a means of engaging critically with the social codes of rank and gender.

The most famous of these predecessors, Beau Brummell, made the glove a fetish, securing its position of prominence in the iconography of the dandy. According to legend, Brummell engaged three different specialists to fashion his gloves: one for the palm, one for the fingers, and one for the thumb.[36] Robert Dighton's 1805 portrait of Brummell pictures this prototypical dandy, with one arm akimbo, one glove removed, and holding a top hat and stick in his bare hand (fig. 16). He holds the hat by its brim, displaying a deep, silk-lined interior. Here, the top hat, like the dandy himself, seems to figure both the male and female poles of sexual subjectivity, hinting broadly at the possibility of self-generation.[37] As Rhonda Garelick observes, the dandy "longs to recreate himself as an emblem of complete originality, with no progenitors save other dandies."[38] The society of dandies, this implies, reproduces, renews itself, through emulation as opposed to procreation.

Brooks's top hat (in contrast to Brummell's) signifies androgyny (and autochthony) not so much by its formal ambivalence as by its simultaneous reference to both male and female sartorial codes. The top hat, in addition to its status as an emblem of the masculine elite, had assumed preeminence, in the 1920s, as a feature of *la dernière mode féminine* (fig. 17). A spread in the Parisian periodical *Fémina* showcases a confection closely resembling that of Brooks and identified as "the Brummell top-hat."[39] Unlike Dighton's Brummell or Whistler's *Comte Robert de Montesquiou-Fezensac* (fig. 18) (to name a painting with which Brooks would surely have been familiar), the dandy pictured in the 1923 self-portrait displays no cane, no crop, no maulstick, not even a tightly furled umbrella. Her right hand, instead, lightly fingers the gap in her jacket. The phallus apparently does not figure into the economy of this image, yet the portrait remains intelligible within the tolerances of the dandy genre.

When Marius-Ary Leblond, in his 1901 essay "Les Peintres de la femme nouvelle," identified the aesthetic idioms best suited to the articulation of the modern feminine subject, he anticipated the rapprochement between aesthetics and subjectivity that Brooks effected in her portraiture of the 1920s: "The new woman is not beautiful. She looks rather like a boy, and illustrates more than anything the expression of a firm character, a serene soul, a robustly harmonious body. . . . They are no longer women of pleasure and leisure but women who study, of very sober comportment. And nothing suits them better than heavy and somber colors . . . that express firmness, . . . roughness, and decisiveness."[40] Brooks's somber, monochromatic palette distanced her from female colleagues, such as Marie Laurencin, whose pastel tones played to and with prevailing notions of feminine sensibility and taste.

Period criticism often describes the tonalities of Brooks's palette as "Whistlerian."[41] Montesquiou, careful not to characterize Brooks's work as derivative, nuanced this comparison: "Just as [Whistler] bragged that

Fig. 16. Robert Dighton,
Beau Brummell, 1805.

he never set foot in the museum of Madrid [to study the portraiture of Velázquez], Madame Brooks proclaims that she never set foot in Whistler's atelier; she is none the less—and I compliment her on it—one of the most curious and most sincere students of this master, whom she has studied, understood, and whose mode she has continued according to her own fashion."[42] The decadent poet Gabriel D'Annunzio, an intimate friend of Brooks whom she represented in two portraits, also compared her to Whistler, dubbing her "the cleverest color symphonist in modern art."[43] Her works hung adjacent to Whistler's famous *Arrangement in Grey and Black: Portrait of the Artist's Mother* at the Exposition des Artistes Américains (Musée du Luxembourg, Paris, 1919), where critics compared her "symphonies in grey, white, and black" favorably with those of her compatriot.[44]

Brooks solicited the comparison to Whistler in a number of ways.[45] In the manner of Whistler, she used harmonious tonalities to unify her paintings internally and simultaneously to negotiate an artful liaison with the surrounding décor. As Barney observed, "no component finds its place unless it makes sense in relation to the whole."[46] Like Whistler, Brooks designed picture frames for her works that served to integrate the paintings with the surroundings. As a result, her paintings seemed to at once blend in to the environment and stand out from it. In the case of her 1923 self-portrait, for instance, the frame's width and low, gently rounded profile smooth the transition between the represented space of the painting and the real space of the viewer. The frame's silver-leaf finish harmonizes with and reflects the surroundings, yet the black form of the portrait

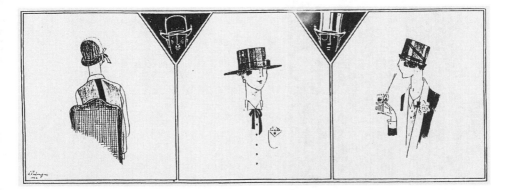

Fig. 17. Illustration from *Fémina*, 1924, picturing the "Brummell" top hat.

subject commands full attention, emerging from a field of halftones as if coming into view through a thick fog. Montesquiou praised at length the shades of black and gray that dominated Brooks's palette and her "manner of disposing them, not only in her paintings, but in her apartments and studios."[47] In her memoirs, Brooks describes the totalizing aesthetic that she strove to create, one that could override both the physical and disciplinary bounds of painting to transform the environment according to its own dictates. The organizing aesthetic principles that she articulates— "to make my surroundings coincide with some disturbing significance within my artist's brain"—are those of nineteenth-century aestheticism.[48] Yet she puts her own stamp upon this legacy.

If Brooks contrived to situate herself in the lineage of aesthetes like Whistler, she took equal pains to distinguish herself—lest she be perceived, like so many of her women colleagues, as an imitator. In her unpublished

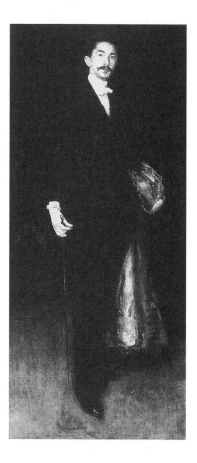

Fig. 18. James Abbott McNeill Whistler, *Comte Robert de Montesquiou-Fezensac,* 1891–1892.
© *The Frick Collection, New York*

memoirs, "No Pleasant Memories" (whose vitriolic character recalls Whistler's memoir *The Gentle Art of Making Enemies*), Brooks both acknowledged and set herself apart from this predecessor: "Of all the painters of that period, I of course admired Whistler most. I also criticised him long before I was able to express my own personality in painting. I wondered at the magic subtlety of his tones but thought his 'symphonies' lacked corresponding subtlety of expression. There was no surprise, no paradox. No complexity. His was a painter's perfect technique expressing delicate visual beauty. My own disturbed temperament was to aspire towards more indeterminate moods."[49] Here she suggests that her "disturbed temperament" (the temperament of a neurasthenic, the temperament of an invert) enables her to perceive the world with a greater subtlety, to appreciate its "indeterminate" nuances, to achieve not mere technical mastery but true genius.[50]

Critics, too, typically viewed the painter's response to Whistler as one of recognition, not emulation. Roger-Marx noted, for instance: "Madame Brooks appears completely in accord with her own self, faithful to her own aspirations, concerned above all with her own character. Her resolute independence and tenacious will make her impervious to all influence. She only approaches Claude Debussy and Whistler to the extent that she finds herself in them."[51] Some latter-day Brooks scholars have characterized her work as backward-looking, behind the times, because of her apparent debt to nineteenth-century trends. Yet Brooks's contemporaries clearly saw things differently.[52] Flament praised Brooks as "a painter of curious talent, very rare, original. . . . A woman who has managed to avoid enslavement to the taste of her era."[53] For Brooks and her admirers, the name Whistler evoked not only a still-viable and even vital aesthetic project but a particular set of values figured by the dandy-aesthete. If dandy-aesthetes like Whistler and Montesquiou embodied this ethos at the fin de siècle, Brooks positioned herself, in the new century, as their successor.

In critical writings of the period, the names cited in association with Brooks include not only Whistler, Debussy, and Proust but also Poe, Verlaine, Baudelaire, Mallarmé—and, above all, Wilde.[54] While these references to the "decadent school" introduce Brooks, by association, into a pantheon previously reserved (like the status of genius itself) for men, the identification with Wilde inducts her into an explicitly homosexual canon. Wilde's condemnation, in 1895, for "acts of gross indecency" collapsed his sexual, social, and artistic transgressions into a single category—a category

bodied forth by the now less ambiguous figure of the dandy-aesthete. In her memoirs, Brooks honored Wilde—along with Whistler—as a "fellow lapidé" (literally, a victim of stoning).[55] This epithet (for Brooks, a tribute) overlaps with Romantic clichés of tormented artistic genius as well as certain period representations of homosexuality. A. T. Fitzroy's 1918 novel *Despised and Rejected*, to cite just one example, represents homosexuals as "the advance-guard of a more enlightened civilisation."[56] Brooks, who shared this view, must have been pleased when a critic noted that her work displayed the exquisite subtlety of "a page from Wilde." Her sartorial and artistic choices pay undeniable homage to the martyred dandy who, like Brooks, affected to heed only his own counsel, indifferent to public opinion.[57] To be great, as Wilde once wrote to Whistler, was to be misunderstood.[58]

If we did not take into account what was happening in the elite male homosexual circles with which Brooks and her milieu intersected during the 1920s, the artist's evocation of Wilde would seem like yet another reference to a bygone era, on a par with her citations of Whistler. Yet in the 1920s, a new generation of homosexuals—born in the twentieth century and coming of age in the aftermath of the Great War—rallied to revitalize the cult of Wilde.[59] During this period—when Brooks divided her time between Paris and London (where she maintained a studio close to those once occupied by Whistler and Wilde)—dandy-aesthete youths held sway in some of the most prestigious cultural venues of both capitals. The theater, which Brooks attended with some regularity, was one of the public spaces to which homosexuals gravitated; it provided a pretext for the sartorial display upon which homosexual visibility was largely contingent. The *promenoirs* and upper galleries of theaters such as Paris's Garnier Opéra and London's Coliseum served, throughout the 1920s, as rallying points for homosexual men. Cocteau (made up with lipstick and rouge) felt sufficiently *chez lui* at Garnier, for instance, to hail friends espied from afar in falsetto or to scramble over intervening rows of seats to join them.[60] And why not? After all, the reigning impresarios—Sergei Diaghilev of the Ballets Russes and Rolf de Maré of the Ballets Suédois—were confirmed homosexual dandies themselves.[61]

Critical accounts of the London ballet seasons to which Brooks subscribed in the 1920s characterized the habitués of the galleries as "highly sensitized beings" and "small-talk aesthetes."[62] Herbert Farjeon, writing for *Vogue*, wrote that the youthful dandies who overran the ballet theater seemed "to recline on art like Madame Récamier on her couch and to

regard the dancers and décor as a kind of personal adornment. Indeed, they might be said to wear the Russian Ballet like a carnation in their button-holes."[63] An Etonian balletomane recalled his classmates Brian Howard and Harold Acton in precisely such terms. The pair, he reminisced, would stroll into the stalls "in full evening dress, with long white gloves draped over one arm, carrying silver-tipped canes and top hats, looking . . . like a couple of Oscar Wildes."[64] In the box seats, the lesbian elite also held its own in the realm of style. With her lady friend in tow, for instance, the painter Gluck (portrayed by Brooks in 1923 as *Peter, a Young English-woman*) distinguished herself by attending the Russian Ballet costumed in a Cossack hat, plus fours, and high-top boots.[65] Radclyffe Hall appeared at premieres resplendent in her signature broad-brimmed hat, a high collar, man's stock, and black military cloak.[66] Not be upstaged, her lover Una, Lady Troubridge (whom Brooks also painted while she was in London), shouldered a full-length leopard-skin coat and sported her hallmark monocle for such occasions.

Given this context, it is not surprising that many of the era's leading specialists in the field of sexology continued to view costume, a key signifier of gender, as a symptom of gender inversion. Ellis, for instance, who had contributed to the codification of a figure known as the "mannish lesbian," debated the psychic implications of cross-dressing with his correspondent Bryher throughout the 1920s.[67] Ellis had rehearsed the already well-established premise that a feminine subject dressed in male attire represented a "man trapped in a woman's body" (a member of the "intermediate" or "third" sex) in his pioneering book *Sexual Inversion*.[68] This work, first published in 1897, became accessible to sufficiently motivated lay readers in England and France in the 1920s. Subsequently, Ellis's theories became a focus of discussion by Paris's lesbian literati. Among others, Monnier, Beach, Cahun, and Bryher cultivated personal or professional relations with the author in the course of this decade.

To suggest that Brooks—who frequented Beach's bookstore, corresponded with Bryher, and enjoyed an intimate alliance with Paris's most provocative literary hostess—would have been aware of Ellis's work hardly strains credibility. I argue that Brooks, in the 1923 self-portrait, configures her body by means of makeup and costume in ways that disavow any symptomatic relationship between costume and gender, outward appearance and inner "truth"—and thus the biological explanations of sexual identity advanced by sexologists such as Ellis. Yet Brooks too put great stock in the radical signifying power of costume. Unlike Ellis, however,

she appears to have shared the opinion of aficionados from Wilde to Benjamin, who held that "fashion stands in opposition to the organic."[69] At the very least, she most certainly believed that fashion could be deployed strategically to enhance her personal and cultural authority.

To wit, she designed an entire wardrobe of costumes (ceremonial robes of intellectual and spiritual leadership, riding habits, smoking jackets, and heroic capes) appropriate for the personage of social and artistic stature whom she aspired to become. She modeled these fashions in the photographs that she took or commissioned for diffusion in the press. On her fiftieth birthday, for instance, she posed in a photographer's studio costumed as she had painted herself in the self-portrait completed a year earlier (fig. 19).[70] Here, she strikes an erect three-quarters pose, averting her gaze slightly from the camera as if to take a longer view. Every inch the dandy, she fingers the fine velvet lapel of her frock coat with a manicured hand and pivots her chin toward the upturned collar that frames her face. Lest her haughty bearing and gentleman's redingote not suffice, this portrait provides a few supplementary cues: the white carnation in the buttonhole, the kerchief peeking out of the breast pocket, and the top hat clasped lightly in one hand identify her as a dandy (with a twist). "Never have I had such a string of would-be admirers fall for my black curly hair and my white collars," Brooks boasted to Barney in a letter from London during this era. "They like the dandy in me and are in no way interested in my inner-self or value."[71] Her comment, like the self-representation that she had recently crafted in oil on canvas, implicitly dismisses theories of sexual subjectivity that deduce inner character from surface characteristics.

Brooks's penchant for haberdashery, then, was willful, strategic, and theatrical—not, in her own opinion, the involuntary expression of her invert's soul. And while her clothing and coiffure may well have attracted a number of sexually adventurous women, the fashions that she favored would not have seemed especially exotic to her worldly suitors. As we have seen, by the time Brooks executed her 1923 self-portrait, *la mode garçonne* circulated widely in French fashion magazines, and at the fashion's extremes, dandy chic had found favor with certain lesbians in London as well as in Paris and Berlin. Within post-war debates about gender and sexual identity, the garçonne style was alternately described as a symptom and a cause of feminism, lesbianism, and, by the same logic, of the demise of the patriarchal order. The travesty mode embraced by Brooks—as a cause rather than a symptom—carried the symbolic weight, in other words, of a widespread social crisis concerning gender roles.

Oscillating between feminine and masculine codes, post-war fashion figured (and figured in) a redistribution of social, cultural, economic, and political power. For lesbians, masculinized fashions—whose history included interdiction under the French law of 1801 and pathologization in the literature of sexology—articulated a double liberation: liberation from conventional strictures of femininity and from those of heterosexuality.[72]

Given the symbolic charge of man-tailored feminine fashions, it is intriguing that Brooks's portraits of cross-dressing women provoked so little negative commentary. Indeed, the reviews of her work that appeared in respected publications such as *Le Figaro*, *L'Art Vivant*, *Vogue*, and *International Studio* ranged from ambivalent to favorable. A critic reviewing the Salon des Indépendants of 1925 called Brooks "a refined spirit who remains troubling for the conception of her models, chosen from an elegant but terribly equivocal milieu."[73] This critic's choice of words implies that while elegance and class did not erase the "troubling" implications of Brooks's portraiture, an aura of aristocratic decadence mitigated against the threat that her "models" posed. Certainly Brooks enjoyed a

Fig. 19. Romaine Brooks
modeling her fashions, 1924.
*National Collection of Fine Arts
research material on Romaine
Brooks, 1874–1969, Archives
of American Art, Smithsonian
Institution*

degree of tolerance for her eccentricities thanks to the exemptions that her personal fortune afforded her. In the public contexts in which Brooks exposed her work, the costumes, props, poses, and aesthetic choices that may have signaled deviant sexuality to the knowing eye dovetailed neatly with more ancient codes of aristocratic privilege for some, while others wrote off these trappings as contemporary fashion statements or the whimsies of a woman from an alien culture (and also an alien subculture). Barney wrote, in a poem about Brooks and her ilk: "they arrive like destiny, without cause, / without reason, without consideration, without pretext, they / are there, with the rapidity of a flash of lightning, / too terrible, too sudden, too / convincing, to 'other' to be / even an object of hatred."[74] Brooks's status as a foreigner (in both her rejected homeland and her adopted one) inflected critical responses to her work from France to America, differences in the various sites of reception notwithstanding. American critics viewed her "outlandish" paintings as disturbingly un-American. A critic writing for the *Boston Evening Transcript*, for instance, described her work as a "transplanted American effort," a hybrid, French art by an American artist.[75] Barney glossed this perception, describing Brooks's as an artist who, like the poet Walt Whitman, belonged "to no time, to no country, to no milieu, to no school, to no tradition." For Barney, Brooks represented the purest product of "a civilization in decline, whose character she was able to capture."[76]

Such characterizations suggest the extent to which Brooks occupied the center of Barney's own representational project. From their first meeting in 1915 forward, Barney lobbied to secure for her companion some guarantee of lasting recognition.[77] Barney played a behind-the-scenes role in the painter's induction into the Legion of Honor, for example, in 1920.[78] She saw to it that Brooks's paintings were documented photographically and that her exhibition catalogues were not only meticulously produced but also distributed to the painter's best advantage. Barney repeatedly arranged, through her network of social contacts, for favorable coverage of Brooks's work in the press.[79] She campaigned for close to forty years (from the 1930s to the 1970s) to secure for Brooks's paintings and drawings a place in a national collection in either France or America—finally prevailing upon the institution now known as the Smithsonian American Art Museum.[80] A slim, elegantly appointed monograph, *Romaine Brooks: Portraits, tableaux, dessins*, published in 1952, survives—thanks to Barney's efforts—in major library collections as tangible evidence of the couple's shared desire to make history. Although indexed under the author

name of Romaine Brooks, this book was created by Natalie Barney. In a letter from Nice, where Brooks took up residence after the Second World War, the artist acknowledged, "I've just received your book . . . very well done as a whole. . . . Thanks to Nat Nat's efforts it is all very successful! . . . I haven't read the preface yet," she admitted freely (revealing the extent of her detachment from the production process), "All love from a grateful Angel."[81] The booklet's cover, printed on thick gray paper, features a photogravure of the artist's 1923 self-portrait (fig. 20). From the outset, this iconic cover image colludes with the monographic format to reproduce the model of artistic genius that Brooks had fashioned thirty years earlier with the original portrait—a model that reconciled the painter's status as a cosmopolitan expatriate lesbian with her status as a visionary artist.[82]

On the back cover of the monograph we find a list identifying Brooks's sitters (fig. 21). The subject of the monograph herself, "L'Artiste Romaine Brooks," tops this honor roll, under the heading "Personnages d'une

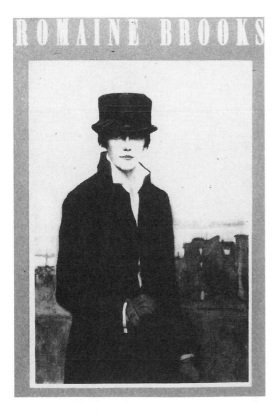

Fig. 20. Front cover, *Romaine Brooks: Portraits, tableaux, dessins*, 1952. *National Collection of Fine Arts research material on Romaine Brooks, 1874–1969, Archives of American Art, Smithsonian Institution*

Epoque." Eighteen faces, thumbnail details from a selection of the portraits reproduced in this volume, frame the roster elaborated beneath the artist's moniker. Represented here we find, among others, the Italian poet Gabriel D'Annunzio; the Russian ballet dancer Ida Rubinstein; the French literary celebrities Elisabeth de Gramont, Jean Cocteau, and Paul Morand; the American decorator Elsie de Wolfe; the reigning hostess of Paris-Lesbos, Natalie Barney; the Italian pianist Renata Borgatti; and the Princesse Lucien Murat, author of *La Vie amoureuse de Christine de Suède, la reine androgyne*.[83] This register, like that of Barney's salon and her Académie des Femmes, constitutes what Edward Carpenter called "a peculiar aristocracy . . . representatives of the higher mental and artistic element," the vast majority of whom were homosexual.[84] Some of the personalities memorialized here had literal claims to aristocratic status by blood, by alliance, or both; their noble titles set the tone for Brooks's gallery of portraits. Yet it was the sensibility shared by the members of this pantheon, the monograph seems to suggest, that united these artists and patrons in a circle of cultural empowerment, for the gifts that distinguished them could not be transmitted via bloodlines or legal bonds of alliance. Aristocrat, artist, or

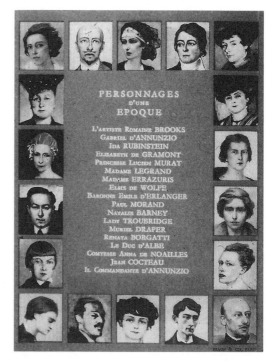

Fig. 21. Back cover, *Romaine Brooks: Portraits, tableaux, dessins*, 1952. *National Collection of Fine Arts research material on Romaine Brooks, 1874–1969, Archives of American Art, Smithsonian Institution*

a fortuitous combination of both, these sovereign figures—like the flâneur, the dandy-aesthete, the wealthy expat, or the elite homosexual—inhabited and enriched the privileged margins of their society.

Gramont, upon whom Barney prevailed to compose an introduction to the monograph, concluded, "These portraits may well be the last witnesses of our contemporaries."[85] A celebrated author and an intimate friend of both Barney and Brooks, Gramont undoubtedly chose her words with care, aware of the fullness of their meanings. The portraits, she implies here, witness (see) and bear witness to (affirm) a category of elite subjects whose visibility, historically, has been problematic. For these portrait subjects, marginality (eccentricity, deviance, class privilege) was a credential identifying them as exceptional. Whether one considers homosexuality a precondition of artistic sensibility, as many homosexuals argued at the time, or whether the artistic vocation simply accommodated homosexuality more graciously than other métiers, "being other than normal" freed the members of Brooks's circle from certain social constraints and gave them, in Barney's words, "a perilous advantage."[86]

THREE

"*Narcissus and Narcissus*"

CLAUDE CAHUN AND MARCEL MOORE

Le féminisme est déjà dans les fées.

—Claude Cahun,
Aveux non avenus

Like the gallery of amazon geniuses immortalized by Brooks in her portraiture of the 1920s, the photographic work generated by Claude Cahun and her lover Marcel Moore during this period takes the politics of gender and sexual identity as a central problematic. In a 1921 text, "L'Idée-maîtresse" Cahun describes her sexual "creed" as "the guiding principle" to which she adhered. "'The love that dare not speak its name'. . . lies like a golden haze upon my horizon," she declaims," . . . I am in her; she is in me; and I will follow her always, never loosing sight of her."[1] Cahun embraced same-sex desire, this "idée-maîtresse," as her Muse, the matrix of her personality, and "the indestructible crown" of her every act.[2] Cahun's statement of belief recycles Wilde's famous courtroom recital of a line penned by his lover Alfred Douglas about same-sex devotion ("the love that dare not speak its name"). Cahun shared with her own lover Moore, as well as with Wilde, the "dreadful mania" of citation—a rhetorical turn that too often obscured her literary statements or burdened them with pretension.[3] The camera (itself endowed with the ability to cite, to repeat, to reconstrue) turned Cahun's incursions into an inherited, and fundamentally hostile, representational field into a more playful and more legible practice that could be shared with a partner or partners.

Roland Barthes has likened photography to theater, which strikes me as a useful disposition to adopt with respect to Cahun and Moore, whose photographic work has more typically been described as "self-portraiture."[4]

To assume, as I do, that Moore performs the photographer's role is to interpret these photographs as a production of two people acting together—a performer (typically Cahun) and a director (typically Moore) adhering to the same "guiding principle." Ample evidence, both formal and archival, justifies the claim of coproduction.[5] Let us consider one persuasive visual clue, an ex libris designed by Cahun, emblazoned with the initials L.S.M. (fig. 22). The crowning monogram—or rather duogram— merges L.S. (Lucy Schwob) with S.M. (Suzanne Malherbe). It pivots upon a shared sign: S, a self-complementing flourish that turns singular to plural. "Elles s'aiment," the letters pronounce. They love each other. But who are they? A composite body, that of L.S.M., intrudes, as if to answer this question: a pair of lips inscribed "Lucy Schwob," from which a gauntlet stretches skyward, signaling, balanced upon an eye, an "I," of the same proportions whose iris spells "Suzanne Malherbe." The entire construct rests upon a well-turned ankle, a foot modeling a high-heeled shoe, posed near the ground line of the enclosing heraldic frame. The division of emotional labor here is clear: if Lucy Schwob reaches for the sky, Suzanne Malherbe both balances and grounds her. Lucy Schwob reposes upon, depends upon, Suzanne Malherbe. The division of artistic labor is equally clear: Lucy Schwob speaks (writes, performs); Suzanne Malherbe visualizes. The crudeness of this drawing, what is more, reveals Cahun's limitations as a visual artist, while accentuating the ad hoc character of the composite represented here—a bricolage scrapped together from key signifiers of agency, each partner giving her best.

Golda M. Goldman, a Paris correspondent for the *Chicago Tribune*, interviewed these two "radical daughters of conservative families" in 1929 and described Cahun's literary, theatrical, and musical promise in her column "Who's Who Abroad." Goldman explains: "as she is the niece of that well-known French writer, Marcel Schwob, Mlle. Schwob chose . . . the pen-name of Claude Cahun for her poetic work, so as to gain nothing from her relative's reputation."[6] In a separate article devoted to Moore, Goldman applauds the graphic artist's "mastery of line both delicate and strong, . . . pictorial effectiveness, and . . . beautiful use of color." She praises Moore's "very clever black and white illustrations for books, some the poems of her half-sister Claude Cahun. . . . At present the artist is engaged in making a series of distorted photographs of her sister, which probably will be used to illustrate the volume *Aveux non avenus*. . . . Entirely printed by herself, these photographs are something quite new in the field."[7]

Fig. 22. Claude Cahun, untitled ("duogram"), ca. 1919.
Courtesy of the Jersey Heritage Trust Collection

Moore's partnership with Cahun dated, like the earliest photographs in the oeuvre referenced by Goldman, from the first decade of the twentieth century, when the two schoolgirls met in Nantes.[8] The collaboration evolved continuously and generated hundreds of rolls of film over a period of four and a half decades. The last of these picturing Cahun date from 1954, the year of her death.[9] These rolls of film, whose pockets alternately bear the name of one and then of the other partner, preserve images of both Cahun and Moore taken in the same settings, indicating Moore's involvement, start to finish, in the production of photographs featuring Cahun and the reverse. Acknowledging this complicity, Cahun described herself more than once as Moore's fabrication; "Je suis l'oeuvre de ta vie," she wrote as early as 1914.[10] Many of the photographs that the pair produced thematize or formalize the joint character of this venture. The photographer's shadow that intrudes episodically upon the foreground of pictures featuring Cahun (and also some featuring Moore) clearly marks the collaborator's presence.

One early photograph pictures a baby-faced Cahun striking a pose that has particular significance within homosexual culture (fig. 23). The photograph glosses *Jeune Homme nu assis au bord de la mer, figure d'étude* (1836) by Hippolyte Flandrin, a painting that, since its acquisition by the French state in 1857, has engendered numerous responses from artists and has circulated far and wide in reproductions. An engraved reproduction by Jean-Baptiste Danguin (fig. 24), for instance, was commissioned by the state in 1887 and printed by the thousands. Flandrin's *Figure d'étude* garnered, in the late nineteenth and early twentieth century, a large homosexual audience thanks in part to Danguin's print. As Michael Camille has demonstrated, "mechanical reproduction was crucial to the appropriation of this body as an icon of various identities in the century that followed."[11] Flandrin's male nude fills the frame, perched like a statue upon a rocky pedestal overlooking the sea, the picture of stasis and self-containment. The nude's self-embracing posture (knees drawn to the chest, head tucked, eyes closed) allows the viewer to scrutinize his faceless form unobserved, without apology. This dynamic of objectification, more common in art of the female nude, invests the image with a (homo)-erotic charge.

The subject of this study—a male figure that could be described as self-absorbed, passive, alienated—undoubtedly contributed to the persistence of certain homophobic clichés. At the same time, Camille points out, the mass circulation of lithographic and photographic prints freed the flow of

Fig. 23. Claude Cahun and Marcel Moore, untitled (after Flandrin), ca. 1911.
Courtesy of the Jersey Heritage Trust Collection

Fig. 24. Jean-Baptiste Danguin, 1887 engraving after Hippolyte Flandrin, *Jeune Homme nu assis au bord de la mer, figure d'étude,* 1836.

previously unique and sequestered homoerotic images like Flandrin's painting into "a multitude of new public and private places, including the bedroom, and into new subjective sites of subcultural identity. Reproductions of artworks," he concludes, " . . . played an important part in constituting certain 'tastes.'"[12] Reinterpretations of Flandrin's nude by turn-of-the-century art photographers such as F. Holland Day and Baron Wilhelm von Gloeden assured the figure's on-going currency within gay male communities of the 1910s and 1920s.

Moore's photograph of Cahun enters into this representational fray. The deviations from the visual source, Flandrin's painting, change the disposition of this icon in a number of important ways. Although Cahun, like Flandrin's nude, perches on a rock at the shore, knees drawn to the chest, spine bowed, she has rotated the original position 180 degrees, bookend-wise, profiling the left rather than the right side of her body. The reversal signals the critical function of this work, alerting us to attend to other points of divergence. It is surely significant, for instance, that Cahun poses clothed in a modest bathing costume, while Flandrin's model exposes his naked body, posed upon an idealizing swath of silken drapery, to the viewer's scrutiny. If calm seas, a vast sky, and flat horizon contribute to the serenity and timelessness of Flandrin's scene, the ragged granite boulders crowding in on Cahun in this picture make her flesh seem palpably mortal. Cahun's head, not bowed like that of Flandrin's sitter, turns to face the observer—whom she fixes with unblinking eyes. While the feet of Flandrin's figure taper off the edge of his rocky perch with a statuesque indifference to the surrounding abyss, Cahun's feet tense as if to acknowledge another human presence very close at hand: the presence of Moore, the photographer. Moore's close presence takes the form of a silhouette—a shadowy index traced upon the photograph in the lower right-hand corner, a space typically reserved for the maker's signature. This mise-en-scène reworks the history of both social and artistic representation in sophisticated and highly conscious ways.[13] The adaptation of Flandrin's painting offers a lesbian critique of an important male homosexual reference while demonstrating solidarity with male communities.

Like Brooks's lesbian revision of the iconography of dandy-aestheticism, the send-up of Flandrin's *Figure d'étude* "lesbianized" a male homosexual icon. By the same token, like Brooks, Cahun and Moore sought to create alternatives to dominant-culture representations of women. Another photograph from the 1910s makes the feminist dimension of the couple's photographic project explicit (fig. 25). This snapshot pictures a

girlish Cahun seated at her writing table, a camera box to one side and a leather-bound tome titled *L'Image de la femme* positioned with its lettered spine toward the viewer. The book, an 1899 survey by Armand Dayot, catalogues images of feminine beauty from classical statuary to portraits of great ladies throughout the ages (fig. 26).[14] The choice of props here— the archive of feminine role models (over which Cahun pours like a diligent student) and the camera (with which Cahun and Moore will produce alternatives)—announce a career of resistance to the cultural heritage that unites the feminine specimens singled out by Dayot under the reductive title "the image of woman." Perusing the vacuous faces portrayed here, one grasps the motivation for updating and correcting this repertoire: images of professional, intellectual, political, artistic, or physical accomplishment appear nowhere in the survey. Moore's photograph of Cahun surveying *L'Image de la femme* could be taken, then, as a sort of mission statement.

Shortly after crafting this photographic manifesto, its authors assumed the pseudonyms by which they are still known. Choosing the gender-ambiguous "Claude" and masculine "Marcel," they extended a tradition of dissimulation by women aspiring to the professional echelons of cultural production. Such pseudonyms, a literary form of travesty, affirm a time-honored feminine career strategy while renouncing patriarchal notions of lineage—that is to say, the reproduction and preservation of the father's name. In the case of both Cahun and Moore, the alliterative initials C.C. and M.M. reproduce *themselves* (initiating self-generation, as it were) while investing each name with the character of a pair, a double pair— pair of lovers, pair of sisters.

When the Paris correspondent for the *Chicago Tribune* represented this couple as "sisters" in her 1928 newspaper article, she was not (or not only) speaking in euphemistic terms. In 1917, Cahun's divorced father, Maurice Schwob, had married Moore's widowed mother, Marie-Eugénie Malherbe, making Cahun and Moore (already in the eighth year of their romantic and artistic partnership) stepsisters. This event undoubtedly facilitated the couple's joint ventures to some extent, providing cover for their intimacy, but it also reinforced the institutional framework of the nuclear family—a framework at once legitimating and constraining.

The Schwob family, as it happened, exercised considerable influence in the spheres of literature and journalism at the beginning of the century, and the earliest works by Cahun and Moore appeared in family publications.[15] Moore's fashion designs for modern women—like the one reproduced

Fig. 25. Claude Cahun and
Marcel Moore, untitled
(Cahun reading *L'Image de
la femme*), ca. 1915.
*Courtesy of the Jersey Heritage
Trust Collection*

Fig. 26. Title page,
L'Image de la femme by
Armand Dayot, 1899.

here picturing a trousered woman walking in her own shadow (fig. 27)—
found favor in the "women's pages" of the family-controlled newspaper,
Phare de la Loire, while Cahun's byline appeared in the theater and liter-
ary sections. Even after the couple moved from the Schwob compound in
Nantes to an apartment in Paris in 1920, Cahun's cultural reportage con-
tinued to enliven the paper's pages. Cahun's writings (including her 1918
report protesting legal actions against Maud Allan's revival of Wilde's play
Salomé in England, as well as her reconfigured fables "Héroïnes") also
appeared in Paris's elite literary journal, *Mercure de France*, which her lit-
erary uncle Marcel (the author of *Vies imaginaires*) helped to found.[16]

Mercure first ran the verses titled "Vues et visions," which Cahun
would publish in 1919 under separate cover, with pen-and-ink images
executed by Moore in the decadent style of Wilde's illustrator Aubrey

Fig. 27. Marcel Moore, fashion
design, ca. 1915.
*Courtesy of the Jersey Heritage Trust
Collection*

Beardsley.[17] This allegorical work, by the twenty-five-year old Cahun and her twenty-seven-year-old partner, was the couple's first public coproduction. Cahun dedicated the publication to Moore. "I dedicate this puerile prose to you," she wrote, "so that the entire book will belong to you and in this way your designs may redeem my text in our eyes."[18] The interlacing of possessive articles here, like the interlacing of text and images in the book, leaves little doubt about the intimacy of the collaboration. *Vues et visions*, an exercise in double vision, consists of twenty-five pairs of prose poems, each framed by a drawing. One page describes a mundane "view," elevated by way of fantasy to the status of a "vision" on the facing page. Each view transpires in a real location (the Brittany seaport of Le Croisic, where Cahun and Moore vacationed) and in real time; each vision transpires on the mythic terrain of classical antiquity—Piraeus, Rome, Hadrian's villa.

The adoption of antiquity as a point of reference, while redolent of mainstream high culture and the interwar *rappel à l'ordre*, would also have resonated within Paris's gay subcultures, where influential women and men of letters contributed to homophile reconstructions of antiquity from the turn of the century until the Second World War.[19] John Addington Symonds published a social history of pederasty titled "A Problem in Greek Ethics" as an appendix to Ellis's sexological treatise *Sexual Inversion*, for instance. Plato's *Symposium*, a text that explores in some depth the question of love between men, served as a reference for Symonds and other homosexual authors of the period—including Wilde (who penned lines of poetry in Greek), E. M. Forester, Edward Carpenter, André Gide, and even Cahun. Cahun borrowed *Symposium* from Adrienne Monnier's lending library in January of 1918, as Moore began work on the illustrations for *Vues et visions*, and refers to this canonical text more than once in her "Les Jeux uraniens."[20] The classical revival took a specifically Sapphic turn in the first decades of the twentieth century, propelled by the enthusiasm of Renée Vivien and Natalie Barney, as discussed in chapter 1. Barney's sapphic reading list would have included—in addition to literature produced by female admirers from Vivien to Lucy Delarue Mardrus—an homage from a male sympathizer, Pierre Louÿs, who dedicated his *Chansons de Bilitis* to "the young women of the future society."[21] Louÿs's "little book of love in antiquity," a "translation" of love songs composed by a Sapphic courtesan of his own invention, reworked the foundations upon which new cultural identities (and, he imagined, new societies) would be constructed. Louÿs's volume became a reference

for generations of lesbians and helped to shape the literary scene within which Cahun and Moore imagined heroines like "Sappho the Misunderstood."[22] Indeed, Cahun held the book in high enough esteem to try her hand at an English translation.

Against the backdrop of this homophile reconstruction of antiquity, the paired scenes in *Vues et visions*—which raise commonplace events (two fishing vessels passing in the port of Le Croisic) to the level of metaphor (two women of pleasure brushing past each other in a Roman plaza)—create an intertext that reverberates with homoerotic double sense. One diptych makes the relationship of Cahun and Moore's book to other contemporary affirmations of homosexual cultural identity particularly clear: a set of illustrated texts opposing "La Nuit moderne" to "La Lumière antique" (figs. 28 and 29). On the waterfront of modern-day Le Croisic, two intertwined figures, cloaked in shadows, disappear into the obscurity of the night, "feeling their way in the darkness toward the unknown."[23] Moore's engraved illustration, which frames the text in the manner of an illumination, represents the two androgynous figures at once embracing and bracing each other against a troubled nature: an agitated sea, a "somber and heavy" sky, pitch darkness penetrated by a few

Fig. 28. Claude Cahun and Marcel Moore, "La Nuit moderne," from *Vues et visions*, 1919. *Private Collection, Paris*

vague streaks of light on the distant horizon. What is the source of this light? "Is it the sky, is it the sea, is it death, is it . . . ? one does not know." But on this light, "the only hope, the only possible finale to this nocturnal obscurity," the two lovers set their sights.[24] Their faces, inclined one toward the other, glow like pale apparitions in the blackness that dominates the scene.

In contrast, in the drawing for "La Lumière antique," Moore imposes only the sparest marks of black upon the pristine whiteness of the page. The composition here, like the composition of the text, mirrors and transforms the previous image. The picture again foregrounds two embracing lovers, apparently a man and boy. In opposition to the shadows that cloak modernity's lovers, a "golden haze" illuminates those of classical antiquity. The lovers approach (rather than flee) the settlement (the Greek port of Piraeus), "where the rooftops sparkle with the first rays of sunrise." These dwellers of antiquity, like their modern analogues, also set their sights on a destination beyond the horizon of visibility, "toward the unknown," but this time they go "in the light and in joy."[25] The seas in the background are placid, the sky buoyant with white, billowing clouds—and imbued, according to Cahun's text, with a "subtle rose-colored light.

Fig. 29. Claude Cahun and Marcel Moore, "La Lumière antique," from *Vues et visions*, 1919. *Private Collection, Paris*

Le Pirée. Périclès. — La jetée blanche, toute neuve ; çà et là quelques taches d'ombre. Le ciel floconneux et blanc. A l'horizon, une vague lumière rose. Est-ce le soleil levant, est-ce un Eros sans flèches, une vie nouvelle, est-ce...? on ne sait pas.

Au bout de la jetée, accoudé, je rêve.

Deux formes blanches passent et s'éloignent, confondues dans une brume dorée. Elles s'en vont vers la ville, dont les toits scintillent aux premiers rayons de l'aurore, elles s'en vont plus loin peut-être, vers l'inconnu, dans la lumière et dans la joie.

Is it the rising sun, is it Eros without arrows, a new life, is it . . . ? one does not know."[26] Whether by inversion (night/day, obscurity/illumination, death/life) or by transposition (modernity/antiquity, Le Croisic/Piraeus), the text and illustrations work in tandem to transform a stark reality into an ideal that affirms the authors' affection for each other and the legitimacy of their bond.

This volume's publication could be viewed as Cahun and Moore's artistic coming out, since it undoubtedly raised their public profile as a couple while making their homophila glaringly apparent to those aware of the codes invoked. It was at this point that Cahun and Moore came out of reclusion and opened the doors of their Left Bank atelier to a dynamic population of intellectuals, artists, and political activists. Their address book from this fertile period traces the cultural and intellectual parameters of interwar Paris, containing, among others, the names Pierre Albert-Birot, Louis Aragon, Natalie Barney, Georges Bataille, André Breton, Sylvia Beach, Roger Caillois, Pierre Caminade, Jean Cocteau, René Crevel, Salvador Dali, Robert Desnos, Youki Desnos, Paul Eluard, Max Ernst, Léon-Paul Fargue, Paul Fort, Alberto Giacometti, Jane Heap, Aldous Huxley, Jacques Lacan, Georgette Leblanc, Pierre Mac Orlan, Man Ray, Henri Michaux, Mops, Marguerite Moreno, and Gertrude Stein. These names, barred one by one as internal divisions and external forces shattered the possibility of community, register not only the richness but also the violence of the decades between the two world wars.[27] However fragile, this eclectic community constituted the audience for Cahun and Moore's second major collaborative work, *Aveux non avenus* (disavowed confessions), published in 1930. The book, a literary mosaic assembled by Cahun, features photocollage illustrations that Moore composed from the store of pictures she had taken of her lover. Whereas the earlier publication, *Vues et visions*, had created an inhabitable, if more or less covert, literary space for conventionally unrepresentable subjects (homosexuals), the more mature work functioned quite openly as provocation.

Like Virginia Woolf's nearly contemporaneous *Orlando* (a "fictional biography" of her lover Vita Sackville-West), *Aveux non avenus* radically transforms both the structure and discursive function of the biographical genre.[28] It is no coincidence that feminist writers gravitated toward this genre—which has traditionally served, like portraiture, to naturalize hierarchies of social subjectivity by "preserving" the histories of noteworthy men. In *Orlando*, Woolf's skepticism about the historical authority of real names, actual events, established chronologies—in short, the

traditional mainstays of biography—enables her to construct a new kind of biographical subject within a new set of parameters (while wrecking havoc on the old ones). Several geopolitical itineraries, four centuries of personal-cultural-social history, and two genders (the "odd, incongruous strands" of Sackville-West's psyche) intertwine to render Woolf's hero/ heroine Orlando.[29] Woolf's *Orlando* takes heroic biography on an unexpected turn, glossing Thomas Carlyle's notion that history "is the essence of innumerable biographies."

Aveux non avenus takes issue more specifically with the artist's memoir—a genre privileged by Brooks (as well as Barney) and also exploited (somewhat more surprisingly) by key members of the surrealist milieu in which Cahun and Moore had begun to circulate.[30] The artist's memoir typically employs diaristic strategies to permanently unite the artistic persona with "his" oeuvre under the banner of genius via the device of the artist's signature.[31] The book produced by Cahun and Moore sets out to dismantle both a literary genre, autobiography, and its subject—the authoritative self whom the artist's signature authenticates. The artist's signature (whether or not pseudonymous) launches the work of art into the capitalist as well as the symbolic economy.[32] As a general rule, when a male artist (Man Ray, for instance) signs a work with his *nom d'artiste*, he constructs an artistic persona at the intersection of the "real" historical world and the fantasy world of the commodity, where objects trade roles with subjects.[33] The pseudonym often performs a very different function in the career of a female artist. In the interests of self-commodification, Man Ray may have refashioned his name (and the choice "Man" is not without significance), but he never disavowed his patriarchal birthright. The pseudonymous signatures of Cahun and Moore, on the other hand, served to falsify the already "disavowed" testimony that constitutes their "confessions." The false signatures not only detached the authors from paternal structures of kinship; they disarticulated the speaking subjects from the ideological operations of realism. In this way, the inauthentic signatures reverberated with the self-canceling title "disavowed confessions" to set the paradoxical dynamic of the book in motion.

There are several ways to translate the title *Aveux non avenus,* and no single option proves adequate in and of itself. *Aveux* may be translated as "avowals" or "confessions" (I prefer the latter for reasons that I will make plain). The untranslatable phrase *non avenus* indicates that which has "not happened." This concept I translate loosely as "disavowed," which contains both "avow" and its negation, and thus has the ability to signify

the slippage of fixed meaning toward ambiguity—away from narrative sense. The cover graphic of the book prepares us visually for the project's critical thrust, creating out of the contradictory title a canceling X—with the palindrome NON reiterated at its crux (fig. 30). This logo engages with more than one modernist preoccupation, most evidently: the poetics, politics, and aesthetics of negation. Cahun cited Henri Bergson on this subject in her writings: "Negation differs . . . from affirmation properly speaking in that it is an affirmation in the second degree," she quoted.[34] Certainly one could view the assertive NON at the center of this book as a statement of (self) affirmation, since every "no" creates the space for a "yes" to something else. Goldman, in her *Chicago Tribune* article on Cahun, translates the title *Aveux non avenus* as "Denials" (at Cahun's suggestion? Moore's?).[35] Certainly "denials" (as in "no") sums up the way in which serious publishers tended to respond to "women's writing," stigmtized for its putatively confessional character. But even more pointedly, denial offered a backhanded way of affirming the literary and personal choices that had marginalized women writers generally, and Cahun specifically, with respect to Paris's literary society. Cahun nevertheless sought the "sympathy" of this society upon occasion.[36]

"There are times," she confessed to Adrienne Monnier, "when I suffer so much from this isolation, of which my nature and all kinds of other circumstances are the cause, that . . . ," her words trailed off, tellingly, into silence.[37] Ironically, Monnier (a publisher herself) pressed Cahun to adopt the impossibly burdened and not particularly valorized confessional genre. Cahun's response?

> You have told me to write a confession because you knew only too well that this is currently the only literary task that might seem to me first and foremost realizable, where I feel at ease, permit myself a direct link, contact with the real world, with the facts. . . . But I believe that I have understood in what manner, in what form you envision this confession (in sum: without deceit of any sort).[38]

"Don't get your hopes up," Cahun added.[39]

Two years later, in 1928, she presented Monnier with the manuscript of *Aveux non avenus*, which in no way resembled the *journal intime* that Monnier had counseled her to write. Would Monnier consider publishing the book? Would she write the preface? Both requests met with adamant denials. "What ever I may do, never could I avoid your objections, too

profound, which address the very essence of my temperament," Cahun conceded to the woman whose recognition she had sought.[40] No, she would never write her confessions. Reveal her secrets to the mirror, yes. Publish her "meditations," yes.[41] But confessions? Confess to what? To whom? "Denial," then, describes both Monnier's rejection of Cahun and Cahun's response to Monnier—as well, perhaps, as the psychic defense that would enable Cahun to transform the interdiction "no" into a sort of "yes."

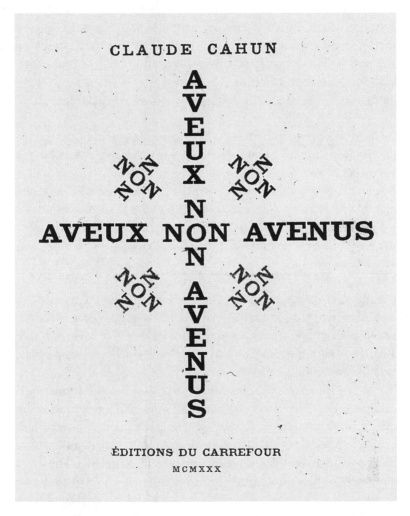

Fig. 30. Claude Cahun and Marcel Moore, front cover, *Aveux non avenus*, 1930.
Private Collection, Paris

The word *confessions* recurs with emphatic frequency in the short exchange of letters between Monnier and Cahun. Redolent of Catholic ritual, criminal interrogation, psychoanalysis, and the tabloid press, the word *confessions* also harks back to the very origins of the autobiographical genre. The modern figure of the author, as Barthes reminds us in "Death of the Author," emerged in France in the eighteenth century, along with rationalism's emphasis on the nobility of the individual. In Enlightenment-era texts such as Jean-Jacques Rousseau's *Confessions*, the author reigned as the text's unique point of origin—"as if it were always in the end, through the more or less transparent allegory of the fiction, the voice of a single person, the *author* 'confiding' in us."[42] Rousseau's title, from which *Aveux non avenus* pointedly departs, invokes (in addition to absolution) the author's absolute representational authority.

On the first page of his autobiography, Rousseau declares:

> The purpose of my initiative—which is not only without precedent but also inimitable—is to display to my kind a portrait of a man that is in every way true to nature, and the man I shall portray will be myself. . . . My unique self [Moi seul]. . . . I am made like no other man that I have seen; I dare to believe that I am made like none who exists. If I am worth no more, at least I am distinct. If nature rightly or wrongly broke the mold in which I was cast, one can only judge after having read me.[43]

Rousseau's text claims to record, in a manner he describes as "true to nature," the "real world" that Cahun disclaims in her letters to Monnier. Rousseau not only presents the author as a unique and sovereign subject, he collapses—with the injunction to read "me"—any separation between the self and its representation.

The "I" in *Aveux non avenus*, in comparison, has no distinct outline, no clear referent. The mercurial narrator, who addresses an equally indefinite "you," inhabits a number of avatars.[44] Cahun, having already posed as a whole cast of characters before Moore's camera and performed on the stage of two of Paris's experimental theaters, the Théâtre Esotérique and Le Plateau, adapted the principles of travesty to a literary mode throughout this book.[45] Here, as with the photographic oeuvre, failures of illusionism, particularly gaps in the text, participate in the signification process. "What pleases me above all in your incomplete and circular enterprise," Cahun confided in her partner, "are the places you have

had the sense to leave empty."[46] Indeed, empty spaces—the interstices between textual and pictorial images, the lapses that occur "between the acts" of representation—shape the poetic character of *Aveux non avenus*. The conceit of an unnamed, ungendered narrator, has particular significance. This resistance to determination, as Leigh Gilmore notes, creates a break in the "signifying chain of identity," which itself "coheres through the progressive, motivated, and linked signification of sex, gender, and sexuality. Autobiography not only depends on this signification, it seems to prove its reality."[47] *Aveux non avenus*—with its syntactical lapses and its narrative indeterminacy—emphasizes the failures in this self-ratifying evidentiary chain. The gap itself could be interpreted as a placeholder for illegitimate subjects—homosexuals and women, for instance—within the larger system of social signification.[48]

Unlike Rousseau's *Confessions*—which unfolds in numbered paragraphs, chapters, and volumes along a chronological timeline—this anti-autobiography presents what Barthes would have called "a tissue of quotations," snippets from variously dated sources (letters, poems, meditations, parables) cited out of context.[49] And unlike the speaker of Rousseau's *Confessions*, the narrator here makes no claim of authority. "I make a copy of this exercise (which my partner wrote . . . with my own hand)," the writer notes, "in order to demonstrate how we seek to determine the boundaries of our characters."[50] Yet in fact, such statements make it mind-bogglingly unclear just where one partner leaves off and the other begins—let alone which gesture imitates and which gesture originates.[51] The estrangement of autobiographical or literary events from any fixed or authoritative point of origin prevents the reader from identifying an authorial plan, from looking to the author as the "key" to the meaning of the work. If Rousseau claims to expresses his own unique essence, the narrator of *Aveux non avenus* represents the self as a synergistic figure, a self in relation, like the duogram L.S.M., like the team Cahun and Moore.

As a critique of autobiography (and by extension of self-portraiture, autobiography's pictorial analogue), *Aveux non avenus* clearly participates in modernism's interrogation of Enlightenment paradigms of thought—including constructions of the authoritative self and the strategies of realism that serve to naturalize these constructions.[52] For women of the pre-suffrage era, like Cahun and Moore, whose authority depended on acts of impersonation (the adoption of a masculine voice or pseudonym, among other forms of travesty), this reevaluation of "the author" (that is, the

authorized speaking subject) proved especially vexed. Susan Suleiman points out that although French vanguard artists of this period reclaimed the social and cultural margins that women had traditionally occupied, the male initiators of this trend freely chose their marginal status—whereas women remained marginalized whether they liked it or not.[53] Nonsubjects (women, who did not achieve full citizenship in France until after the Second World War) and unrepresentable subjects (lesbians, whose bodies and relationships could not cohere within the patriarchal economy) would seem to have had little to lose if the existing categories of social subjectivity folded under the strain of critical reexamination.[54] Yet how could one demand the right to exist, the right to speak, without envisioning a speaking self—that is, certain conventions of subjective coherence?

A section of *Aveux non avenus* titled "Eloge des paradoxes" finesses this dilemma. "Each time one invents a phrase," the narrator suggests, "it would be prudent to invert it to see if it holds up."[55] Like negation, inversion functions throughout the oeuvre produced by Cahun and Moore as both a structural logic ("simpler than Euclidian proofs") and a central thematic.[56] Figures of inversion (mirror images, palindromes, syntactical and formal reversals) animate *Aveux non avenus* and its illustrations from the cover of the book forward. These devices—including the title "Disavowed Confessions," which both invokes and revokes the authority of narrative positivism—provide leverage with which to deconstruct dominant models of psychic and social subjectivity, in particular notions of sexual subjectivity such as inversion.

The confessional paradigm, progressively secularized from Rousseau's moment on, had, by the twentieth century, come to occupy a place of prominence in the methodologies of the modern medical and social sciences, as Michel Foucault has shown. Foucault, in *The History of Sexuality*, aptly characterizes sexology, like psychiatry, as "a confessional science, a science which relied on a many-sided extortion, and took for its object what was unmentionable but admitted to nonetheless."[57] Sigmund Freud, whose newly translated works were on display in the vitrines of Paris bookshops throughout the 1910s and 1920s, dubbed psychoanalysis "the talking cure." His theories gained acceptance by psychiatrists practicing in Paris, including those whose lectures and demonstrations Cahun attended at St. Anne's Hospital in the 1930s.[58] The invocation of confession in the title *Aveux non avenus* places this book in dialogue with some of the era's most significant writings on gender and sexuality, including the theories of both Freud and Ellis.

A display in the publisher's storefront window at the time that *Aveux non avenus* was launched in 1930 attracted the eye of passersby to Moore's ten collage plates, arranged as if to frame an "author portrait" picturing Cahun and her mirror image (fig. 31). Since autobiography "enables one to reflect on oneself by presenting an image of the self for contemplation,"[59] what could make a more appropriate author portrait than a mirror image representing the author and her reflected image? This mirror image—which I analyze in some depth below—provides a point of entry into early twentieth-century discourses on "narcissistic" feminine sexuality and reverses the customary function of the mirror as a signifier of self-absorption and vanity in representations of women. Cahun's author portrait emphasizes the tension between the reflected subject and the photographic subject as the two faces pull away in opposite directions, straining to achieve some distance from each other, both trapped within their respective frames. If woman, to borrow the words of a women's columnist, "lives always before her glass, and makes a mirror of existence," this woman appears to be looking for a way out of her house of mirrors.[60]

In the era of the modern woman, the thematic of narcissistic femininity, especially literary and pictorial images that relied on the mirror as a prop, proliferated hysterically. "The myth of Narcissus," Cahun remarked, "is everywhere. It haunts us."[61] Cahun and Moore came of age during a period when toilette scenes like *Verre de Venise*, painted Jacques-Émile Blanche, won critical acclaim at salons such as the one sponsored by the prestigious Societé Nationale des Beaux-Arts (fig. 32). The feminist implications of Cahun's (futile) attempts to escape the self-replicating frames of mirror and image become glaringly clear when we compare her author portrait to the kind of salon painting that society painters like Blanche continued to churn out annually in the first decades of the twentieth century. Typically, the alignment of the painting's frame with the mirror frame in such genre scenes collapses the distinction between the woman and her image, rendering both infinitely reproducible. The painter of *Verre de Venise* represents his model and her image frozen in a pose that suggests nothing so much as a pair of perfectly matched dance partners waiting for the orchestra to strike the first note before stepping out together on the ballroom floor. Even the placement within the pictured boudoir of a set of matching arm chairs—one on each side of the mirror's plane of reflection—participates in Blanche's mise-en-scène of narcissistic coupling.

The woman entranced by her reflection in the mirror, a cliché of auto-erotic pleasure in the art and literature of this period, played a pivotal role in modern constructions of homosexual as well as feminine sexuality. Ellis, for example, supplemented his real-life homosexual case studies with "true to life" passages from literature. He drew, for instance, from Juan Valera y Alcalá Galiano's 1897 book, *Génio y figura*, in which the heroine imitates Narcissus by attempting to embrace her own reflection—a gesture replicated in salon paintings like *Verre de Venise*.[62] The use of literary or secondhand evidence undermined Ellis's credibility in some circles, prompting one reviewer to complain: "Mr. Havelock Ellis's book is written in a purely dispassionate and scientific style and the only exception we take to the treatment is that we consider some of his quotations unnecessary because a scientific public is already familiar with the originals [e.g., case studies from Krafft-Ebing], and some of them useless, being drawn from tainted sources [e.g., works of fiction, hearsay, unscientific testimony]."[63] Cahun—who had translated Havelock Ellis's two-volume

Fig. 31. Marcel Moore, photograph documenting the launch of *Aveux non avenus*, window display at the bookshop of the publisher, Paris, 1930. *Courtesy of the Jersey Heritage Trust Collection*

treatise on "Woman in Society" for publication in French in 1929, would certainly have been familiar with the sexologist's methods.[64]

It was Ellis who introduced the figure of Narcissus into psychoanalytical discourse in an 1898. In a paper titled "Auto-Erotism, a Psychological Study," Ellis re-gendered the mythical character, representing this self-preoccupied type as feminine (or alternatively, effeminate). He described the "tendency which is sometimes found, more especially perhaps in women, for the sexual emotions to be absorbed, and often entirely lost in self-admiration. This narcissus-like tendency, of which the normal germ in women is symbolized by the mirror, is found in minor degree in some feminine-minded men."[65] Ellis's writings and other cultural texts of this period (including works of journalism, fiction, art, and science) located the mirror within what the narrator of *Aveux non avenus* describes as a

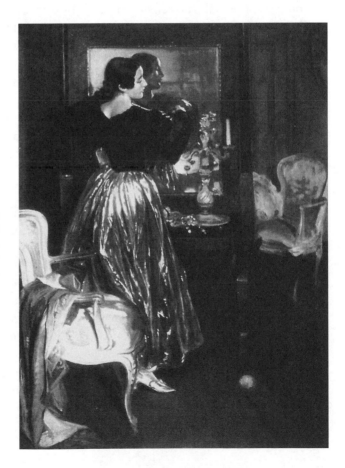

Fig. 32. Jacques-Emile Blanche, *Verre de Venise*. Reproduced in *Les Arts*, no. 65, May 1907.

"clear etymology of narcissism."[66] Yet the concept of narcissism—like its emblem, the mirror—is prone to reversals of meaning that render the etymology (and thus the question of origins) anything but clear. The short passage from Ellis's text cited above generates more confusion than clarity; the originally male Narcissus emerges as a woman before her mirror and then evolves into an effeminate man. The slippage between auto-eroticism and homoeroticism that makes the mirror imagery in paintings like Blanche's *Verre de Venise* so titillating takes a more serious turn in Ellis's text, where mirror imagery clearly serves to naturalize alienated images of femininity and homosexuality as reflections of reality.

While Ellis, in his early essay, classed the sexuality of women and that of "effeminate men" under the shared rubric of narcissism, Freud made the link between the figure of Narcissus and male homosexuality explicit. In his 1914 essay "On Narcissism: An Introduction" (one of many texts on psychosexual subjectivity studied by the members of Cahun and Moore's circle) Freud wrote: "We have discovered, especially clearly in people whose libidinal development has suffered some disturbance, such as perverts and homosexuals, that in their later choice of love objects they have taken as a model not their mother but their own selves."[67] Male homoeroticism, as represented here, is governed by autoerotic drives (drives conventionally associated with female sexuality). Sexual desire between women, in the turn-of-the-century imagination, appeared either as an extension of these feminine autoerotic drives or as a result of a transgender identification on the part of one of the partners (active, other-directed desire being a male, not a female, prerogative). The narcissistic scenario renders the distinction between female homosexuality and female sexuality per se problematic.

Cahun's restaging of the narcissistic scene—the simultaneous evocation of both likeness and difference, the triangulation of a doubled internal image with an external point of self-regard (that of her lover's camera)—offers an alternative to representations of the same-sex partnership as a self-enclosed unit deficient in social or cultural meaning. While the work adds weight to Cahun and Moore's expanding counter-compendium of feminine images, the author portrait comments, at the same time, on emerging theories of psychosexual development that feature mirror imagery (Jacques Lacan) and narcissism (Freud and Ellis) as organizing metaphors. Yet narcissism is not the only relational model with which the photographic tableau engages.

In his pathbreaking 1897 study *Sexual Inversion*, Ellis figures lesbianism

as the coupling of an actively inverted (or mannish) woman with a passively inverted woman. The passive lesbian partner, not encompassed by the notion of psychic inversion ("the soul of a man trapped in the body of a woman"), remains somewhat enigmatic in Ellis's account, despite tortured efforts to explain her choice of partners. The un-mannish partner,

> in which homosexuality, while fairly distinct, is only slightly marked . . . differ[s] in the first place from the normal or average woman in that [she is] not repelled or disgusted by love-like advances from persons of [her] own sex. [Such women] are not usually attractive to the average man, though to this rule there are many exceptions. Their faces may be plain or ill-made, but not seldom they possess good figures, a point which is apt to carry more weight with the inverted woman than beauty of face. Their sexual impulses are seldom well marked, but they are of strongly affectionate nature. On the whole they are women who are not very robust and well-developed, physically or nervously, and who are not well adopted [*sic*] for childbearing, but who still possess many excellent qualities, and they are always womanly.[68]

After establishing that "passive" lesbians "are not usually attractive to the average man," Ellis goes on to offer this as "the reason why they are open to homosexual advances." He notes, however, that such women seem to "possess a genuine though not precisely sexual preference for women over men, and it is this coldness rather than lack of charm which often renders men rather indifferent to them." Notice how the phrasing here—and indeed the logic—turns back on itself, mirror-wise: the fact that men are not attracted to passive lesbians predisposes these women to prefer sexual relations with active lesbians, which in turn makes men indifferent to them.

Despite this confusion, Ellis is clear on one point: What ultimately defines the "feminine" lesbian subject is not her "only slightly marked" physiognomy but her preference for women over men. The "womanly" partner, as described by Ellis, compromises the thesis advanced by specialists of the period—including homosexual rights advocates like Magnus Hirschfeld—that homosexuality is a congenital "condition." For Ellis's "womanly" lesbian, at least, homosexuality would seem to be a matter of choice.[69] This willfulness, combined with the subject's relative invisibility (she is only visible to—or with—a lesbian partner), makes the womanly lesbian a figure of apparent anxiety for Ellis. The *non-dit* surrounding this

figure within Ellis's discipline suggests that his colleagues in the field not only shared Ellis's anxiety but were blinded by it. With the exception of the cameo appearance in *Sexual Inversion* referenced above, the un-mannish lesbian represents a subject of denial in the sexological literature of the era. What is the significance of this hysterical lacuna? Does it imply that the invisible subject of same-sex desire poses a greater threat to patriarchal norms than her more visible partner? And if so, is it because she is difficult for men to spot? Or is it because of what she sees in other women and what other women recognize in her?

Let us return to Cahun's author portrait (fig. 33) and hold these questions up to a (double) self-image produced by two women who formed a couple in which one partner (Moore) was less visible than the other (Cahun). The two-faced subject that Cahun enacts before Moore's lens parses out conventional masculine/feminine binaries along the following lines: active traits (an engaged gaze, a defensive, self-contained stance, a clothed body) adhere to the "real" subject, and passive traits (an averted gaze, a vulnerable, revealing pose, exposed skin) to the reflected image. Yet, as in Ellis's text, the male/female schema fails to cohere within the framework of lesbianism. The subject and her reflection undeniably embody both masculine-coded and feminine-coded traits. The hair is short ("masculine") but dyed blond ("feminine"), the face is masked with makeup, the lips rouged, but the feminine figure is muffled by a man-tailored robe. The subject and her mirror image seem to approach an intermediate—or rather, indeterminate—position from two different angles. And the point at which these trajectories converge—and where the lesbian subject does at last cohere—is in the eye of the (invisible) beholder, Moore's eye.

A letter from Cahun to Moore cited in *Aveux non avenus* describes this convergence in terms that relate the mirror to the photographic portrait (a "mirror with a memory") and implicate both in the mediation of same-sex identification and desire: "Our two heads (hair intermingling inextricably) lean over a photograph. Portrait of one or of the other, our two narcissisms drowning together there, it is the impossible realized in a magic mirror. Exchange, superimposition, the fusion of desires. The unity of the image achieved through the close intimacy of two bodies—if needs be, sending their souls to the devil!"[70] In the magic mirror described above (as in the author portrait), "feminine narcissism" recognizes "narcissistic" homoeroticism as a twin. Here Cahun reclaims the doubly stigmatized Narcissus as both a feminist and a homophile signifier. Speaking

as a sister and a lover, she quips, "Narcissism? . . . It's one of my finest qualities!"[71] Even as Cahun appears to embrace (and in so doing revalue) the forms of identity embedded in the term narcissism, she also expresses a desire, in her portrait, to see herself and be seen as something more, something else.[72] Notwithstanding Cahun's affirmation of narcissism as a *productive* rather than sterile mechanism, the mirror pictured in the author portrait does not frame the term narcissism as the underlying truth of feminine and lesbian subjectivity but rather as an enabling fiction of patriarchal authority. The mirror (which doubles and inverts the subject) offers a metaphor for sexual inversion that may be turned against its own iconographic and discursive traditions to serve emancipatory purposes —to mediate the complex but symmetrical exchange of regards between and among women, to enable recognition and desire within a field of reciprocity.

A photograph taken by Cahun that pictures Moore in a slightly different pose before the same looking glass introduces another facet of this

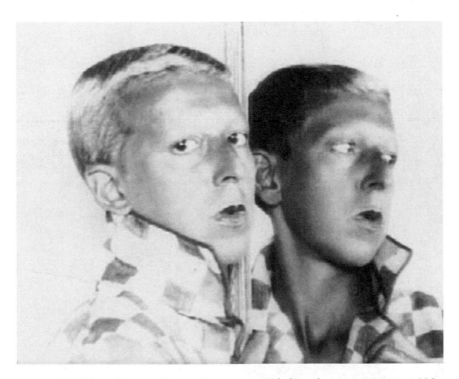

Fig. 33. Claude Cahun and Marcel Moore, untitled (author portrait), ca. 1928. *Courtesy of the Jersey Heritage Trust Collection*

interrogation of narcissism (figs. 34 and 35). Viewed as pendants, these photographs picture the subject and object (of representation, of desire) as interchangeable, albeit not identical, entities. What we have here is not Narcissus and his/her reflection but "Narcissus and Narcissus," to borrow a heading from *Aveux non avenus*.[73] "The desire for a responding eye," Peggy Phelan suggests, "like the hunger for a responsive voice, informs the desire to see the self *through* the image of the other." And this operation, in which one aspires to see, and therefore become, the self in the mirror of the other (which we might productively consider an act of impersonation), *normally* transpires within an "unequal political, linguistic, and psychic field" in which one lacks and the other has.[74] As envisioned by Cahun and Moore, however, such acts of impersonation have

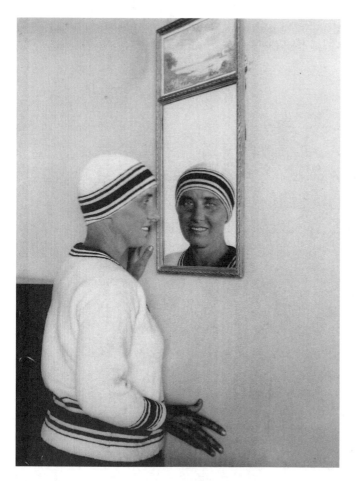

Fig. 34. Claude Cahun and Marcel Moore, untitled (Moore with mirror image), ca. 1928. *Courtesy of the Jersey Heritage Trust Collection*

little to do with "passing," in the traditional sense of the term, from a dis-
advantageous position to a more advantageous one. Nor do they mesh
with Lacanian scenarios of social subjectification and desire that entail
having power (in the case of the male) or being its token (in the case of
the female). Here the desiring gaze is conceived as mobile and therefore
in principle reciprocally empowering.

Notice the dynamics of looking and "looking like" in these two pho-
tographs. In the photograph of Cahun taken by Moore, the subject turns
away from her own reflection to return the regard of the camera, the re-
gard of the lover looking through the camera's lens. In the photograph of
Moore taken by Cahun, the subject meets her lover's regard via the mir-
ror image. The mirror is not, in either case, a closed system (self vis-à-vis

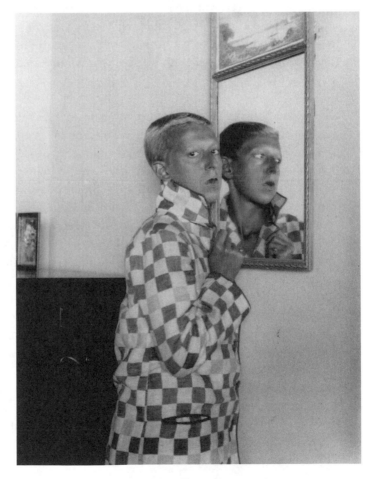

Fig. 35. Claude
Cahun and Marcel
Moore, untitled
(Cahun with mirror
image), ca. 1928.
Courtesy of the
Jersey Heritage Trust
Collection

self-same), nor a space of Lacanian alienation (real self vs. ideal self). Triangulated by the external regard of the collaborator and her camera, the mirror opens the field of representation to possibilities of transformation and exchange. I suggest that this exchange, this doubling and redoubling of the portrait subject/object, not only construes Cahun and Moore as a sort of coupled subject;[75] it paradoxically construes each half of this couple as a whole unto herself. The set of photographs, what is more, pictures a particular collaborative mode of authorship. These faces reflected by turn in the same mirror figure the agency (the complicity in the production of meaning) of both partners—the pictured and the picturer, the performer and the spectator. As Mary Ann Doane has usefully observed, "the face . . . that bodily part not accessible to the subject's own gaze (or accessible only as a virtual image in a mirror) . . . is *for* the other. It is the most articulate sector of the body, but it is mute without the other's reading."[76] Viewed in this light, Cahun and Moore's mirror-image portrait photographs appear to represent both a "we" and an "I" in relationship—via the mirror, via the camera—to a "you" for whom (and of whom) the "I" makes sense.

Ten collages "composed by Moore after designs by the author," the title page of the book states, serve as faceplates for the chapters of *Aveux non avenus*. Here Moore has reassembled fragments of Cahun's body culled from the couple's "monstrous dictionary" of photographic images.[77] The photographs used as source material for these collages picture an already dramatically fictionalized subject: a self in masquerade, in male or female travesty, a self encumbered by countless cultural clichés—but, nevertheless, a self reinvented. The narrator of *Aveux non avenus* describes these instances of self-invention, in which she imagines that she is other, as an ecstatic dream.[78] What medium could reenact the theater of the unconscious, the dream, more convincingly than collage? With its significant distortion of images, its fragmentation of time and space, its sly displacements of emphasis, collage mimics the strategies deployed by the unconscious mind to disarm the policing faculties of consciousness.[79] The medium works, by analogy, to loosen the hold of positivist visual regimes, and the social and political relations that these regimes engender. Nothing could better suit the authors' purposes.

Most of the collages executed by Moore for this book revolve around the thematic of vision. The frontispiece, the only plate in the book actually signed by Moore, presents a single enucleated eye cradled like an

offering in a chalice formed by two hands (fig. 36), the eye that Moore offers to Cahun. "Because I see the world through your eyes," Cahun told her, "you mustn't think that I am a poor observer. You didn't close your soul to me, you didn't refuse me the usage of your clear regard. . . . Your eyes, far from troubling my view, provide me with corrective lenses."[80] In this faceplate Moore's eye, her lens, also provides Cahun with a (deforming) mirror; we can just make out the reflection, *contre-jour*, of the subject on which this eye is trained. Although Cahun had used the eye as an emblem for Moore in the ex libris she designed over a decade earlier, the eye represented here must be viewed not only as a reference to Moore but also as an emblem of (monolithic) authority—as the word *Dieu*, spelled out in mirror writing above the eye, indicates. The collage collapses several interrelated iconographic registers: the coded language of the couple, the symbols of monotheism, and the privileged tropes of surrealism.

The ocular imagery elaborated by Georges Bataille in his roughly contemporaneous *L'Histoire de l'oeil* (1928) offers a point of comparison with respect to the latter. In Bataille's text, the sun, the egg, the third eye, the eyeball, the vagina, the anus, the penis run together into one all-encompassing sexual metaphor from which there is no way out (but, perchance, a way in). Similarly, the eye and its avatars dominate both the pictorial and the poetic imagery of *Aveux non avenus* from cover plate to final page. The eye at the center of this book and at the center of its cover plate—as in Bataille's novel—is also, of course, the "I."[81] An episode described near the conclusion of *Aveux non avenus* makes the analogy explicit:

> Strike . . . at the heart of the eye. . . . Strike the most visible: exactly the blackest part of the dilated pupil. And so as not to miss, [take aim] in front of a magnifying glass. . . .
>
> For the first time, the beautiful little convex images, the illuminations of the eye . . . cease to exist. What I see there, that abominable bleeding hole, comes from past times, from me, from the interior.
>
> A hand falls, slack.
>
> Intensity and shame serve no further purpose: if [the eye] is not dead, it's as good as dead. . . . renouncing itself, its sovereignty . . . [the eye] only now dares to look at itself.[82]

The annihilation of this eye—the suicide of the autobiographical subject—these are the terms of self-knowledge, the conditions of a new

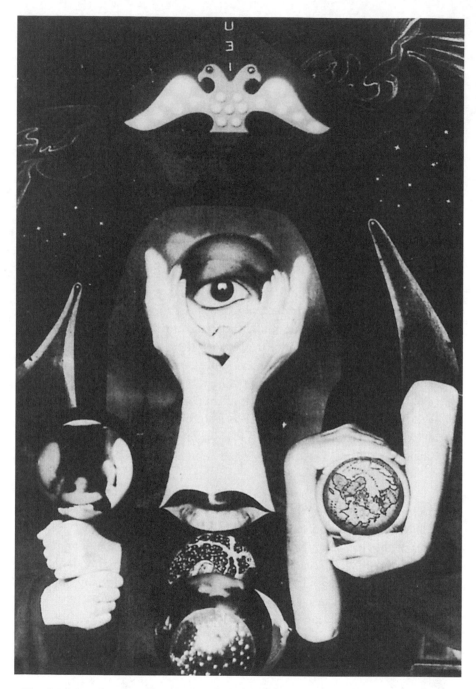

Fig. 36. Marcel Moore, frontispiece for *Aveux non avenus*, 1930.
Private Collection, Paris

vision: blindness. This blindness, Cahun suggests, renders mimetism meaningless and makes any representation of the self as same, as a reflection of the other, impossible. In this illuminated state of blindness, those "beautiful little convex images, the illuminations of the eye" that have ceased to exist and the face in the mirror refuses, as in Cahun's author portrait, to look back. It is the condition of what Phelan describes as an ability to "inhabit the blank without forcing the other to fill it."[83]

The suicide episode—with its moment of blinding truth ("une image du monde formée des verités qui vous crèvent la vue")—speaks obliquely to several other of the book's plates.[84] For instance, the faceplate for chapter 2 (displayed in its original dimensions in the publisher's window alongside the author portrait) can be understood as a related allegory (fig. 37). This collage, which introduces a chapter titled "Moi-même (faute de mieux)" (myself [for want of something better]), converses with the autobiographical "I" that Rousseau identified in his *Confessions* as "Moi-seul," my singular self.[85] In place of Rousseau's rational and natural world—with it's plumbable depths, its navigable horizon, and orthogonals converging reassuringly at some central point in the distance—Moore's collage for "Moi-même (faute de mieux)" presents us with a black abyss, a "widening circle of shadow" (death, as pictured in the suicide episode).[86] Within this disorienting field, parts of Cahun's body circulate—legs, arms, hands—released from the normal imperatives of anatomy.

Here again the organizing tropes (the eye, the mirror, feminine dismemberment) correspond with surrealism's hallmark imagery. We are reminded of Hans Bellmer, whose *poupées* decompose and recompose the female body in various monstrous ways. Opposing the manifestly deformed feminine subject of Bellmer's photographs to the apparently pristine feminine figures preserved in the annals of "straight photography," Rosalind Krauss notes that, in surrealist practice, "woman and the photograph become figures for each other's condition."[87] The feminine body—figured in patriarchal discourse as incomplete, imperfect, and therefore denied full membership in the "family of man"—is not so much dismembered in surrealism, Krauss argues, as re-membered in a way that makes plain the ideological stakes of cultural deformation. Krauss's insight opens another perspective on Moore's illustrations for *Aveux non avenus*, where collage and the lesbian body may also be productively viewed as "figures for each other's condition." The disfigurement of femininity participates here in a process of reconfiguration. The lesbian body

emerges, resurrected, from—and *as*—this process. This body desires "to become rather than to be."[88] A manifestly "impossible identity," the lesbian body provides a symbolic "rallying point . . . for a certain resistance to classification," as Moore's collage for "Moi-même (faute de mieux)" demonstrates.[89]

Here, two reflections of Cahun—one inverted in the pupil of her own beholding eye, the other righted in a mirror framing herself as the beheld—provide the focal points. Occupying opposite poles of the composition, each image appears to reflect upon the other in startled recognition—as if caught in the act of becoming. Cahun's hand, captured in the circle of the mirror's reflection, holds an invisible mirror (the mirror that is always mentally present) up to her already reflected face. Her eyes stand out, as if caught in a spotlight. A second hand—this one Moore's—controls the visual relations here, however. Clasping lightly between two fingers a tiny foot and leg excised from a photo of Cahun, Moore's hand adjusts the angle of the mirror to capture and magnify her lover's reflection, "placing," Cahun acknowledged, "your own imprint upon my acts that they be admired."[90]

Yet another hand, scissored out of the book's galleys, intrudes upon the circle inscribed by the mirror's frame. This third hand, whose index finger

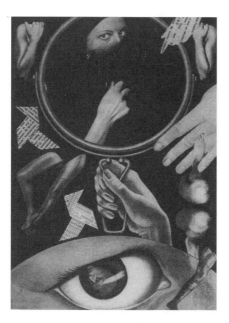

Fig. 37. Marcel Moore, faceplate for chapter titled "Moi-même (faute de mieux)," in *Aveux non avenus*, 1930. *Private Collection, Paris*

points to Cahun's reflection in a promotional manner, delivers a cryptic message from the text.[91] The hand-shaped hole left in the book's galleys points to a statement that links the pointing finger in the collage to a pointing finger in the text: "After a thousand attempts by trial and error, just once I put my finger on God (deep in my heart and despite my insincere protests), here I am, at last, a prophet."[92] In the narrative that follows, this prophet plummets back to earth, to the material conditions of a feminine destiny that she aspires to transcend. "There is too much of everything," the text protests (hence, perhaps, the excess of feminine parts that circulate outside the fields inscribed by the eye and mirror in Moore's collage).[93] The narrator explicates: "If an element doesn't fit my composition, I leave it out. One thing after the other, I eliminate everything. . . . I shave my head, pull out my teeth, remove my breasts . . . everything that perturbs or waylays my regard: the stomach, the ovaries, the mind, conscious and cyst-bound."[94] This passage describes a pared-down subject like the one captured in the mirror-like surfaces of Moore's collage. It describes a feminine subject divesting herself of her attributes—her long hair, her toothy smile, her breasts, her womb, her ovaries, her socially conditioned mind—in the interests of re-creating, rather than reproducing, a social subject.

The project of re-creation proposed here calls for the implementation of new modes of expression, the development of new modes of perception. The medium of collage, in the hands of Moore, would appear to respond to these demands. *Aveux non avenus* and its plates dislodge the customary markers of gender, in other words, to provoke a perceptual crisis that has social as well as artistic repercussions. When the book's narrator evokes "le confusion des genres," s/he describes, in the same breath, an indeterminate gendered subject and an indeterminate means of representation (the French word *genre* signifying both gender and genre).[95] Calling attention to this slippage, Moore insinuates the words *brouiller les cartes* (a figure of speech meaning "to muddle the issue") into her collage. In the passage of Cahun's text from which Moore has culled this phrase, the narrator reflects with some frustration upon the shortfalls of the available symbolic terms, however redistributed: "Mix up the order of the cards in the deck. Masculine? Feminine? That depends on the occasion. Neuter is the only gender that invariably suits me. If it existed in our language one would not observe this oscillation in my thinking."[96] Reshuffling the deck, however, will not pry the symbols loose from their historical meanings.

As Barthes concludes in "Death of the Author," "a code cannot be destroyed, only 'played off.'"[97] To create another vocabulary, the narrator of *Aveux non avenus* recognizes, "to polish the silver of the mirror, wink my eye, blur my image . . . correct my flaws and recopy my gestures, divide myself to conquer myself, multiply myself to impose myself . . . this can change nothing."[98] For this reason, the tactics that Cahun and Moore adopt in their game of give and take with a culture that denies them representation always retain a provisional character. Their representational strategies, which rely on citation, build on historical precedents to set in motion a sort of literary and visual jurisprudence—supple, living, proceeding from mouth to mouth, hand to hand, by trial and error.

The only constant in this oeuvre is the insistence of the self, the selves, to exist, to express, and, yes, to leave behind autobiographical traces. However, as we have seen, the autobiographical "I" represented throughout *Aveux non avenus* little resembles the "moi-seul" portrayed by Rousseau (for whom Nature broke the mold). This is, instead, an "I" represented in complicity with a "you." We sense this "you" throughout the oeuvre: a hand, a voice, a shadow, a gap, a double.

We see this "you" quite clearly holding up the backdrop in another photograph, taken ca. 1925, for which Cahun poses with a huge star (a star of David partially eclipsed) tied tightly around her neck and comet-like reflections bracketing her head (fig. 38).[99] Moore's eyes peer over the black backdrop at her mate's reflection in a mirror upon which the photographic lens is also trained. It is explicitly for Moore that Cahun "stars" in this picture. Yet the "you"—the collaborator, the audience—addressed by the "I" represented here (and throughout the oeuvre) could be understood implicitly as a plural form of address. The narrator of *Aveux non avenus* suggests as much in her description of a scene like the one rehearsed in many of the photographs: "Before her mirror . . . touched by grace . . . she consents to recognize herself. And the illusion she creates for herself extends to certain others [quelques autres]."[100]

Sandra Gilbert and Susan Gubar, in their jointly authored analysis of literature produced by lesbians in the early twentieth century, suggest that lesbian modernists evolved a "collaborative aesthetic out of their common sense of extreme cultural expatriation."[101] This expansion of the conceptual parameters of expatriation allows us to consider Cahun and Moore in such terms prior to their immigration to the Isle of Jersey in 1937. The factors contributing to a sense of being "a stranger everywhere,"

as Elisabeth de Gramont noted with respect to Brooks,[102] include many of the conditions I have discussed in relation to Cahun and Moore: a rejection of the native community and family name, a repudiation of stereotypes of sexual subjectivity, and a declared resistance to both the inherited culture and existing models of opposition. At home in no geographic place, no literary or art historical territory, lesbian activists such as Brooks and Barney or Cahun and Moore "attempted to forge a cultural tradition out of what they had: each other."[103] Their complicity, in addition to challenging prevailing modes of cultural production, hedged against the problem of the cultural exile's isolation and vulnerability.

Cahun and Moore, I conclude, did not aspire to create a new paradigm so much as a new process. By engaging each other in continuous acts of artistic and subjective re-creation, they improvised spaces of possibility that extended beyond the sphere of their partnership to "quelques autres," to certain kindred spirits capable of envisioning "new heavens and a new earth." This, indeed, is the epitaph inscribed on their tombstone: "And I saw new heavens and a new earth." Nine words, appropriated from the Revelation of Saint John, represent the last citational act of Cahun and

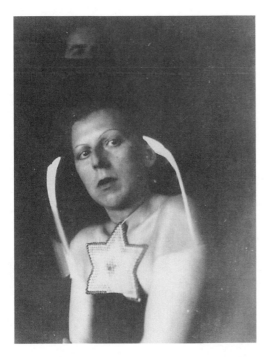

Fig. 38. Claude Cahun and Marcel Moore, untitled (star), ca. 1925.
Collection of Leslie Tonkonow and Klaus Ottmann

Moore's career The quote implies without bringing to closure the full phrasing of this apocalyptic verse: "for the first heaven and the first earth were passed away, and there was no more sea."[104] True to their credo of togetherness, the two who spoke of their union as a "singular plural" came to rest in a plot overlooking the channel that separated them from their native shores, beneath a single monument bearing two names and two six-pointed stars reclaimed from the night.[105]

FOUR

Suzy Solidor and Her Likes

Amour est ce qu'on veut
Qu'avez-vous à blâmer?
J'aime comme il me plaît
Ce qu'il me plaît d'aimer.

—Paul Valéry, *composed*
for Suzy Solidor

ortraits of Suzy Solidor lined the walls of La Vie Parisienne, the cabaret where she presided—on the fringes of Paris's exclusive first arrondissement, and at the heart of what would become the city's first gay quartier—from 1932 to 1946.[1] Some of the portraits, like Yves Brayer's sketch of Solidor performing "on stage," incorporate the night-club's decor—paintings, objects, and audience—as if to acknowledge the process through which this lesbian icon enacted her own celebrity (fig. 39). Portraiture, like theater, like the face itself, exists for—and cannot signify without—an external regard. Identity could also be described as theatrical, to the extent that it exists in relation to the other—with respect to sexual identity, in relation to the object of desire. Homosexual identity, more specifically, defines itself in relation to two "others": the refused, opposite-sex other identified with normative, heterosexual erotic schemas and the same-sex other, object of perverse desire. Brayer's portrait represents Solidor as the focal point and enabler of multiple erotic identifications. She performs, slightly elevated and in the spot light, at the center of an intimate performance arena. To her right, habitués of the club would have had no trouble recognizing Henri Bry massaging the ivories of a too grand piano. Bry, an openly homosexual entertainer, taunted Solidor nightly with comic proposals of marriage in the course of her routine.

A pair of cross-dressed spectators in the foreground of Brayer's portrait represent the homosexual sector of the audience for whom La Vie Parisienne reserved a special place. Across the table, a trio of well-heeled socialites make themselves at home. Two portraits hanging in the penumbra surrounding the singer evoke the scores of likenesses that constituted the club's decor, works realized by artists whose stars were on the rise in Paris between the two world wars. Artists like Brayer competed for the chance to depict Solidor, recognizing the advantage of placing their work at a point where Paris's transgressive subcultures, Europe's upper crust, and the artistic establishment converged.

The portraits jostled each other for primacy, hanging frame to frame, "from the cash register to the washroom."[2] Pictures of Solidor invaded even the coatroom, which served as a "musée des erreurs," a repository for efforts that failed to garner the sitter's favor.[3] The eclectic character of this collection—which included works in a variety of media and styles by artists from over a dozen countries—reflected not only the nightclub performer's status as an "artiste mondialement connue à Paris" but also her desire to resist inscription within rigid categorical boundaries—be they

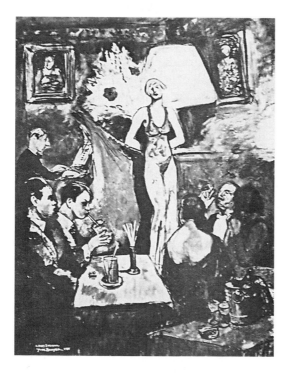

Fig. 39. Yves Brayer, *Suzy Solidor*, 1935, reproduced in *Deux Cents Peintres, un modèle*. © 2004 Artists Rights Society (ARS), New York/ADGAP, Paris

sexual, social, political, or artistic.[4] The portraits de-classed Solidor and reframed her (variously) to her advantage. Although not a single likeness here bears Solidor's signature, the collection itself constitutes a self-representational oeuvre. Like her contemporaries Claude Cahun, Marcel Moore, Romaine Brooks, and, for that matter, Natalie Barney, Solidor too explored portraiture as a site of self-invention and self-inscription. In all five cases, these artists' relations to the objects with which they surrounded themselves—Brooks with her portraits of modern women, Barney with the women themselves, Cahun and Moore with the (photo)graphic traces of their self-exploratory acts, Solidor with her self-centered decor—participated in what might productively be considered "the dramaturgy of the self."[5] However, as the only (arguably) self-made woman among them, Solidor stood apart from the other lesbian cultural figures I have discussed thus far.

Despite the approbation of influential male intellectuals from Paul Valéry to Robert Desnos, Solidor did not win the favor of Paris's lesbian intelligentsia. While male intellectuals applauded Solidor's animal appeal and her cultural sophistication from a secure position, many lesbian cultural leaders (with the notable exception of Colette) avoided the taint of association with this dubious "sister." A roster of Paris lesbians who did *not* frequent Solidor's club would include—in addition to Claude Cahun, Marcel Moore, Romaine Brooks, and Natalie Barney—literary lights such as Elisabeth de Gramont, Gertrude Stein, Djuna Barnes, and H.D.; cinematographers and producers like Germaine Dulac and Bryher; photographers Berenice Abbott and Gisèle Freund; the founders of the *Little Review*, Margaret Anderson and Jane Heap; the influential literary arbiters Adrienne Monnier and Sylvia Beach; and the journalists Golda Goldman and Janet Flanner. In contrast to this well-educated sorority, Solidor benefited from no inherited capital, be it symbolic or financial, as she herself emphasized.

Solidor's parentage was in no way distinguished. Her mother was not an artist or aristocrat, educator or international society hostess, but a charwoman in the service of a provincial notable. According to Solidor, this employer (a descendant of Saint-Malo's most legendary corsair, Robert Surcouf) impregnated her mother.[6] Born out of wedlock, Solidor was given her mother's surname, Rocher. Following what she described as a childhood of truancy in the Brittany seaport, the rebellious Suzanne Rocher, determined to avoid the career of domestic service for which she was destined, obtained a driver's license and enlisted in the army ambulance corps.[7]

In the wake of the 1914–1918 war, she migrated to Paris, equipped with little more than her arresting looks and perhaps a list of contacts passed on by her sisters in the ambulance corps. According to the origin myth upon which she continuously embroidered, the adolescent veteran presented herself, suitcase in hand, at the door of a Right Bank *boutique d'antiquité* owned and operated by the celebrated lesbian socialite Yvonne de Bremond d'Ars. Over the next eleven years, Bremond d'Ars, well connected in aristocratic, artistic, and homosexual circles, turned the "little uncultivated Breton" she found on her doorstep into an urban sophisticate.[8]

Indeed, Bremond d'Ars played the role of Pygmalion with an acknowledged flair. "She sculpted me," declared Solidor. "Each day she added something to her oeuvre."[9] "Mademoiselle," as Solidor called her, groomed and dressed the novice in fashions by Lanvin; she paid for lessons of diction, comportment, drama, and music; she inculcated in Solidor a certain erudition. Patiently, she created a "propitious atmosphere" for Solidor's "initiation . . . to the codes of Lesbos"—even though Solidor, by her own estimation, "was not a born tribade."[10] "All of the books that she put at my disposal," Solidor embellished, "celebrated the cult of sapphism: [in my bookcase], Verlaine's *Femmes* nestled up against the poetic oeuvre of Renée Vivien."[11] Chez Bremond d'Ars, Solidor familiarized herself with a set of references shared by an elite homosexual literary community: the writings of François Villon, Arthur Rimbaud, Charles Baudelaire; manuscripts by Pierre Louÿs and Paul Valéry "vaunting the beauty of the lovers of Bilitis and Chloé";[12] fragments of Sapphic poetry; the writings of Oscar Wilde; *Idylle saphique*, in which the courtesan Liane de Pougy commemorates her affair with Natalie Barney; Rémy de Gourmont's *L'Amazone* (also a tribute to Barney); and more recent entries to this bibliography, such as Hall's infamous *Le Puits de solitude*.

It was Bremond d'Ars who first cast Solidor as a work of art and first presented her to the public as an image. Bremond d'Ars commissioned the very first portraits in what would become Solidor's collection.[13] She "upholstered" the bedroom that she shared with Solidor with these paintings, prefiguring the decor of Solidor's nightclub. "She had me pose, almost always nude, for a quantity of artists such as Domergue, Van Dongen, Marie Laurencin, Vertès, Foujita, Kisling . . . not to mention even better ones."[14] In reality, if Solidor appears unclothed in works by Vertès and Domergue, she looks the very picture of propriety as rendered by Moise Kisling, Foujita, Laurencin, and Kees van Dongen. Van Dongen, for instance, presents us with just the head and shoulders of his sitter, whom

he pictures as a youthful sailor (fig. 40). This boyish girl with flaxen hair
bobbed at the ears, a mariner's stripes, and eyes as vacant as the violet
sky would grow into the role that Van Dongen prefigures here. In 1927,
though, when this image was created, the sailor's suit meant no more, no
less, than the fishnet bathing costume or Greek lace-up sandals acquired
for Solidor by her benefactor—attire for a season at Deauville, where Bre-
mond d'Ars displayed her "treasure" annually with a "sort of ostenta-
tious rage."[15]

 After a decade of preening for her proprietary employer on the side-
walks of Paris and boardwalks of seaside resorts, Solidor reclaimed the
independence that was a bastard's birthright.[16] She broke with Bremond
d'Ars, using the relations that she had cultivated during her apprentice-
ship to launch a career as an entertainer—and to continue a career as a
lesbian spectacle and an *oeuvre d'art*. Motivated by promotional concerns
(and perhaps a bastard's spirit of revenge), the would-be celebrity aban-
doned her mother's name, Rocher, in favor of the patronymic Surcouf.
The pirated patronymic, tinged with the romance of the high seas and
realms beyond the reach of the law, at once marked and redressed Solidor's

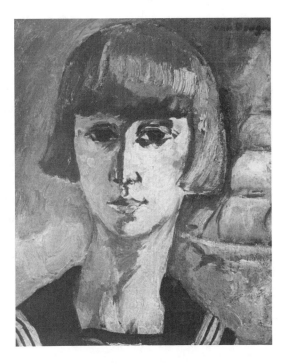

Fig. 40. Kees van Dongen,
Suzy Solidor, 1927,
reproduced in *Deux Cents
Peintres, un modèle*.
© *2004 Artists Rights Society
(ARS), New York/ADGAP,
Paris*

illegitimacy. Surcouf's staunchly bourgeois legal heirs prevailed on the courts, however, to impose an interdiction. "Our off-spring are not in the habit of appearing clad only in three rubies (of which one on each breast) or of exhibiting themselves in bathing suits fashioned of mother-of-pearl or fish net," they declaimed.[17] Ultimately, the Tour Solidor, the fortress tower that keeps watch over Saint-Malo, capital of the corsairs and historical city of asylum,[18] provided the entertainer with a stage name: Suzy Solidor. The phonetics of the name (*solide or*, solid gold) even retained the glint of pirate's booty.

From its inception, the name Solidor appeared in headlines, in lights, in gossip columns, on record jackets, book jackets, and high-society guest lists. The name attracted listeners to Radio-France and viewers to the earliest national television broadcasts.[19] It lent cachet to the emerging recording industry and the *cinéma parlant* as well. Solidor starred, for instance, in the second film version of Margueritte's novel *La Garçonne*, directed by Jean de Limur. The first version, a silent film produced in the 1920s, was banned shortly after its release. In Limur's remake, Solidor played the role of a nightclub proprietor who introduces the heroine, Monique Lerbier, to the pleasures of opium and sapphic eroticism. Within a reconstituted nightclub setting, replete with portraits borrowed from the walls of La Vie Parisienne, Solidor sang one of her standbys, "La Vie est un feu de paille." Her costars included two legendary cabaret performers: Arletty and Piaf. Solidor, a relative newcomer to the entertainment business, worked hard to keep her name in circulation, making the rounds of charity fundraisers, art openings, ship launchings, automobile rallies, groundbreaking ceremonies for new metro stations, book signings, opera and ballet galas, funerals, horse races, fashion shows, and Suzy Solidor look-alike contests ("Madame, mademoiselle, vous pouvez gagner 250fr: Ressemblez-vous à Suzy Solidor?")[20]—events, in short, that would attract the attention of the media. But unlike the stars produced by the burgeoning recording and movie studios, a population with whom she constantly rubbed shoulders in the course of these activities, Solidor maintained personal control of her public image and career.

It is no coincidence that several of her portraitists pictured Solidor at the helm of the ship. A painting signed Jincart, reproduced in promotional material that Solidor distributed, figures a swashbuckling Solidor, face to the wind, one gauntleted hand steadying the wheel of the ship, the other clutching a drawn sword (fig. 41). She looks like an illustration from her own novel, *Fil d'or*, whose heroine—a cross-dressing female sea captain—

dodges the law to navigate "where the waters are most treacherous . . . to do combat with the sea each day of [her] life" and, ultimately, to earn her "redemption."[21] The novel, like Jincart's painting, represents a romantic outcast battling hostile elements to master her own fate. The sea of faces that flooded La Vie Parisienne each night was, for the novel's author, an analogous arena of combat and redemption.

During the 1930s and early 1940s, Solidor appeared episodically in theatrical and music-hall productions, and ventured once or twice again into the realm of cinema. She poured most of her energy, however, into the operation of her own night spot at 13 rue Ste. Anne. By Solidor's account, there were only ten or twelve such clubs—including Cocteau's haunt, Le Boeuf sur le Toit—when she made her debut on the entertainment scene.[22] It is certainly true that very few other women opened clubs

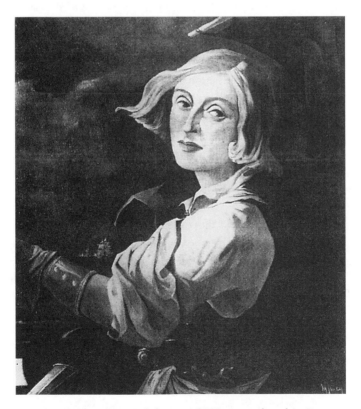

Fig. 41. Jincart, *Suzy Solidor*, ca. 1939, reproduced in *Deux Cents Peintres, un modèle*.
© 2004 Artists Rights Society (ARS), New York/ADGAP, Paris

in Paris during this decade, despite the growing popularity of these inti-
mate entertainment venues.[23] Among them, Solidor alone entered the
entertainment business through her own front door, without working her
way up through the music-hall and cabaret circuit. Unlike her colleagues,
who built their reputations from scratch, Solidor had already captivated
an audience (thanks to the exhibitionism of Bremond d'Ars) before she
officially launched her career as a professional performer.

First, in her quai Voltaire *boutique d'antiquités,* called La Grande
Mademoiselle, and then in her clubs La Vie Parisienne and Chez Suzy
Solidor, she played to this audience on a near nightly basis for thirty years.
The nightclub clientele—artists, aristocrats, celebrities, high-ranking offi-
cers and officials of state, wealthy industrialists, visiting potentates, and
an inner circle of lesbian colleagues, entertainers, and demimondaines—
never seemed to tire of Solidor's variety act. Surrounded by a kaleido-
scope of images representing the proprietor in a range of postures, club
patrons succumbed to her charms night after night, year after year, as her
portrait collection expanded. Her fans followed as she moved from venue
to venue, from the Left Bank to the Right Bank to the Côte d'Azur.

As her performance routine matured, Solidor skillfully tempered rustic
authenticity with chic modernity, homoeroticism with heteroeroticism,
masculinity with femininity, constantly renewing the vitality of her spec-
tacle and reigning over the performance arena as if it were a fiefdom. The
images of Solidor that filled the space around her emptied it of anything
else, creating a "milieu," a circle emptied out and then filled in, a per-
sonalized theater.[24] Solidor took possession of and arranged this space,
and the collection of objects with which she filled it, in a way that made
her both the producer and the star of the show. One of the aging Solidor's
last promotional photographs shows her posing, surrounded by like-
nesses, cloaked in black after the fashion of a legendary predecessor, the
impresario/performer Aristide Bruant (1851–1925). Like Solidor, Bruant—
whose notorious cabaret, Le Mirliton, extended the pleasures and abuses
of Bohemian Montmartre to a high-born clientele—carefully cultivated
(with the help of trend-setting artists) a profitably transgressive public
image. The promotional portrait of Solidor-as-Bruant, with its overdeter-
mined emphasis on posing and imposture, challenges the viewer to get to
the bottom of the performer's self-fictions (fig. 42).

The power of Solidor's productions (the magnetism of her presence
within the arenas she created) derived in part, from the tension between
the contrasting projections that she and her collection embodied: between

Fig. 42. Suzy Solidor, in her Haut-de-Cagnes club, ca. 1960, posing as
Aristide Bruant against the backdrop of her portraits.
Photo courtesy of Doris Lemaire, Cagnes-sur-Mer

virility and tenderness, between seducer and seduced, between the rudeness of the material and the polish of its presentation. Describing herself as "a Parisian who retained the trace of all the flaws and qualities of her origins,"[25] she draped cosmopolitan sophistication like a brigand's cloak over her pampered but naturally athletic body. Her husky voice and elegant diction heightened the drama of these competing effects, as did the eclectic, ever-expanding portrait collection that set the scene for her performances.

Solidor was neither the first nor the only public figure to shape her public image and to enhance her reputation via portraiture—as the example of Brooks and the counterexamples of Cahun and Moore demonstrate. Historically, indeed, one of the primary functions of portraiture has been to underwrite the authority and enhance the renown of the culturally and politically powerful. Many of the social and artistic celebrities whom Solidor courted forged alliances and kept themselves in the public eye by sitting for their portraits. Image-conscious personalities such as the *salonière* Anna de Noailles, the cosmetics tycoon Helena Rubinstein, and the poet Jean Cocteau, to name three who frequented Solidor's club, recognized the social and commercial utility of the portrait genre. Some of the most significant cultural producers and patrons of the previous century had dramatized their influence in this way. *Grandes dames* such as Madame Récamier (portrayed, most notably, by Jacques-Louis David and François Gérard) and artists such as Whistler (portrayed in caricatures and portraits by as many as one hundred artists) understood the self-promotional potential of portraiture.[26] Of these sitters, however, none constituted a collection of self-images quite like that of Solidor.

Perhaps only the collection of the comtesse de Castiglione surpasses Solidor's ambition in strictly quantitative terms. Solidor sat for close to 250 portraits. The countess posed for almost twice that number. Most of the countess's images issued from the same portrait studio, that of the nineteenth-century photographer Pierre-Louis Pierson. Castiglione's choice of medium (photography, a putatively documentary genre) and of a commercial interpreter, as well as the serial character of her portrait enterprise, could be viewed as evidence of her intention to shift the emphasis, as Solidor did, away from the agency of the portrait maker toward that of the sitter—as one famous portrait of the countess staring back at the camera through a frame held to one eye seems to imply (fig. 43). However, as Abigail Solomon-Godeau has cautioned, although the photographs

for which the countess posed are unarguably "the personal expression of an individual woman's investment in her image—in herself *as* image . . . this individual act of expression is underwritten by conventions that make her less an author than a scribe."[27] Is it safe to assume that Solidor, at a later moment in history, was in a better position to assert her own authority? At the very least, important differences in class, arenas of production and display, and historical context make drawing an analogy between Solidor and Castiglione a shaky proposition.

The self-promotional initiatives of Sarah Bernhardt, France's premiere mass celebrity, more closely resembled Solidor's enterprise, though. To wit, Bernhardt fully exploited the latest fads and technologies to this end—most notably, the latest photographic and stereographic developments. For instance, a *carte-de-visite* (which would have been displayed among the collectables in the photographer's vitrine) pictures Bernhardt, ca. 1879, paintbrush in one hand, palette in the other, putting the finishing touches on an already framed easel painting (fig. 44). At first glance, the effect of this gilded frame and the fact that Bernhardt's painting hand rhymes so precisely with the hand of the

Fig. 43. Pierre-Louis Pierson, *Comtesse de Castiglione*, ca. 1855, reproduced in Robert de Montesquiou's homage, *La Divine Comtesse: Etude d'après Madame de Castiglione* (Paris: Manzi Joyant, 1913).

woman that she has painted invest the tableau with the character of a mirror image. We quickly become aware, though, that the framed image is not the product of passive mimetism but the result of Bernhardt's creative act. The artist poses, one foot turned out like a dancer, costumed in improbably spotless white trousers and matching frock coat, ruffles overflowing the lapels, a corsage pinned to her shoulder. Focusing on her canvas, she cuts her famous silhouette against a background darkened for contrast like the one in her painting. Bernhardt was always on stage, always engaged in the creation of her image—here the image of an artist of many dimensions, a Renaissance woman—and Solidor followed in her footsteps. Like Bernhardt, who excelled as an actor, director, set and costume designer, painter, sculptor, and writer, Solidor demonstrated her artistic prowess in multiple arenas. Like Bernhardt, who, in addition to recognizing the self-promotional potential of photography, recorded her voice on Edison's earliest devices and performed in the first moving pictures, Solidor too exploited the latest technologies of her era. Like Bernhardt, who toured by balloon and received guests couched in the white satin–lined casket that she kept in her parlor, Solidor calculated appearances that would attract the attention of the print media and add texture to her myth. Like Bernhardt, Solidor, with her penchant for travesty roles and her passions for members of both sexes, garnered a cult following in Paris's lesbian communities. And, like Bernhardt, Solidor "inspired" innumerable works of art and literature.

The mise-en-scène of Suzy Solidor by Suzy Solidor, however, unlike that of Sarah Bernhardt by Sarah Bernhardt, transpired after the Great War, with its complex consequences for women in both public and private life. Imaging technologies, too, had changed dramatically in the interim. Cinema, for one, had evolved from an experimental arena into an industry. The *monstre sacré* of the theatrical stage (and Bernhardt, who died in 1923, was among the last of these) had ceded to the *vedette* of the silver screen—thanks in large measure to breakthroughs in filmic technologies. If Bernhardt had to work harder than Solidor to achieve autonomy in the solidly masculine public sphere of the fin de siècle, Solidor had to work harder than Bernhardt to distinguish herself as "an original" within the media-driven celebrity culture that accompanied the ascent of cinema. Solidor, in other words, faced a very different set of challenges than Bernhardt as she vied for a margin of self-determination within a rapidly evolving entertainment economy—a "star system" that functioned on an international scale.[28]

Solidor's exploitation of original artworks set her one-woman promotional operation apart from the industry that created stars like Garbo, whose Hollywood handlers catered to the demands advertisers, fan magazines, newspapers, and correspondence clubs.[29] Hollywood-generated celebrity photographs, even more than the movies themselves, played a critical role in the creation of 1930s viewing communities, and thus stars. Garbo's face became the logo unifying a filmography identified by the star rather than by the auteur. In the 1930s, fans stood in line to see "the latest Garbo." Who among them could have identified the director of *Mata Hari* or *Queen Christina*? Garbo's face was featured on magazine covers, enlarged for posters, billboards, and even theater marquees.[30] As Louise Brooks commented, "When I think of Garbo, I do not see her moving in any particular film. I see her staring mysteriously into the camera. . . . She

Fig. 44. Poirel, *Sarah Bernhardt*, carte-de-visite, ca. 1880.

is a still picture—unchangeable."[31] Barthes suggests that Garbo's face crystallizes "this fragile moment when the cinema is about to draw an existential from an essential beauty, when the archetype leans toward the fascination of mortal faces."[32] Solidor's image, in contrast, as a result of its dissipated character, seems neither existential nor essential, appearing instead as a shifting play of surfaces. Her portrait collection forces the viewer's eye to move constantly, creating a blur, a composite, an image that cannot not be seized.

Indeed, perusing the scores of portraits hanging in the club, the uninitiated observer might not have recognized, in this eclectic ensemble, that the paintings all represented one and the same model. But then, thanks to the mass media and Solidor's grasp of its potential, few uninitiated observers ever crossed the threshold of her club. Solidor attracted attention to her collection by traveling with it when she took her show on the road and by inviting her public to champagne celebrations at the nightclub each time she unveiled a new acquisition. Society and entertainment columns pictured each addition to the collection. Photos of Solidor posing (in the club, at home, on tour) with one or more of her portraits were reproduced in popular niche publications such as *Les Ondes*, *La Rampe*, *Mon Ciné*, *La Vie Parisienne*, *Comoedia*, *Marianne*, and *Plaisirs de France*. Portrait images of Solidor were also occasionally reproduced in the official catalogues of annual salons, as well as in coverage of these exhibitions by art journals.[33] Even the newsreels, a new phenomenon, captured Solidor's likenesses.

In 1932, for instance, a Pathé-Gaumont news feature titled "Un Bel Atelier moderne" caught Solidor posing nude in Tamara de Lempicka's studio.[34] We witness Lempicka, working frontally and up close, depicting a modern amazon, one breast bared, face helmeted by a cask of brassy hair, posing against a nocturnal urban skyline (fig. 45). Lempicka's geometrical, art deco aesthetic transforms Solidor into an objet d'art while her proximity to the sitter eroticizes the visual relations. The subject's cold, come-hither eyes, the manicured hands that finger a silken drape, the erect nipple of that precisely semispherical breast, the impenetrable surfaces of a body on display in the hard, artificial light of a city night congeal into a sort of modern erotic archetype: a spectacularized, sexually available but sexually predatory body, one that appears both objectified and objectifying, Solidor's body.

Such portrait images, previewed in the news media, captured the imagination of every client entering Solidor's club. A bust of the proprietor

executed in oil by Othon Friesz, a pinup by Jean-Gabriel Domergue,[35] life drawings by Francis Picabia and Mariette Lydis, a caricature by Jean Cocteau, an impression in pastel pinks and blues by Marie Laurencin—all met the eyes of the arriving clientele. The promiscuity of the display, whose density and variety rivaled that of the patrons packed shoulder to shoulder around the club's small tables, made it nearly impossible to consider these portraits as individual works of art.

The hodgepodge effect prevented any single portrait from standing out against the others, foregrounding the collection as a whole (thus, Solidor's oeuvre, Solidor's celebrity) at the expense of its individual parts (and the individual artists). More importantly, no portrait image ever eclipsed the subject "in the flesh." Each work was absorbed into a collective pictorial context that framed Solidor to her best advantage—as one society columnist recording his impressions of a soirée at La Vie Parisienne affirmed:

> I admire [Suzy Solidor] both as a woman and as an artist—and I must not be the only one, since a hundred painters—one more famous than the next—have executed her portrait. [The portraits] hang on all the walls, works by Foujita, Marie Laurencin, Domergue, Van Dongen . . . , and if one has the good fortune to be dead-drunk, one sees two thousand images swirling before one's eyes. . . . But Suzy Solidor, in flesh and blood makes this collection of art works pale.[36]

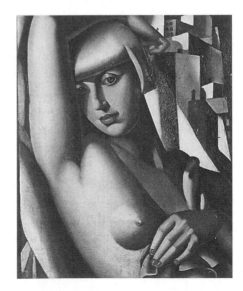

Fig. 45. Tamara de Lempicka, *Suzy Solidor*, 1932, reproduced in *Deux Cents Peintres, un modèle.* © 2004 Artists Rights Society (ARS), New York/ADGAP, Paris

One thing that the artists for whom Solidor posed had in common was that they were all celebrities of sorts themselves in the 1920s and 1930s. Murals by Mikhail Yacovleff, Othon Friesz, and Roger Chapelain-Midy decorated the foyer of the new Théâtre National Populaire in Paris's Palais de Chaillot at Trocadero (lavishly renovated in 1937). The internationally acclaimed Ballets Suédois featured sets and costumes by Hélène Perdriat. Louis Touchagues designed the decor for the Palais de Tokyo. Jacques Thiout and Christian Bérard turned heads in the arena of high fashion. Jean Dunand set trends, with his luxuriously lacquered decorative schemes, in the realm of interior architecture. *Affiches* by Paul Colin enlivened Paris's most sophisticated night spots, and Jean-Gabriel Domergue created the poster for the first international film festival at Cannes. Erté's star was on the rise in Hollywood, and Jacqueline Marval's portrait oeuvre functioned as a pictorial register of the cosmopolitan beau monde. Each of these artists produced a portrait image of Solidor, and most frequented the club. "Each night my painter friends came," Solidor reminisced in a radio interview, "to see me, but also to assure that their portraits were properly displayed."[37] Where these celebrity artists went, the journalists followed, "satisfied to report on the overall scene."[38] The champagne *vernissages* that Solidor hosted to unveil each new portrait enhanced the club's allure, as did the transgressive climate that the proprietor created around herself and La Vie Parisienne.

Many of the artists who portrayed Solidor flirted openly with sexual scandal and perversion. Cocteau had published a daring album of homoerotic drawings, *Le Livre blanc*, in 1928.[39] Lydis, who illustrated deluxe editions of erotically charged works by Baudelaire and Colette, explored in her paintings and drawings "the world of suffering and voluptuousness . . . with all the fatal lyricism of Sappho."[40] The signature Vertès appeared with regularity in racy pulp magazines, and his erotic drawings illustrated texts by Louÿs (*Poésies érotiques*) and Colette (*Vagabonde*, 1927, and *Chéri*, 1929). The society painter Kees van Dongen's images of the modern woman and sapphic love served as plates for Margueritte's sensational *La Garçonne* (1922). Critics referred to the images created by Dietz Edzard as "black flowers of romanticism" and labeled Jules Pascin (whose sketch of Solidor was described in the press as "deux femmes se saphisant sur un canapé") the "pornographer of the School of Paris."[41] Lempicka's sapphic icons provoked reflections by reviewers on the underlying eroticism of her practice as a painter; "Where does the voluptuousness of touch leave off and the voluptuousness of painting begin?" one of her

critics mused.[42] Via portraits bearing signatures like these, Solidor illustrated a text of her own elaboration, a dramatic text governed by the conventions of erotic fiction.

The legibility of this oeuvre as a statement of perverse desire made Solidor the *figure de proue* (or symbolic figurehead) of an increasingly visible lesbian following. Commercial artists and caricaturists pictured her quite literally as the figurehead of a sailing vessel (fig. 46). The Russian artist Zinowiev's portrait of Solidor-as-figurehead occupied pride of place in the nightclub, hanging just above the piano throughout the 1930s (fig. 47).[43] Zinowiev invests Solidor's feminine body—somewhat inelegantly spliced to its metaphorical equivalent, the vessel—with phallic rigidity. Her arms, like those of a martyr tied to the stake, are pinned behind her (the riggings that crisscross the bow of the ship reinforce the suggestion of bondage). Her pale head and torso—"lovingly patinated by the light," streamlined, erect as the ship's bowsprit—lunge at the darkening horizon. Her lower body, which merges with the vessel's prow, penetrates the briny deep. The effect of this picture, with its mixing of gendered metaphors, is one of ambivalence. The figurehead represents Solidor as a forerunner, yes, and as such a figure of influence, audacity, and freedom, but it also depicts her as a sort of fetish object, sexualized, bound. However contradictory, each of these interpretations reconciles in its own way with Solidor's status as a lesbian icon.

Solidor assumed the role of lesbian figurehead with humor, naming her country getaway in Médan, which Colette helped to decorate, Le Puits de Solitude, an ironic citation of the title of Radclyffe Hall's scandalous—if somewhat stuffy—lesbian novel.[44] As more than one journalist pointed out, solitude was an unlikely term to evoke in association with Solidor, who was typically surrounded by doting women. Solidor's theme song "Ouvre," with its unequivocal lyrics ("open your trembling knees, open your thighs") became a sort of lesbian anthem—and remains so to this day.[45] As gossip columnists frequently remarked, Solidor "never hid the vigorous and tender passion that creatures of her own sex inspired in her." On the contrary, she flaunted it. Lesbianism sold well in 1930s Paris.

Reporters claimed that the performers and servers who worked in Solidor's club "were all her 'little allies.'"[46] There was some truth to this assertion. Solidor "adopted" a series of young protégées, and some remained in the entourage for decades. Doris Lemaire, for example, celebrated her sixteenth birthday in the celebrity's embrace on the dance floor of the Paris nightclub and remained more or less at her side, and on and

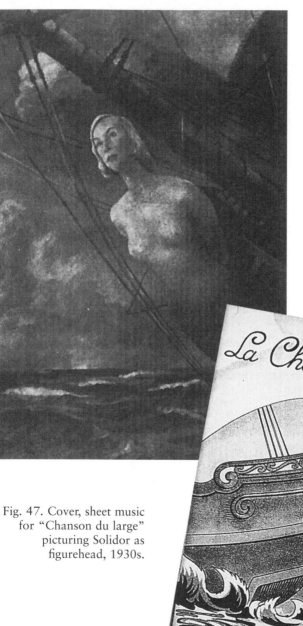

Fig. 46. Zinowiev, *Suzy Solidor, Figure de proue,* 1930s, *reproduced in Deux Cents Peintres, un modèle.*

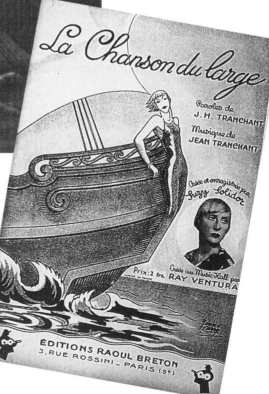

Fig. 47. Cover, sheet music for "Chanson du large" picturing Solidor as figurehead, 1930s.

off in her employ, until Solidor's death in 1983.[47] And Solidor did indeed launch a number of lesbian as well as gay male performing artists—including her successor Colette Mars, who took over La Vie Parisienne in the 1940s, and her "god daughter" Dany Dauberson, who drew Solidor admirers to the lesbian bar Carroll's in the 1950s.[48] These affiliations contributed to the sophistication of Solidor's reputation and that of her club.

It was Solidor's calculated revelations about her attachments to women, what she called her "solidorité féminine," that underwrote this reputation—and made the performer and her club the focus of constant media attention.[49] Journalists could always count on her for a titillating one-liner. "When I eat fois gras and have a nightmare," Solidor tossed off to an interviewer who grilled her about the men in her life, "I dream that I am married. Actually, I'm a confirmed bachelor [un vieux garçon]."[50] She informed another interviewer, inquiring about an up-coming tour of Greece, that above all she looked forward to visiting the Temple of Lesbos "with all the fervor of a pilgrim."[51] As for the homophobic slurs that Solidor's candidness about her sexuality occasionally provoked, she dismissed them with contempt. "These stories won't cost me a single friend," she insisted. "Just as the adversaries of the nude tend to be ugly women, these rumormongers are sexually frustrated lovers whom I've banished from my bedroom."[52] Backing up her bold remarks to members of the press with equally bold acts, Solidor hosted women-only "tea dances" at the club twice a week and recorded an album titled *Paris-Lesbien* as a gesture of recognition to her lesbian following.[53] The album featured songs with titles such as "Tout comme un homme," "Sous tes doigts," and "Obsession," whose lyrics ("Chaque femme je la veux / Des talons jusqu'au cheveux") openly celebrate lesbian desire. Solidor's self-identification as a womanizer, despite significant liaisons with men, undeniably ramped up her allure as a celebrity and added a breath of *succès à scandale* to the hearsay about her club.[54] "Without *Confessions* [a magazine in which Solidor revealed the "strange destiny of a woman without men"] and an aura of unwholesomeness, there wouldn't be so many customers at [La Vie Parisienne]," one entertainment columnist affirmed.[55]

While maintaining the homophile atmosphere within La Vie Parisienne, Solidor did not shortchange her heterosexual clientele. A journalist entering the premises for the first time was struck by the clublike camaraderie among the habitués. He noted that the hostess "spoke to all of her clients as if they were her friends because they all were her friends. She mingled constantly with the guests, coming and going in the dim light. . . .

And in that little room, as intimate as a boudoir, I felt a growing sense of well-being, an indulgent tenderness for those around me and for my-self."[56] Another observer, a longtime patron, mused about what he called the "professionalism" of Solidor's charm: "Was she such a good actor that she seemed attentive while thinking of a thousand other things, or was she really that attentive?" Anyway, he concluded, she made her customers feel so at home that "they forgot that they had to pay for it."[57]

Solidor's performance style on stage was also "professionally intimate." Her voice, which one enchanted reviewer described as "a little black, a little magical," made each moment of her performance seem like "a sort of miracle," whatever the nature of the material.[58] And the material varied as widely as the images of Solidor mounted on the club's walls. She punctuated her musical sets with dramatic renderings of verses composed by her "poet friends." Between love songs conceived in the realist tradition and nostalgic songs of the sea, she recited poems by Paul Valéry, Maurice Magre, Francis Carco, Paul Fort, but especially Cocteau. The audience, charmed by the versatility of this déclassé performer, hung on her every word as she segued from poem to poem and then, perhaps, to a musical adaptation of a verse penned by Paul Verlaine or Jacques Prévert that had been tailored to her voice and style by one of her several popular composers.[59] The effect on clients, who had the impression that Solidor was speaking to and about each of them personally, was by all reports spellbinding.

No one balked when Solidor spoke or sang torchy verses addressed to women—texts customarily interpreted by men, like "Fin voilier," in which she compared "the gorgeous body of my blond" to "a beautiful ship" that she governed.[60] While Solidor visibly relished such instances of textual inversion, the majority of the songs and poems she performed were open to more than one interpretation. By modulating the repertoire and the delivery with subtlety and intelligence, Solidor created a stage persona that was at once intensely seductive and entirely mercurial. And she never stepped out of character (or, more accurately, out of characters).

It is fitting that the portraits for which Solidor posed represent the performer in so many different roles. Dunand lends luster to the star, preening her best profile and professional smile in the spotlight. Foujita pictures an "ingénue libertine," fixed in the worshipping gaze of her dog and decked out like a character from the writings of Colette. Most of the portraits in this collection sexualize the sitter in one way or another. Beltram Y Masses aptly portrays Solidor herself as a collection—arranging, in a

piano-top display, a framed photograph of the performer's face, a pair of elbow-length black gloves, a smoking cigarette balanced on the edge of an ashtray, and the sheet music to the theme song "Ouvre." Man Ray's nude studies rake the amazonian musculature of Solidor's torso with avid highlights and voluptuous shadows, a tenebristic effect he pushes further in some prints by solarizing the body's contours. Lydis pictures Solidor, languorous and prone, barely clothed, head thrown back and eyes closed.

In the late 1930s, "la femme la plus portraiturée de Paris" published an illustrated catalogue of these likenesses.[61] Autographed copies of *Quarante Peintres, un modèle* were available for purchase at the bar.[62] Solidor prefaced the souvenir catalogue with words of praise solicited from (male) members of her entourage. Here, Joseph Kessel, author à la mode and editor of the magazine *Confessions*, recorded his impressions of the portraits on display in La Vie Parisienne. "From the walls forty faces that inspired forty artists of different races from every country watch her," he recounts. "Forty faces, all in her likeness, confront the real, the living subject who at once resembles them and defies them."[63] Solidor herself described the environment of the nightclub as one in which, at every turn, she caught her own reflection in "a series of distorting mirrors." In order to stave off a sense of alienation, she continued, "I force myself to resemble my latest portrait."[64]

Solidor's "act" owed its dynamism, in part, to the way she played with, against, and to this gallery of likenesses. The gallery was not merely a material record of a star's narcissism, although this dismissal undoubtedly satisfied her detractors. "When I look at the portraits," the sitter claimed, "it isn't my own image that I see; it's all of the artists: once again I see Kisling, once again I see Foujita, all my friends."[65] For Solidor, the portraits appear to have constituted a kind of audience incorporating both her own (externalized) self-regard and the appraisal of an elite and sympathetic artistic public—a public captivated by an ever-changing image, the evasive object of desire.

In *Quarante Peintres, un modèle*, Cocteau described the charismatic performer as she leaned back against the piano to draw from deep within "a voice that comes out of the most intimate zones of her being," a voice that "issues from her sex."[66] Yet, listening to her sing, audiences must have asked, "Which sex?" Solidor's voice ranged without apparent strain from the alto to the soprano registers. Playing up this ambiguity, Solidor interpreted songs such as "Partir avant le jour," a duet in which the part

of the male vocalist soared an octave above Solidor's.[67] This crossing of vocal registers reiterated the conceit of travesty (that is, the fluidity of roles) that distinguished Solidor's act.

In keeping with her pirate (or pirated) heritage, Solidor's nightclub routine revolved around a repertoire of erotically suggestive ballads about the sea, its vessels, its victims, its rewards, and its pleasures. An oil portrait painted in the 1930s by Jacques-Henri Lartigue depicts the broad-shouldered chanteuse steadying herself against the edge of her piano to hit the metered notes of a chanty, braced as if against the gunwales of a ship in rough seas (fig. 48). The iconographic incongruities here—the performer's form-fitting evening gown and the tall-ship mise-en-scène—would probably not have jarred habitués of La Vie Parisienne. The vogue for sea chanties was, after all, the very essence of urban sophistication at that time. What is more, Solidor had inherited a sector of her audience from Yvonne George, who launched the maritime vogue from the music-hall stage in the 1920s. Her premature death in 1930 left admirers, among them Cocteau, bereft.[68] The sea chanties that made a name for George, like those performed by Solidor, in no way contributed to the revival of a folk art form. They were contemporary creations, designed to appeal to a very modern appetite for "primitive" authenticity. With respect to Solidor's cover of George's theme song, "Nous irons à Valparaiso," one music critic noted: "It is not only a moving rendition, it is also a 'test' that allows us to appreciate the artificiality, the 'chique' of the false sea chanties now in vogue that Mme Suzy Solidor incarnates with, what is more, incontestable talent, a genre that is deplorable in its falsity."[69] Navigating the poles of European modernity, from the cult of the past to the cult of progress, Solidor appropriated as her own a market niche that George had created. She finessed, with her usual aplomb, the apparently contradictory demands of a sophisticated audience—the demand for tradition and novelty, rusticity and urbanity. "I spend my vacations aboard a sailing ship," she would say, as if it were true, "where I prepare my songs in an authentic atmosphere. When I return to the city . . . my work at the cabaret engulfs me. The cinema, too, now . . . I developed a taste for cinema with La Garçonne. In my second film [Figure de proue], I will be playing the role of a woman plying the waves alone across the ocean. Always the ocean."[70] The sea was the constant that made Solidor's act in all its many aspects—the musical repertoire, the memoirs, the literature, the interviews—cohere. The same can be said of the portrait collection; most of the portraits make at least passing reference to the sea—an

anchor, a seashell, a flash of blue in the background, a tall ship on the horizon.

In a caricature titled "La Vedette et sa cour," one of the many featuring Solidor published in the mid-1930s,[71] the artist has sketched a watery horizon across the assortment of objects that constitute the performer's visual framework (fig. 49). This device creates a liaison among the various paintings hanging on the nightclub wall while communicating the salty atmosphere that Solidor generated. In reality, as in this cartoon, the overarching motif of the sea links the disparate objects of the portrait collection—and the many faces of the sitter—together in a relation of kinship. While assuring a certain continuity (the eternal sea), the trope also evokes Solidor's mercuriality (the ever-changing sea). Indeed, the slipperiness of this trope—powerful yet feminine—allowed her to "go overboard" on stage and in her personal life without running the risk of "sinking her own ship."

Beyond the bounds of Solidor's club, maritime themes remained apparent on the interwar entertainment horizon in the wake of George's passing.

Fig. 48. Jacques-Henri Lartigue, *Suzy Solidor*, 1930s, reproduced in *Quarante Peintres, un modèle*.

Solidor's relationship to the genre, though, was unique. While rivals like Damia and Fréhel sang of sailors' girls left grieving on the shore and parlayed feminine narratives of star-crossed love into box office receipts, Solidor—with theme songs such as "N'Espère pas" (1936), "Le Fin Voilier" (1936), and "Partir avant le jour" (1938)—often personified, instead, the free-spirited sailor whose heart refuses to be tethered. She held her chin high and delivered refrains such as this one, from "N'Espère pas":

Do not hope to tie me to your banks,
My boat drifts freely with the stream,
As I pursue, where no one dares to land,
A mirage, a sailor's dream.[72]

Solidor's memoirs, her roles in film and theater (she sang "La Fiancée du pirate" in a 1937 production of Brecht's *Beggar's Opera*), her portraiture, like her nightclub repertoire, all reclaimed for the performer the liberties associated with a seafaring life. This was also true of her 1940 novel *Fil d'or*, the story of a "pirate's child" who evades her enemies, "the hateful

LA VEDETTE ET SA COUR

Fig. 49. "La Vedette et sa cour," 1930s.

masses that condemn all that is unfamiliar to them, who would stone you and bring you to your knees."[73] The voice of the narrator, the protagonist (a "young sailor with a woman's heart"), and the author converge here in a way that troubles the distinction between fact and fiction. This novel aspires, on a more popular register, to the self-mythologizing effects achieved by its more literary stepsisters—contemporary novels such as Colette's *Le Pur et l'impur* and Barnes's *Nightwood*, for instance.

Commenting on the personage that Solidor so persuasively projected in her fiction, her portraiture, her encounters with the press, and her nightclub routine, Albert T'Serstevens, a maritime novelist himself,[74] observed that the chanteuse, with her salty, androgynous appeal, seemed to be "made for singing these sea chanties, with their nostalgia of far-off places, with their odor of iodine, of spume and of becalmed depths. She makes me think, not of a woman, but of a young sailor of Saint-Malo whose eyes rhyme with the blue of the sea, and whose long thin face expresses the lyricism of his voyages."[75] Solidor's changeling voice, her changeling body—more than once portrayed as that of a monstrous yet seductive creature of the sea (mermaid, siren, sea nymph, sea goddess)— riveted the public's attention and provoked a devotion approaching addiction in her followers—male or female, homosexual or heterosexual.

A portrait by the Venezuelan artist Andrade, reproduced in one of Solidor's souvenir catalogues, pictures her as a mermaid—a hybrid creature, half fish, half woman, who is never completely in nor completely out of her element (fig. 50). Solidor's blond head takes the sun setting on a watery horizon as its halo, while her somewhat repulsive scaled body disappears into the sea's dark and mysterious depths. "On ne peut pas reprocher à un poisson de ne pas être un oiseau," Solidor complained in her confessions, although she herself claimed to be neither one nor the other.[76] The lamé gown that clung to her mermaid's body, glinting like fish scales in the nightclub lights, belied the husky voice that, each night, regaled audiences with tales of the sailor's life told in the first person.

The indeterminacy and fluidity that Solidor affected gave her a degree of leeway exceptional for a French woman of her era—especially a woman of her provincial, working-class origins. Indeterminacy was certainly the key to the sexual freedom she exercised: her affairs with men "excused" her lesbianism, and her lesbianism both enhanced her appeal to men and explained her reluctance to marry one of them. "How could I be held responsible," she asks rhetorically in her confessions, "for a confusion that throws me one day upon the protective shoulder of a man and

the next day compels me to embrace, against my forever sterile thighs, and to caress and to sooth, a young and vulnerable creature who could as easily be my daughter as my lover?"[77] At the same time, this neither-fish-nor-fowl model of feminine sexuality—since it was bracketed by the frames of the portrait gallery and set off as "staged" within the performance venue—posed little threat to real-world value systems based on unequal power relations between men and women. Neither did the liberties that Solidor took with the codes of sexual identity position her as a partisan within the debates about gender relations that raged on throughout the interwar period.

If anything, the pan-eroticism that Solidor generated in her routine (on and off stage) uncritically reiterated the class-inflected vision of feminine

Fig. 50. Andrade, *Suzy Solidor*, 1930s, reproduced in *Deux Cents Peintures, un modèle.*

sexuality that informed nineteenth-century literary classics of the realist tradition, such as Zola's 1880 novel *Nana*. Zola's prototypical demi-mondaine Nana, her degenerate appetites and her excesses, crystallized modern stereotypes about female sexuality that continued to reverberate in the literature of sociology, psychology, and criminology well beyond the fin de siècle. The character Nana seems to prefigure the case studies informing works like Bernard Talmey's *Woman*, which showed how sexual contact between members of the weaker sex (and lower class) extended naturally from uncontainable autoerotic impulses. Taking erotic pleasure in herself or in another woman represented, under such circumstances, essentially the same socially meaningless gesture. "While homosexuality has been made a crime in men," Talmey explained, "it has been considered as no offense in women" for this reason.[78] Otto Weininger, in his much-touted treatise *Sex and Character*, describes femininity, similarly, as undifferentiated—and therefore uncontainable. Woman, he writes, exists in "a condition of fusion with all the human beings she knows, even when she is alone. . . . Women have no definite individual limits."[79]

The metaphor of the sea (*la mer*, which, with each utterance evokes its homonym, *la mère*) naturalizes this image of unbounded femininity, a metaphor that Solidor exploited to the fullest. Aptly, several of her portraitists painted Solidor as a figure born of and borne up by the sea. In Jean-Dominique van Caulaert's painting, for instance, Solidor's shimmering gown, her eyes, the sky, the ocean waves from which her body emerges and into which it dissolves, share the same tonal range and texture. To a large extent it was the figure of the sea—leitmotif of Solidor's musical repertoire, her portrait iconography, and her personal mythology—that negotiated the celebrity's safe passage as both a "loose woman" and a "free woman" (a woman without boundaries, a woman out of bounds). Even more specifically, Solidor's identification with the sea's denizens (pirates, sailors, sirens, mermaids) glossed her sexual ambiguity in culturally acceptable ways. Solidor barely raised eyebrows when she signed letters to friends "votre amiral breton" or appeared on the boardwalk in Deauville, and in the society pages of the press, decked out in a sailor's suit or pirate's costume. Here, once again, the "lesbianization" of the already (homo)sexually nuanced mode—in this case, the maritime mode—enabled a lesbian artist to inscribe herself within already established traditions of sexual marginality (as Brooks had done with the dandy-aesthete and Cahun and Moore with their send-up of Flandrin's nude study).

The sailor's success as a feature of male homosexual culture was an

established fact well before Solidor made her début on Paris's club scene. Sailors already had a penchant for "the most liberal notions of morality," to paraphrase Herman Melville, thanks in part to the vividness of accounts produced by the authors of best-selling fiction.[80] In the popular imagination, a sailor's sexuality is never firmly moored. This fluidity invests the sailor trope with the ability to catalyze alternative readings within a given narrative context or viewing community. Not surprisingly, Solidor's marine themes captured the fancy of sectors of the public whose viewpoints and tastes otherwise diverged, particularly with respect to sexual matters.

The mobilizations and demobilizations associated with the 1914–1918 war had accelerated the elevation of the sailor to cult status within European sexual subcultures. Edouard Roditi, a poet, literary critic, and aficionado of Paris's homosexual nightlife recalled:

> French pederasts of this era (at least those who were not in the closet), displayed an almost patriotic attraction to uniforms. . . . Cocteau and his milieu were probably responsible in part for this vogue for sailors and the red pompom. . . . In Paris, there were even meeting places for such special tastes: in the dance halls of the rue de Lappe, for instance, sailors on leave were often relatively numerous; I went there for the first time with the great American poet Hart Crane, who was drunk and wanted to cruise for sailors.[81]

Cocteau, whom Solidor counted among her hundreds of closest friends, routinely descended upon the waterfront hotels of Toulon to cruise. The verb *to cruise* itself demonstrates the extent to which homosexual and maritime practices overlapped. In his memoir *Professional Secrets*, Cocteau recounts, "From all over the world, men who have lost their hearts to masculine beauty come to Toulon to marvel at the sailors lounging around the town alone or in groups, answering stares with smiles and never refusing propositions."[82] In Cocteau's eyes, the sailor's costume served to eroticize the male body—its tailoring molding the buttocks, biceps, deltoids, and pectorals. The bell-bottom cut of the pants allowed sailors "to roll their trousers up around the thighs,"[83] and the drop fly framed the sailor's groin.

Solidor's gay male devotés, spearheaded by Cocteau, homoeroticized the lyrics of her 1938 hit "Escale"—a poetic account of a one-night stand with a handsome sailor. The "open window" evoked in the song's refrain

became even more explicitly erotic: the modified lyrics bid the sailor to open his *braguette* (the button-up flap providing access to his groin) rather than his *fenêtre* (window).[84] Whistling the tune of Solidor's "Escale" was understood in male homosexual circles as a kind of musical wink: a wink of recognition and of proposition.

The Ballets Russes, one of the most influential cultural enterprises of the early twentieth century (and an enclave for gay male performers and artists—among them, Cocteau), exploited the ambiguities of maritime themes and motifs on a grand scale. The sailor—thanks to a long-standing hornpipe tradition in the seafaring sector—provided a credible pretext for the display of male virtuosity, and the Ballets Russes produced two hugely successful tributes to sailors, *Les Matelots* and *The Triumph of Neptune*, in the 1920s. These ballets, which received ovations from both gay and straight audiences in Paris and in London, embroidered upon vaudevillian romantic farce formulas while glossing them in a gay-affirmative manner.[85] On the other side of the footlights, Serge Lifar, the ballet's premier dancer, appeared in his sailor costume at high society parties and posed for the press with influential public figures—including, of course, Solidor. Displays of ballet-related art in theater lobbies (Pedro Pruna's portrait of Lifar clad only in his briefs and a sailor cap, for instance), deluxe souvenir programs, limited edition fine-art albums, illustrated synopses, and carefully orchestrated gallery exhibitions reverberated with the nautical themes of the ballet programs that so appealed to the company's gay following. This following, while striking a distinctive subcultural stance, was also thoroughly integrated into every sector of the wider ballet-going public—*le tout Paris, le gratin*, the cosmopolitan artistic vanguard, the intellectual elite—a public that constituted Solidor's clientele as well.

It seems clear that Solidor, who launched her entertainment career in 1932, adopted a performance mode and set of motifs whose popularity had long since crested a decade earlier in elite cultural arenas such as the ballet theater. The maritime chic of the 1920s had become the 1930s maritime cliché, permeating middle-class consumer culture. During the summer months, the rude quays of Toulon, Marseille, Villefranche, and Brest became holiday promenades "avidly frequented by snobs who came looking for the indispensable invitation to adventure."[86] From Montparnasse to Montmartre, sailor bars (*boites à matelots*) re-created the exotic dockside ambiance of these tourist destinations by means of maritime decorative schemes and sailor-suited "orchestras of accordionists recruited from

Toulon."[87] The public clambered after watercolors and prints representing "with vigor and without vain sensitivity, sailors in their low-life hangouts."[88] What with the influx of *chansons de marin,* maritime fashions, maritime decorative schemes, swashbuckler movies (for example, Douglas Fairbanks, *Le Pirate noir,* 1926), and pulp publications vaunting the high seas (T'Serstevens, *Les Corsaires du roi,* or *The Memoirs of a Buccaneer;* Pierre Loti, *Le Matelot* and *Mon Frère Yves;* Henry de Montfreid, *Les Secrets de la mer Rouge* and *Aventures de mer*), the market niche had nearly reached the point of saturation by the time Solidor emerged on the entertainment scene with her maritime routines.

Why, then, would Solidor have invested so heavily in a flagging theatrical conceit? Why—by inscribing herself in the lineage of Surcouf, aristocrat of pirates, among many other gambits—did she aspire to make this overexploited genre her own? Apparently the maritime offered Solidor a pretext like no other for turning both the rude conditions of her birth and her sophisticated adult proclivities to professional advantage. The lyrics of Solidor's songs, the plotlines of her books, and the outfits fashioned after the sailor's uniform or the swashbuckler's costume that she occasionally modeled in her off-stage hours wove the story of her childhood in Saint-Malo, her debut in Deauville, and her performance career in Paris into a romantic narrative. The lyrics of songs like those of "La Chanson de la belle pirate" ("Abandoning my women's robes / I embarked upon a sailing boat / And made an oath under the moon / To be a soldier of fortune")[89] contributed to the image of audacity and abandon that Solidor cultivated. Acting out the soldier of fortune in vamp's clothing, Solidor enacted an ambiguity that afforded her the leeway she needed to preserve a degree of autonomy within the still restrictive social environment of 1930s Paris. Several of the portraits hanging in the club evoked the harsh environment that Solidor managed to dominate: Jincart's painting of Solidor at the helm of a ship, for instance; or a drawing by Laprade, reproduced in the same souvenir catalogue, in which she appears decked out in foul weather gear, braving the hostile elements. The author of neither the works of art with which she surrounded herself nor the songs and poems that she interpreted in their midst, Solidor made, out of this requisitioned material, a fortune—a destiny, that is, and the where with all to enjoy it.

In Paris during the 1930s, Solidor brought lesbianism out of the rarefied environment of the salons frequented by Brooks and hosted by Barney, out of the vanguard movements to which Cahun and Moore adhered,

and into the brightly lit and highly commercial world of popular culture. While Brooks measured success by the extent to which she and her work remained misunderstood, and Cahun and Moore embraced marginality as a form of protest, Solidor sought the spotlight—and thrived in it. I have argued that Brooks, in her portraiture, related lesbianism to genius, and that Cahun and Moore visualized the revolutionary potential of same-sex desire. Solidor represents a more worldly position, recognizing the capital advantages of acting sexually ambiguous on the entertainment scene. The performer's collection of original art works—portraits rendered from every angle—stretched the parameters of her erotic appeal, reified the gender, class, and sexual mobility to which she aspired, and substantiated her status as a celebrity.

Conclusion

Ils durent, en fin de compte, nous condamner sans croire à notre existence . . . comme à regret.

—Claude Cahun,
"Le Muet dans la mêlée"

This story began in Paris with the Great War of 1914–1918. Twentieth-century warfare, with its industrial efficiency, broke faith with the Enlightenment's promise of progress and made the creation of new systems of social engagement—or the resurrection of archaic ones—seem urgent. Representational systems, gender systems, class systems, political systems all hung in the balance. Politicians demanded change or promised restoration. In Paris, no fewer than twenty cabinets formed and crumbled between 1918 and 1939, the dates that bracket this investigation. The subjects of my case studies experienced these decades as a time of intense creativity. They participated in the post-war reconstruction of Western culture in a highly motivated ways, each according to her own imperatives. Collectively, they revolutionized the politics of (self) representation, as lesbianism—conceived as a social, sexual, and cultural identity—came to the fore in the images that they projected of themselves.

By the time that war broke out in Europe for the second time in the twentieth century, this identificatory emphasis had lost currency. From France, Barney reported by letter on the dissolution of her milieu—on Brooks, who sat alone in Nice "surrounded by all the portraits she did of notre belle époque," on the disappearance of cultural icons like Stein and Cocteau. With each death that "cuts us down," Djuna Barnes responded

from New York, " . . . our legendary time is being calendared."[1] The society of visible and vocal homosexuals that had earned recognition in Paris during the interwar years grew ghostly silent during the Occupation and reconstruction period. Its members were aging, tiring, and no new blood revitalized Barney's salon. The post–World War I drive for emancipation —on professional, sexual, cultural, economic, and political fronts—imploded, under enormous social and political pressure, into the insistence of a hearty few upon transgressive, if largely depoliticized, lesbian "lifestyles." Lesbianism as a form of cultural and/or political activism would not resurge anew until the 1970s. By then, even in Paris, most of the women I have discussed here were, if not dead, then long forgotten.[2] Yet the iconography of modern womanhood that lesbians of the interwar era had helped to codify (to conventionalize, that is, and to normalize) survived. In the interim, this iconography had devolved, however, into a very different kind of code—an encoded language, a cryptography.

Although my individual case studies conclude with the advent of the Second World War, this epilogue provides an opportunity to consider revelatory events beyond the historical scope of the book's chapters. It not only permits me to track Romaine Brooks, Claude Cahun, Marcel Moore, and Suzy Solidor after the outbreak of the war to determine which of their self-representational practices survived beyond (or were modified by) this turning point; it also enables me to evoke the dissolution of what I refer to in this volume's title as "lesbian Paris," bringing to light the volatility and fragility of nondominant communities more generally.

If, as Monnier claimed, women coming into their own during the 1914–1918 conflict were "blessed by the terrible goddess of war," I am tempted to suggest that the same goddess cursed them two decades later. It would be simplistic, though, to blame the destruction of the fruitful sexual and artistic alliances loosely described here as lesbian Paris on the Second World War. In fact, oppositional communities of every sort—buffeted by internal divisions (political discord, cultural and aesthetic rifts, professional and sexual rivalries), pressured by economic crises, and targeted by social and political campaigns (the pro-natalist manifestations that periodically blocked the streets of downtown Paris, for instance)— began to unravel well before France and England declared war against Germany on 3 September 1939.

Cahun and Moore, for example, packed up their affairs and moved from Paris to the Isle of Jersey in 1937. Since the German invasion of France may not have seemed inevitable at this early date, one can only

speculate as to their motives. Their disillusionment with the political climate in the capital surely influenced the decision to expatriate. The outbreaks of anti-Semitism, the swelling ranks of right-wing factions such as the Croix de Feu, the electoral and administrative frustrations of the Front Populaire, and the violent schisms that divided their circle of surrealist friends and the Association des Ecrivains et Artistes Révolutionnaires to which they adhered undoubtedly contributed to the couple's estrangement from the city they loved. Brooks too had abandoned Paris well before France came under siege. She spent most of her time between 1932 and 1938 in New York coping with the effects of the 1929 stock market crash on her inherited financial holdings. Other key members of the Paris expatriate community also returned to the States well in advance of the hostilities—among them Berenice Abbott and Djuna Barnes. In 1929 Abbott abandoned the edgy portrait practice that had made her reputation in Paris to produce a photographic record of "Changing New York" under the auspices of the Federal Art Project. Barnes, whose thematically lesbian literature of 1920s and 1930s Paris marked the highpoint of her creative career, burrowed into Manhattan's West Village and lowered her lesbian profile. She refused to include *Ladies Almanack*, for instance, in the collected works that she prepared for publication, lest this lusty parable cast a "salacious" pall upon her literary legacy.

For Paris's nascent lesbian society, the Second World War came as a coup de grâce. The conflict razed the earth upon which Paris-Lesbos had been founded and left behind no grounds for reconstruction.[3] Expatriates, Jews, artists, sexual deviants, and radicals repatriated, went into exile, or went underground, losing touch with each other for years. Gertrude Stein and Alice Toklas, for example, took refuge in eastern France, in a remote area called Le Bugey whose regional fare Toklas memorialized in the cook book she partly composed there. Stein and Toklas survived the war thanks to the good offices of a collaborator named Bernard Faÿ, a wealthy Royalist Catholic who had been named director of the Bibliothèque Nationale by the German administration in 1940 (replacing a Jew) and who served as personal advisor to Pétain throughout the Occupation.[4]

Brooks, whose writings from this period share with those of Stein and Toklas an astonishing detachment, spent what she described as the "war interlude" in a villa "on a hill of Florence," where she remained for the duration, in the company of Barney, under the protection of Mussolini's regime. She did not conceal her admiration for Italy's dictator, whom she described as lifting "the mind to those epic tales which are now to be

enriched by the reality of today." Like many of the exiled aristocrats holed up in surrounding villas, Brooks claimed allegiance to no country but to her privileged class. Throughout the conflict, she and Barney put their villa and staff at the disposal of various displaced citizens of Europe's ruling class. For instance, they took one neighbor's "very valuable Oriental carpets" under their care "in order to save them should the Americans arrive with the Communists in their wake." Brooks's memoirs reveal much about the politics of this dispossessed population. "We have been hiding our trunks and boxes [of valuables] in all possible places though from whom or from what no one knows precisely." The members of this elite community feared the Germans, the Partigiani, the Allies, but most of all they feared the Bolsheviks, who were "menacing France, menacing all Europe." As to their attitude about the Free French, they suspected that De Gaulle, "a friend of Stalin," was "directing the Communist movement in Africa" while waiting for his chance "to enter and Bolshevize France." Nevertheless, Brooks considered herself nonpartisan, pan-European, above the political fray, exceptional. "No artist stands for war," she proclaimed. On hearing a rumor that the Villa d'Este at Tivoli had been destroyed, she asked, showing her hand, "Are all the old palaces and monuments [in] the world to be destroyed by this war? Palaces and monuments created in those times when Aryan geniuses, like giants, led the way."[5]

In stark contrast to Brooks and Barney, Cahun and Moore continued to combat the forces of fascism just as they and their surrealist comrades had in Paris. They refused to retreat to England (with half of Jersey's population) when the German Army invaded the island in 1940. On the contrary, they launched a two-woman, anti-Nazi propaganda operation and, after four years of conducting successful covert actions, were apprehended and condemned to death. Cahun's memoir from this period recounts:

> The Gestapo searched four years in vain. If we lived prepared for any inquisition, however sudden, they never believed, despite their informers, that we could be the ones they were looking for. Even with proof in hand, they didn't believe their eyes. They remained convinced that we could only be co-conspirators, accomplices to . . . X. In order to get them to stop interrogating us on the subject of our hypothetical affiliations with . . . X, or with the Intelligence Service (!!!), we had to demonstrate to them that we were completely conscious and capable of our "crimes." A little patience—on both sides—was necessary. . . . Noting that we were women, those

inferior beings . . . ; that we had the reputation on Jersey of peace-able *bourgeoises*; that it was impossible to pass us off . . . for "terrorists"; that, at the time of our arrest and throughout our interrogation, we maintained a cold hostility, devoid of any sign of emotional violence . . . they lost their "Aryan" bearings: our "idealism" couldn't be rec-onciled with their cynical conception of humanity. It taunted what re-mained, despite everything, of their psychological curiosity. . . . They were forced, at the end of the day, to condemn us without be-lieving in our existence. In a manner of speaking. As if with regret.[6]

Moore discussed their ordeal in an interview with a Jersey journalist just after the liberation of the island, and the couple's release from prison, in May of 1945. "We were sentenced [to death] for 'Propaganda undermin-ing the morale of the German Forces.' Then we were sentenced to six years' penal servitude for listening to the B.B.C. and to six months for having arms and a camera," she explained. "My sister asked if we did the six years and six months first, and the judge gravely remarked, 'No, the death sentence cancels that.'"[7] In prison, awaiting deportation, they each attempted suicide to cheat their captors of the option to deliver the death blow. Thanks to an appeal by the island's bailiff, the death sentence had been converted—but the conspiratorial "sisters" spent nearly a year in solitary confinement.

In the meantime, their seaside home was commandeered and system-atically ransacked by the German military police. They brutalized the gilded plaster head that the sculptor Channa Orloff had made in Cahun's likeness, smashing the distinctive Semitic profile. They destroyed the cou-ple's "degenerate" books and photographs. "Quite a few negatives have survived," Cahun wrote after the war. "We had so many that they gave up on destroying them . . . but I've never had the time or the courage to verify exactly what remains—knowing that my favorites are lost."[8] This Gestapo campaign of eradication links Cahun and Moore's artistic prac-tices, their social/sexual relations, and their acts of political resistance under the unifying charge of sedition.

Back in Paris, Solidor followed a completely different path during the Occupation—the path of *least* resistance. She remained at the center of Paris nightlife, entertaining German officers and sheltering the occasional English spy—without discrimination. "Receiving the client, that's my business!" she exclaimed at hearings during the post-war purge.[9] During the Occupation, however, as in the pre-war era, Solidor's chameleonlike

capacity for adaptation, her fundamental ambivalence, assured her survival. Nothing illustrates this point more effectively than the story of the performer's interpretation, in 1942, of "Lili Marlène," the French version of the anthem adopted by the German troops during World War I. Not only did she feature the number in her nightclub routine "at a time when Lily incarnated the figure of the spy,"[10] but she also broadcast "Lili Marlène" over the airwaves of Radio-Paris (Radio-Allemand, as it was unofficially known) and profited handsomely from a hit recording. During the hearings held by the Commission Gouvernementale d'Epuration in 1945–1946, Solidor defended herself against accusations of collaboration, pointing out that Goebbels himself had judged the song "defeatist" and that her "good friend" Marlene Dietrich, well known for her anti-Nazi sentiments, had recorded a version of the ballad in English for the benefit of the American GIs. "[I believed] it was the hymn of the American army," Solidor insisted in an interview.[11] Despite interventions on her behalf by high-ranking connections—including an English diplomat, a prince, a number of fellow entertainers, and at least two members of the Resistance—the commission ultimately imposed sanctions. They condemned, above all, her complicity with Radio-Paris, which broadcast her rendition of "Lili Marlène" as well as an anti-English number, "Le 31 du mois d'août," with the refrain "Et merde pour la reine d'Angleterre / Qui nous a déclaré la guerre."[12] For putting her name and her celebrity in the service of the German propaganda machine, Solidor was banned from recording or performing in France for one year and forbidden to operate a business in her name for five years.[13] Drawing on her considerable promotional skills, she launched a counterpropaganda campaign in the press, but the stigma of collaboration clung to her. She sold her cabaret to Colette Mars and set out on a tour of America, as Jacques Robert reported in his *Paris Matin* story, "Avec cent quinze tableaux et un chien né d'un lion et d'une chèvre, Suzy Solidor va faire le tour du monde." In New York and Montreal, she made new conquests and gave her clientele in Paris five years to forget that during the war La Vie Parisienne had become "La Vie Hitlérienne."[14]

What these individual stories reveal collectively and comparatively about the convergence of lesbian culture, feminism, and visual culture in early twentieth-century Paris amounts to more than the sum of the parts. Although this book's case-study approach in no way compromises the distinctive character of each subject's career, it accommodates more fully

than a monographic or survey format could my own ambitions as a historian of visual culture. These ambitions include the introduction of sexual identity as a focus for the investigation of cultural (especially visual) artifacts produced in a period and place—Paris of the 1920s and 1930s— where patriarchy appeared to be alternately losing and desperately tightening its grip. The effect of this pulsation was one of disarray—and of enormous vitality. Under such circumstances, alternatives to patriarchal schemas of creativity, productivity, and social utility seemed imaginable. Art, particularly portraiture, provided an experimental arena in which the imaginable approached the practicable. This is significant to the extent that, as Michael Ann Holly has argued, "the work of art . . . does not have its origin in the 'real thing'—quite the reverse. The material thing in the world has its origin—*only comes into its own*—in its visual representation."[15] What interests me particularly for the purposes of this study is the relationship (and nonequivalence) between the stable notion of origins and the more dynamic notion of coming into being, which implies both becoming and continuing to evolve. With this in mind, I have viewed one of art history's most traditional objects of investigation—portraiture—from postmodern and lesbian-feminist perspectives, focusing especially on the ways in which gender and sexual identity "come into their own" in and through representation.

I have, in addition, widened the angle of vision to consider portraiture within a broad representational field that includes period theories of sexuality as well as popular culture representations of gendered and sexual identity. What has this approach enabled me to discover that traditional monographical, biographical, stylistic, nationalistic, or even social-historical perspectives do not reveal? For one thing, it throws into relief a whole population of culturally and sexually active women upon a terrain, Paris of the 1920s and 1930s, that men—those whose names spring to mind in association with Paris modernism—once appeared to dominate. One could argue, justifiably, that having chosen to focus on acts of self-representation by women, I inevitably looked for (and therefore found) a historical panorama in which women enjoyed preeminence. Yet my choice of case studies, in general if not in particular, was foreordained by earlier choices —personal, political, and practical—that bear more directly on method.

For example, what I learned by thumbing through bins of theater programs, illustrated magazines, postcards, sheet music, fashion plates, advice books, and popular novels at Paris's flea markets differs radically from what I learned by conducting research in the institutional archives that

house cultural artifacts deemed more worthy of preservation. Unlike institutional archives—whose constitution and indexing typically reinforces the legitimacy of the dominant culture—popular culture may be viewed as an archive of unofficial and illegitimate histories. If we accept the premise that institutionalized culture is paradigmatically male (and officially straight), then popular culture seems a promising place to look for evidence of something else—in this case something female, something lesbian, something that the patriarchy would labor to displace or suppress.

By foregrounding images, what is more, I alter the body of knowledge that has been fleshed out by more textually oriented historical research in at least one significant way: I show how lesbian Paris looked. You may wonder why I consider this important. After all, "lesbian Paris," however intriguing to me personally, remains at most a constellation of marginalized (and largely mythical) communities. However, knowing how lesbian Paris looked allows us to look again at familiar literary texts, visual artifacts, material culture, and historical documents with a different archive of images in mind—and thus to rediscover the strangeness of Paris modernism.[16] What is more, the question of how lesbians looked to, at, and for each other—how they envisioned and represented themselves in 1920s and 1930s Paris—achieves broader significance to the extent that lesbians effected critical embodiments of twentieth-century womanhood. Becoming "modern women," they acted out the tensions and contradictions that animated Western modernity as a whole. The history of lesbians, in other words, is not *just* the history of lesbians—any more than "women's history" pertains exclusively to women. These histories relate inextricably to the systems that shaped them, which they in turn impact. The same can be said of the art produced by women and lesbians.

"To make art is to signal belonging, as much as difference," Anne Wagner has proven in *Three Artists (Three Women)*.[17] Paradoxically, to signal difference (in the case of Paris lesbians, in terms of both gender and sexual identity) is to acknowledge—and thus tacitly validate—the assumptions and values underlying the notion of sameness. "Different from what?" we are forced to ask. Belonging, of course, is also tricky—in that it requires assimilation to existing models. However, by re-purposing these models (via pastiche, collage, deconstructive appropriation, or collective effect), the artists introduced in *Women Together/Women Apart* visualized a place for alternatives within an overall cultural context that included, but also exceeded, their subcultural niches. If both options, belonging and differentiation, pose irresolvable referential dilemmas, they may nevertheless

provide enough leverage to shift "the frame of reference of visibility" by exposing the mechanisms of reduction and erasure within our interlocking systems of social, political, and visual-cultural representation.[18] We have seen how Brooks, for one, used self-portraiture to distinguish herself from other women (in particular women artists) by forging identifications with the interpenetrating echelons of aesthetes and elite male homosexuals. At the same time, her larger portrait project also contributed to the consolidation of a distinctive group identity among her lesbian peers. Paying attention to strategies of belonging as well as those of differentiation enables us to perceive patterns of interaction and identification among Paris lesbians, between lesbians and gay men, between these sexual subcultures and the larger cultural context, that would not be noticeable if the focus were difference, or distinctiveness, alone.

That the identifications embraced and rejected by Brooks, Cahun, Moore, and Solidor were consistent with their political positions as well as their artistic ambitions requires, I hope, no further demonstration. Brooks, whose portraits construct a lesbian canon, entertained Nietzschean ideas about a superrace of geniuses and clung to her class privilege. Cahun and Moore's practices, from art to love, resisted to the very end the politics of dominance and submission. The kaleidoscope of images projected by Solidor warded off the consequences of her acts while working to her social and financial advantage. All four artists used portraiture in ways that demonstrated their grasp of the genre's classifying logic. They realized that to challenge this logic, or to reinvest in it, was necessarily to make political as well as representational choices.

Representational choices may not change the determinate realities of the past, but they affect the way we view these givens and the way we live them out. Seeing Brooks's 1923 self-portrait hanging in the Smithsonian in 1971, for instance, expanded my horizons by legitimating an option that I had not previously perceived as "real." Representational choices, I found, have the power to open multiple possible futures. Whether any of the futures that Paris lesbians of the interwar era envisioned ever came to pass, or if only partially or in unimagined ways, seems less pertinent to me than the example that these visions set for the exercise of agency and choice in the here and now.

NOTES

INTRODUCTION

The epigraph comes from Charlotte Wolff, *Love Between Women* (New York: St. Martin's, 1971), 82.

1. Eve Kosofsky Sedgwick, in *Epistemology of the Closet*, historicizes the closet, observing that "even the phrase 'the closet' as a publicly intelligible signifier for gay-related epistemological issues is made available . . . only by the difference made by the post-Stonewall gay politics oriented around coming *out* of the closet." Eve Kosofsky Sedgwick, *Epistemology of the Closet* (Berkeley and Los Angeles: University of California Press, 1990), 14.

2. Albert Flament, cited in Blandine Chavanne and Bruno Gaudichon, eds., *Romaine Brooks* (Poitiers: Musée de la Ville de Poitiers et de la Société d'Antiquaires de l'Ouest, 1987), 157. "Le chapeau noir assez haut, le regard dans l'ombre du bord qui avance un peu, le visage pâle, les lèvres à peine colorées, un petit veston noir, où le mince ruban rouge de la boutonnière est la seule note qui tranche dans ce camaïeu. . . . Et je regarde de nouveau ce . . . visage sévère et blême, cet être invisible à nos yeux, qu'elle livre là, sur la toile . . . , ce promeneur solitaire, au large des habitations dévastées."

3. Albert Flament, cited ibid.

4. I am grateful to Whitney Chadwick for sharing her insights about the term *amazon*, a signifier that, she has found, crops up similarly wherever women exercise power in the early twentieth century, as those who had the privilege of attending her Clark Art Institute lecture, "Amazons and Warriors: New Images of Femininity in Early Twentieth-Century France," in the fall of 2003 will vividly recall.

5. Because progressives like Ellis viewed homosexuality as biologically determined, congenital—and not a "condition" of a cultural, social, or moral order— they invested the discourse of sexology with universal pretensions. Therefore, they borrowed case studies and drew conclusions with impunity across cultural and national borders.

6. Pierre Vachet, *L'Inquiétude sexuelle* (Paris: Grasset, 1927), and Henri Drouin, *Femmes damnées* (Paris: NRF/Gallimard, 1929), participate in the explosive

development of a popular genre of "expert-opinion" books on sexuality arising in response, Vachet explained (156), to the influx of "ménages de femmes" evident in post-war Paris. At the same time, journalists such as Maryse Choisy ("Dames seules," *Le Rire*, 21 May 1932) went "undercover" to report on these emerging sexual subcultures, while others, such as Marise Querlin, commented on homosexual practices that transpired, with increasing frequency, in plain sight: "Il est de toute évidence que ces pratiques sont devenues courantes depuis la dernière guerre et que ceux qui s'y livrent le font ouvertement." Marise Querlin, *Femmes sans hommes: Choses vues* (Paris: Editions de France, 1931), 48.

7. Valerie Traub, *The Renaissance of Lesbianism in Early Modern England* (Cambridge: Cambridge University Press, 2002), 28.

8. Maryse Choisy, *Un Mois chez les hommes* (Paris: Editions de France, 1929), 222. "À Ahtènes, comme à Paris, comme à New York, ce 'lesbisme' [*sic*] (qu'on ne connaît plus à Lesbos) naît chez la femme qui travaille, la femme qui n'est plus une madone, et pas encore la camarade dont l'homme bien élevé respecte l'indépendance."

9. Choisy, "Dames seules," 3.

10. Traub, *Renaissance of Lesbianism in Early Modern England*, 7.

11. Choisy, "Dames seules," 3.

12. Edward Carpenter, *The Intermediate Sex: A Study of Some Transitional Types of Men and Women* (London: George Allen and Unwin, 1908), 34. Carpenter, like Ellis, speculates at length on the apparent relationship between homosexuality and genius, a precept embraced by many members of Brooks's circle and on which she embroiders in her writings and portraiture. The all but forgotten writings of Dr. Camille Spiess on the superiority of the intermediate sex and the "psycho-synthetic" (androgynous) energies animating genius gained similar currency in France during the 1920s.

13. Natalie Barney (Nice, Hotel d'Angleterre) to Djuna Barnes, 13 January 1963, Djuna Barnes Papers, McKeldin Library, University of Maryland, College Park.

14. Mireille Havet, *Journal, 1918–1919* (Paris: Editions Claire Paulhan, 2003), 62. "Je voudrais que grandir et devenir une femme ne soit pas synonyme de perdre sa liberté."

15. *Vu*, no. 48, 13 February 1929: "Les Etats généraux de la femme: ce que la femme ne peut pas faire en France, ce que la femme peut faire dans le monde."

16. Odette Simon, "Ce que la femme ne peut pas faire en France," *Vu*, no. 48, 13 February 1929, 106–108. "Ne peut pas: / Voter à aucune élection / Obentir un passeport sans autorisation / Pénétrer à la Bourse / Remplir de hautes fonctions / Quitter le domicile conjugal / S'habiller en homme (ordonnance du 7 nov. 1800) / Rendre la justice. Sans l'autorisation de son mari, la femme ne peut signer aucun contrat valable, . . . faire aucun achat, ni consentir aucune vente. . . . il lui est impossible également d'accepter un legs ou une succession, même pas celle de sa propre mère, d'intenter un procès ni de se défendre, de faire une donation, d'être tutrice, membre d'un conseil de famille ou éxecutrice testamentaire, sans l'assentiment de son conjoint." In addition to the prerogatives enumerated by Simon, it was the husband's "responsibility" to authorize or deny his wife the possibility of pursuing an education, taking a trip, exercising a profession, spending wages, obtaining a driver's license, and even seeking medical treatment.

17. Laura Doan argues that the lesbian, "as a reified cultural concept or stereotype, was, prior to the 1928 obscenity trial [over the suppression of Radclyffe Hall's *The Well of Loneliness*] as yet unformed in English culture beyond an intellectual

elite." Doan represents this trial, and its repercussions with respect to lesbian visibility, as analogous to the Oscar Wilde debacle of the 1890s and its effects on gay men in English society a generation earlier. Laura Doan, *Fashioning Sapphism: The Origins of Modern English Lesbian Culture* (New York: Columbia University Press, 2001), xvii. I cannot point to an equivalent watershed moment in the history of lesbianism, or in that of male homosexuality, in France. As Rachilde wrote of the Wilde trials, "in France, we could not have acquitted Oscar Wilde, for the simple reason that we never would have put him on trial" ("En France, on n'aurait pas pu acquitter Oscar Wilde, tout simplement parcequ'on n'aurait pas fait le procès"). Rachilde, "Oscar Wilde et lui," *Mercure de France*, 128 (July–August 1918): 60. Because homosexuality had been decriminalized after the revolution under France's Napoleonic Code, homosexual visibility generally has different implications and different histories here than in countries like England, where legislation criminalizing homosexuality became more explicit, more comprehensive, and was enforced ever more systematically in the late nineteenth and early twentieth centuries.

18. Natalie Barney, *Traits et portraits* (Paris: Mercure de France, 1963), 31. "[On] . . . appartient à une catégorie d'êtres dont l'espèce deviendra peut-être moins rare lorsque le vieux couple terrestre, définitivement discrédité, permettra à chacun de garder ou retrouver son entité. A ce moment de l'évolution humaine, il n'y aura plus de 'mariages,' mais seulement des associations de la tendresse et de la passion. Des antennes infiniment plus delicates mèneront le jeu des affinités. Ces allées et venues remueront de l'espace. Pour apporter quelque chose, il faut venir d'ailleurs. / L'arrêt dans la fidélité, ce point mort de l'union, sera remplacé par un perpétuel devenir."

19. Pierre Louÿs, dedication in *Les Chansons de Bilitis* (Paris: Librairie de l'Art Indépendant, 1895), n.p. "Ce petit livre d'amour antique est dédié respectueusement aux jeunes filles de la société future."

20. The affordances that enabled this perception of lesbianism were time and place specific. In contrast to the period between the wars, during the 1940s era of post-Occupation purging and retrenchment in France, acts of female independence—including lesbianism—encountered increasingly effective and more highly organized resistance, even as measures appeasing the claims of feminists achieved ratification. Women's suffrage, for instance, passed into law in 1944; women exercised their right to vote for the first time in the elections of 1945. In 1946, the preamble of the constitution proposed the principle of equality between men and women in every domain. However, a law requiring a married woman to seek authorization from her husband to exercise a profession (enforced more zealously in the 1940s than in the 1920s) remained on the books until 1965. As for specificity of place, lesbian Paris of the 1920s and 1930s, while it shared traits with lesbian Berlin, had no parallel in England or America during the same period. In America, as Martha Gever has demonstrated, because "lesbianism was considered a perversion and generally regarded as synonymous with depravity, it was hardly something that someone striving for public recognition would want to aver," and lesbianism in post-Victorian England offered an advantage only insofar as it overlapped with class privilege. Martha Gever, *Entertaining Lesbians: Celebrity, Sexuality, and Self-Invention* (New York: Routledge, 2003), 3.

21. Barney, *Traits et portraits*, 31.

22. This is one of two novels by Mackenzie satirizing the transient lesbian population that colonized the Mediterranean island of Capri in the first decades

of the twentieth century. "In two books—in *Vestal Fire* and *Extraordinary Women* —I painted portraits of one after another of the Capri characters I knew," he wrote. Compton Mackenzie, cited in Andro Linklater, introduction to *Extraordinary Women: Themes and Variations* (London: Hogarth Press, 1986), n.p. One of those characters was Romaine Brooks.

23. Jean Royère, *Le Point de vue de Sirius* (Paris: Messein, 1935), cited in Gayle Rubin, introduction to Renée Vivien, *A Woman Appeared to Me*, trans. Jeannette H. Foster (Reno, NV: Naiad Press, 1976), vii.

24. Janet Flanner, introduction to Colette, *The Pure and the Impure*, trans. Herma Brifault (London: Penguin, 1976), 9. *Le Pur et l'impur* (1941) was originally published as *Ces Plaisirs . . .* (1932).

25. The following texts have made important contributions to the study of modern literature from lesbian-feminist perspectives and have served as models for my own approach to the interpretation of visual culture: Sandra M. Gilbert and Susan Gubar, *No-Man's Land: The Place of the Woman Writer in the Twentieth Century* (New Haven: Yale University Press, 1989); Susan Gubar, "Blessings in Disguise: Cross-Dressing as Re-Dressing for Female Modernists," *Massachusetts Review* 22 (Autumn 1981): 477–508; Catharine R. Stimpson, "Zero Degree Deviancy: The Lesbian Novel in English," in *Writing and Sexual Difference*, ed. Elizabeth Abel (Chicago: University of Chicago Press, 1982), 243–259; Jane Marcus, "Sapphistory: The Woolf and *The Well*," in *Lesbian Texts and Contexts: Radical Revisions*, ed. Karla Jay and Joanne Glasgow (New York: New York University Press, 1990), 164–180; Carolyn Allen, *Following Djuna: Women Lovers and the Erotics of Loss* (Bloomington: Indiana University Press, 1996); Terry Castle, *Noël Coward and Radclyffe Hall, Kindred Spirits* (New York: Columbia University Press, 1996); Karla Jay, introduction to *A Perilous Advantage: The Best of Natalie Clifford Barney*, ed. and trans. Anna Livia (Norwich, VT: New Victoria Publishers, 1992). For a cogent overview of the meanings and applications of the term *gender* within academic studies, see Joan Wallach Scott, "Gender: A Useful Category of Historical Analysis," in *Gender and Politics of History* (New York: Columbia University Press, 1988), 28–50. Here, Scott describes gender as the "constitutive element of social relationships based on perceived differences between the sexes" (42).

26. See, e.g., Doan, *Fashioning Sapphism*; Christine Bard, *Les Garçonnes: Modes et fantasmes des années folles* (Paris: Flammarion, 1998); Mary Louise Roberts, *Disruptive Acts: The New Woman in Fin-de-Siècle France* (Chicago: University of Chicago Press, 2002); Gever, *Entertaining Lesbians*; and Bridget Elliott, "Housing the Work: Women Artists, Modernism and the *Maison d'Artiste*: Eileen Gray, Romaine Brooks, and Gluck," in *Women Artists and the Decorative Arts, 1880–1935: The Gender of Ornament*, ed. Bridget Elliott and Janice Helland (Aldershot, UK, and Burlington, VT: Ashgate, 2002), 176–196.

27. See Judith Butler, *Gender Trouble: Feminism and the Subversion of Identity* (London: Routledge, 1990).

28. Monique Wittig, "One Is Not Born a Woman," reprinted in *The Lesbian and Gay Studies Reader*, ed. Henry Abelove, Michèle Aina Barale, and David M. Halperin (New York: Routledge, 1993), 105, 108.

29. Shari Benstock, *Women of the Left Bank: Paris, 1900–1940* (Austin: University of Texas Press, 1986); Mary Louise Roberts, *Civilization without Sexes: Reconstructing Gender in Postwar France, 1917–1927* (Chicago: University of Chicago Press, 1994).

30. Teresa de Lauretis coined the phrase *queer theory* in her 1991 essay "Queer Theory: Lesbian and Gay Sexualities," *difference: A Journal of Feminist Critical Studies* 3, 2 (1991): iii–xviii.

31. My work has been influenced by a number of contemporary scholars who have taken the problematic of lesbian visibility as a central focus. In addition to Laura Doan, I cite Terry Castle, *The Apparitional Lesbian: Female Homosexuality and Modern Culture* (New York: Columbia University Press, 1993); Peggy Phelan, *Unmarked: The Politics of Performance* (New York: Routledge, 1993); Lisa Walker, *Looking Like What You Are: Sexual Style, Race, and Lesbian Identity* (New York: New York University Press, 2001); and Annamarie Jagose, *Inconsequence: Lesbian Representation and the Logic of Sexual Sequence* (Ithaca: Cornell University Press, 2002).

32. Jagose, *Inconsequence*, 2.

33. Ibid., 3. Castle, *Apparitional Lesbian*, argues that lesbians in our culture are hidden in plain sight. Jagose builds on this premise.

34. Gever, *Entertaining Lesbians*, 22–23. "From this perspective," Gever concludes, "it is difficult to disagree with Leo Bersani's acerbic assessment of the emphasis on visibility politics in lesbian and gay circles: 'Visibility is a precondition of surveillance, disciplinary intervention, and, at the limit, gender-cleansing. . . . Once we agreed to be seen, we also agreed to being policed.'" Gever is quoting Leo Bersani, *Homos* (Cambridge: Harvard University Press, 1995), 11–12.

35. Jonathan Weinberg, *Speaking for Vice: Homosexuality in the Art of Charles Demuth, Marsden Hartley, and the First American Avant-Garde* (New Haven: Yale University Press, 1993); Whitney Davis, ed., *Gay and Lesbian Studies in Art History* (New York: Haworth, 1994); and Richard Meyer, *Outlaw Representation: Censorship and Homosexuality in Twentieth-Century American Art* (Oxford: Oxford University Press, 2002), are exemplary.

36. Castle, *Apparitional Lesbian*, 9.

37. Laura Doan, "'Acts of Female Indecency': Sexology's Intervention in Legislating Lesbianism," in *Sexology in Culture: The Documents of Sexual Science*, ed. Lucy Bland and Laura Doan (Chicago: University of Chicago Press, 1998), 200, 211.

38. Havelock Ellis and John Addington Symonds, *Sexual Inversion* (New York: Arno Press, 1975; orig. published 1897), 79.

39. Djuna Barnes, *Ladies Almanack* (New York: New York University Press, 1992; orig. published 1928), 7.

40. Laure Murat, *Passage de l'Odéon* (Paris: Fayard, 2003), 14, 292. Sylvia Beach's papers at Princeton Library contain dozens of letters from Ellis. In a letter dated 11 July 1921, he proposes to send Beach his *Studies* in exchange for *Ulysses* by James Joyce, which Beach had undertaken to publish. Havelock Ellis to Sylvia Beach, 11 July 1921, Princeton Library, Sylvia Beach Papers, C0108, box 194.

41. Murat, *Passage de l'Odéon*, 291. Sylvia Beach, in a letter to her mother, remarks, "I love Havelock Ellis. I took him to have a drawing made by Paul-Emile Bécat [Monnier's brother-in-law] on Thursday and it turned out marvelously. I am going to have it in my shop." Letter dated 29 June 1924, Princeton Library, Sylvia Beach Papers, C0108, box 19a, folder 24.

42. Lucy Bland and Laura Doan, "General Introduction," in *Sexology Uncensored: The Documents of Sexual Science*, ed. Lucy Bland and Laura Doan (Chicago: University of Chicago Press, 1998), 3. Murat, *Passage de l'Odéon*, 138.

43. According to Michel Foucault's often-cited formulation, the sodomite,

previously considered "a temporary aberration," evolved in the nineteenth century into the homosexual, "a species." "As defined by the ancient civil or canonical codes, sodomy was a category of forbidden acts; their perpetrator was nothing more than the juridical subject of them," he writes. "The nineteenth-century homosexual became a personage, a past, a case history, and a childhood, in addition to being a type of life, a life form, and a morphology, with an indiscreet anatomy and possibly a mysterious physiology. Nothing that went into his total composition was unaffected by his sexuality. It was everywhere present in him: at the root of all his actions because it was their insidious and indefinitely active principle; written immodestly on his face and body because it was a secret that always gave itself away." Michel Foucault, *The History of Sexuality*, vol. 1, *An Introduction*, trans. Robert Hurley (1978; reprint, New York: Vintage/Random House, 1990), 43. Although lesbian identity and community formation are often represented (including, admittedly, in the pages of this book) as echoing precedent-setting gay male ontological events, a more careful, gender-specific historical investigation of pre-nineteenth-century sexuality and sexual subjects is indicated.

44. Charlotte Wolff, a follower of Magnus Hirschfeld, is exemplary. Authors such as Marie Stopes, whose books were devoured by Brooks, and Stella Browne contributed to the popularization of prevailing sexological theories.

45. Havelock Ellis, *The Revaluation of Obscenity* (Paris: Hours Press, 1931).

46. Havelock Ellis, *La Femme dans la société*, vol. 1, *L'Hygiène sociale: Etudes de psychologie sociale*, trans. Lucy Schwob (Paris: *Mercure de France*, 1929). Cahun's French translation of the second volume of *La Femme dans la société* was never published. The letter to which I refer, from Lucie Schwob to Adrienne Monnier dated 2 July 1926, is conserved in the archives of the Institut Mémoires de l'Edition Contemporaine (IMEC), Caen.

47. "Editorial on the Publication of Havelock Ellis's *Sexual Inversion*," *Lancet* (1896), cited in Bland and Doan, *Sexology Uncensored*, 51–52.

48. Havelock Ellis to Bryher, 19 December 1918, Bryher Papers, Gen. Mss 97, Correspondence Series 1, Incoming Correspondence, box 10, folder 413, Beinecke Rare Book and Manuscript Library, Yale University.

49. Ellis to Bryher, 8 March 1919, Bryher Papers, Gen. Mss 97, Correspondence Series 1, Incoming Correspondence, box 10, folder 413, Beinecke Rare Book and Manuscript Library, Yale University.

CHAPTER 1. LESBIAN PARIS BETWEEN THE WARS

The epigraph is from Natalie Barney, *Traits et portraits* (Paris: Mercure de France, 1963), 31. "In order to bring something, it is necessary to come from elsewhere."

1. Adrienne Monnier, "Souvenir de l'autre guerre" (1940), in *Rue de l'Odéon* (Paris: Albin Michel, 1989), 37. "À vrai dire, la terrible déesse me fut favorable."

2. Karine Jay, in her thesis "Suzy Solidor (1900–1983): Portrait(s) d'une artiste à la frange dorée de l'art," Université Jean Moulin Lyon III, 1996, reproduces photographs of Solidor posing in 1917–1918 in her military uniform.

3. *Phare de la Loire* and *La Gerbe* were published by Cahun's father, Maurice Schwob.

4. Brooks reproduced her painting *La France croisée*, along with verses penned by the Italian decadent poet Gabriele D'Annunzio, in a publication whose proceeds she earmarked for war relief.

5. Marbury represented Oscar Wilde's literary and theatrical interests in the United States, safeguarding the author's American royalties during his imprisonment

for sodomy and handling subsidiary rights to "The Ballad of Reading Gaol," a powerful indictment against homophobia that lent impetus to homosexual rights movements in both Europe and the United States.

6. Joan Schenkar, *Truly Wilde: The Unsettling Story of Dolly Wilde, Oscar's Unusual Niece* (New York: Basic Books, 2000), 80.

7. Even Brooks had attempted to harden herself for the job of ambulance driving by underdressing in the cold weather, but by her own admission she only succeeded in making herself ill. Brooks later claimed, in an interview with Michel Desbruères, to have posed herself against a city in ruins in her 1923 self-portrait because she was against the war. Blandine Chavanne and Bruno Gaudichon, eds., *Romaine Brooks* (Poitiers: Musée de la Ville de Poitiers et de la Société d'Antiquaires de l'Ouest, 1987), 156.

8. The organization operated under the auspices of the French Army before American military intervention in Europe. The American volunteers answered to French military authority and wore the sky-blue uniforms of the French army. Volunteers from overseas—whether recruited via word of mouth or responding to the call for chauffeurs published in CARD's weekly bulletin *Under Two Flags*—typically benefited from the privileges of class; they had licenses to drive and could pay for their journey and upkeep in France. These women shared, too, the willingness and ability to de-prioritize family obligations: most were unmarried; many were lesbian. CARD was only one of many such volunteer relief organizations initiated and staffed by women. A few of these organizations, CARD among them, contributed to the post-war reconstruction effort; in the north of France—90 percent of which was destroyed—volunteers remained active well into the 1920s, distributing donated supplies, assisting to rebuild housing and schools, establishing health services, planting vegetable gardens and fruit trees, and founding libraries. For an excellent history of CARD, see *Des Américaines en Picardie: Au service de la France dévastée (1917–1924)* (Paris: Musée National de la Coopération Franco-Américaine de Blérancourt/Réunion des Musées Nationaux, 2002). For an overview of the volunteer activities of American women during World War I, see Dorothy Schneider and Carl Schneider, *Into the Breach: American Women Overseas in World War One* (New York: Viking, 1991).

9. Virginia Scharff, *Taking the Wheel* (New York: Free Press, 1991), 97.

10. Marian Bartol, letter, 8 August 1920, Pierpont Morgan Library, cited in *Américaines en Picardie*, 51–52.

11. *Américaines en Picardie*, 51–52.

12. Elizabeth Marbury, *My Crystal Ball: Reminiscences* (New York: Boni and Liveright, 1923), 274.

13. Mireille Havet, *Journal, 1918–1919* (Paris: Editions Claire Paulhan, 2003), 33–34. "Maintenant libre et fantaisiste, elle s'habille en élégant uniforme d'automobiliste kaki, avec la rayure assez ravissante de la croix de guerre étoilée, et de l'insigne des blessés de guerre. Elle porte ses cheveux très courts, et fait évidemment la cour à toutes les femmes jolies."

14. Sylvia Beach to Bryher, "For Your Birthday September 2nd 1950," letter, Gen Mss 97, series 2, Writings, box 93, folder 3399, Beinecke Rare Books Book and Manuscript Library, Yale University.

15. Claude Roger-Marx, cited by Nicole Albert, "Présentation," in *Dames seules*, text by Maryse Choisy and drawings by Marcel Vertès (Paris: Cahiers Gai/Kitsch/Camp, 1993), 15 (reprint of the special issue of *Le Rire*, 21 May 1932). "Le pseudo-male au col raide, à la nuque rase, au tailleurs strict."

16. *Die Dame* (Berlin), July 1929. As Paula Birnbaum points out in her article

"Painting the Perverse: Tamara de Lempicka and the Modern Woman Artist," in *The Modern Woman Revisited: Paris Between the Wars*, ed. Whitney Chadwick and Tirza True Latimer (New Brunswick: Rutgers University Press, 2003), 104n4, Alain Blondel, in *Tamara de Lempicka: Catalogue raisonné, 1921–1979* (Lausanne and Paris: Editions Acatos, 1999), 196–197, cites a photograph by André Kertesz as the model for this portrait. The Kertesz photo, which served as the cover image for the 3 October 1928 issue of the French magazine *Vu*, captures a women decked out in Hermès sportswear at the wheel of an automobile. This iconography, however, was so prevalent throughout the interwar period as to render the establishment of precise chains of influence a gratuitous exercise.

17. Djuna Barnes, *Ladies Almanack* (New York: New York University Press, 1992), 18.

18. Florence Tamagne, *Histoire de l'homosexualité en Europe: Berlin, Londres, Paris, 1919–1939* (Paris: Editions du Seuil, 2000), 340. "Mon costume dit à l'homme: je suis ton égale. . . . Ce sont les porteurs de cheveux courts et de faux cols qui ont toutes les libertés, tous les pouvoirs, eh bien! Je porte moi aussi cheveux courts et faux cols."

19. The Fédération Sportive Féminine suspended Morris's license for persistently wearing pants, despite official reprimands. Morris brought suit against the professional athletes' association; the trial was widely covered in the press in articles such as the one signed R.A., "Je suis moins indécente en pantalon qu'en robe, nous dit Violette Morris," *Paris-Midi*, 26 February 1930, unpaginated clipping, Varietés, box 2, Fonds Bouglé, Bibliothèque Historique de la Ville de Paris. Morris also lent impetus to a trend among women desiring to flatten their silhouettes via surgical ablation of the breasts, an operation that Maryse Choisy also underwent, or so she claimed: "Depuis je me suis fait couper les seins chez la plus grande chirurgienne de Paris." Maryse Choisy, *Un Mois chez les filles* (Paris: Montaigne, 1928), 171.

20. Paul Morand, *Journal d'un attaché d'ambassade, 1916–1917* (Paris: Gallimard, 1996), 253–254; 30 May 1917: "La mode depuis quelques jours est pour les femmes de porter les cheveux courts. Toutes s'y mettent: . . . Coco Chanel, têtes de file."

21. See Albert, "Présentation."

22. See Germaine Dulac, *Ecrits sur le cinéma (1919–1937)* (Paris: Editions Paris Expérimental, 1994). The interviewer, Jacques Guillon, for instance, describes Dulac's attributes as follows: "de grands yeux noirs très mobiles, une bouche un peu forte dont les contractions nerveuses indiquent une grande puissance de volonté; les cheveux coupés et la cravate me font penser à George Sand" (134) (large black restless eyes; a mouth slightly too strong whose nervous contractions indicate an abundance of will power; short hair and a necktie reminiscent of George Sand).

23. Gertrude Stein, *The Autobiography of Alice B. Toklas* (New York: Vintage Books, 1961), 247.

24. Laura Doan, *Fashioning Sapphism: The Origins of Modern English Lesbian Culture* (New York: Columbia University Press, 2001), 110.

25. Mary Louise Roberts, *Civilization without Sexes: Reconstructing Gender in Postwar France, 1917–1927* (Chicago: University of Chicago Press, 1994), 66.

26. Victor Margueritte, "Avant-Propos," in *Le Couple* (Paris: Flammarion, 1924), vii.

27. Roberts, *Civilization without Sexes*, 47–48.

28. Ibid., 47.

29. The title can be translated literally as "woman on the road"; it could be more loosely rendered as "woman on the move," that is to say, woman in evolution.

30. H.D., *Bid Me to Live* (New York: Dial Press, 1960), 97.

31. Ibid.

32. Otto Weininger, *Sex and Character* (London: Heinemann, 1906), 64. The original German-language version of this book, *Geschlecht und Charakter: Eine Prinzipielle Untersuchung*, was published in 1903 and appeared first in English translation in 1906.

33. Havelock Ellis, "Sexual Inversion in Women," *Alienist and Neurologist* 16 (1895): 148–153, cited in Carroll Smith-Rosenberg, "Discourses of Sexuality and Subjectivity: The New Woman, 1870–1936," in *Hidden from History: Reclaiming the Gay and Lesbian Past*, ed. Martin Duberman, Martha Vicinus, and George Chauncey, Jr. (New York: Meridian, 1989), 271.

34. R. W. Shufeldt, "Dr. Havelock Ellis on Sexual Inversion," *Pacific Medical Journal* 65 (1902): 199–207, cited in Duberman, Vicinus, and Chauncey, *Hidden from History*, 271.

35. To an assembly of women students at Newnham College, Cambridge University, Virginia Woolf first delivered the paper that we know as *A Room of One's Own*.

36. William Lee Howard, "Effeminate Men and Masculine Women," *New York Medical Journal* 71 (1900): 687, cited in Duberman, Vicinus, and Chauncey, *Hidden from History*, 271.

37. M. Carey Thomas, the first dean and first woman president of Bryn Mawr College, is exemplary. Under pressure from feminists and antifeminists alike, Thomas retracted the statement that "only our failures marry," claiming she had meant to say "our failures only marry." Lillian Faderman, *To Believe in Women: What Lesbians Have Done for America, a History* (Boston: Houghton Mifflin, 1999), 213. Less than half of the women graduating from Bryn Mawr during the first decade of the twentieth century married.

38. *Revue Française* devoted its 17 June 1928 issue to the "jeune fille américaine."

39. Henri Drouin, *Femmes damnées* (Paris: NRF/Gallimard, 1929), 135–136. "Conséquence fatale de l'accession des femmes aux carrières jusqu'alors réservées aux hommes, un type nouveau est apparu, celui des femmes d'affaires. En matière d'affaires les femmes nous ont rapidement montré qu'elles pouvaient aller aussi loin que nous."

40. Ibid., 129, 131, 132. "Pour ces femmes damnées que Baudelaire oublia, les opérations cérébrales ont une valeur de remplacement. Les orgies du savoir et l'ivresse de la création artistique leur sont un refuge. . . . Mais, chez les femmes artistes, il est bien rare de ne pas trouver à la base de leurs expansions artistiques un vide sensuel. Si Mme de Sévigné avait été une épouse comblée, une mère heureuse, nous eût-elle légué son admirable correspondance? . . . Le type de la femme artiste pour laquelle la création artistique constitue le refuge toujours ouvert pour ses déceptions amoureuses nous paraît George Sand. . . . George restera le type de la virago dont le tempérament insatiable épuisait en quelques jours, en quelques semaines, les amants les plus fougueux. . . . On a osé avancer, non sans quelques preuves impressionnantes, que George Sand était atteinte de frigidité sexuelle. Cette idée nous paraît fort séduisante, car l'oeuvre entière de la 'vache à lettres' en reçoit une lumière inattendue. D'ailleurs, rien de solide ne s'oppose à cette conception du génie sandien."

41. Ibid., 131. The flyleaf of the work cited heralds the forthcoming publication "by the same author" of Sand's biography.

42. Virginia Woolf, *Women and Writing*, ed. Michèle Barrett (San Diego: Harvest/Harcourt Brace, 1979), 62.

43. See Mary Louise Roberts, *Disruptive Acts: The New Woman in Fin-de-Siècle France* (Chicago: University of Chicago Press, 2003).

44. Germaine Krull, "Pensées sur l'art," cited by Pierre Mac Orlan in *Germaine Krull* (Paris: Librarie Gallimard/Les Photographes Nouveaux, 1931), 12.

45. Jean Cocteau to Germaine Krull, April 1930, cited in Orlan, *Germaine Krull, 16.*

46. Charles Baudelaire, "Salon de 1859, Le public moderne et la photographie," in *Oeuvres complètes* (Paris: Gallimard, 1961), 770.

47. Interview with Berenice Abbott, *New York Times*, 16 November 1980. Princeton Library, Noel Riley Fitch Papers, CO 841, box 9. Abbott made this observation at a time when the close-up had only recently come to the fore in Hollywood cinema, as Roland Barthes remarks in "The Face of Garbo," and the human face "still plunged audiences into the deepest ecstasy." Roland Barthes, "The Face of Garbo," in *A Barthes Reader*, ed. Susan Sontag (New York: Hill and Wang, 1996), 82.

48. Abbott arrived in Paris to study sculpture in 1921. In 1925 she took a job as Man Ray's darkroom assistant and shortly thereafter, in 1926, opened a rival portrait studio. She returned to the United States in 1929.

49. Berenice Abbott, *A Guide to Better Photography* (New York: Crown Publishers, 1941), 56.

50. *Vu*, no. 1 (1928): 11–12. "Conçu dans un esprit nouveau et realizé par des moyens nouveaux, *Vu* apporte en France une formule neuve: le reportage illustré d'informations mondiales. Enfin, dans ses pages, *Vu* donnera à la Publicité la place qu'elle occupe dans la vie moderne."

51. *Vogue*, for instance, covered Gertrude Ederle's historic swim across the English Channel in 1926. The eyes of the international media were on Ederle, a gold-medalist in the 1924 Paris Olympics, as she embarked on her second attempt to cross the Channel. She not only became the first woman to successfully meet this challenge but ended up beating all previous records by hours. Two million fans lined the streets of New York to great her with a ticker tape parade on her return.

52. H.D., "Projector II," *Close Up*, October 1927, 37. Bryher Papers, Gen. Mss 97, Film, series 8, box 169, folder 5651, Beinecke Rare Book and Manuscript Library, Yale University.

53. Jayne Marek, "Bryher and *Close Up*, 1927–1933," *H.D. Newsletter* 3, 2 (1990): 27.

54. See Jayne Marek's work on *Close Up* in *Women Editing Modernism: "Little" Magazines and Literary History* (Lexington: University Press of Kentucky, 1995).

55. Some women professionals, however, had reservations on this score. In her 1938 essay *Three Guineas*, Woolf makes plain her own trepidations about professionalism: "We, the daughters of educated men, are between the devil and the deep sea. Behind us lies the patriarchal system; the private house, with its nullity, its immorality, its hypocrisy, its servility. Before us lies the public world, the professional system, with its possessiveness its jealousy, its pugnacity, its greed. The one shuts us up like slaves in a harem; the other forces us to circle, like caterpillars head to tail, round and round the mulberry tree, the sacred tree of property. It is a choice of evils. Each is bad. Had we not better plunge off the bridge into

the river; give up the game; declare that the whole of human life is a mistake and so end it?" Virginia Woolf, *Three Guineas* (1938; reprint, London: Penguin, 1977), 86. The knowledge that Woolf ultimately took the plunge she described (in 1941, Woolf filled the pockets of her coat with stones and walked into the waters of the river Ouse near her Sussex home) invests her remarks with additional poignancy. Woolf recognized that the professional credo of the capitalist marketplace would cause women to renounce their collective quest for social equity in favor of individual celebrity.

56. H.D., *Bid Me to Live*, 97.

57. Woolf, *Three Guineas*, 130, 125.

58. H.D., *Borderline: A Pool Film with Paul Robeson* (London: Mercury Press, 1930), 5.

59. Edward Carpenter, *The Intermediate Sex*, cited in *Sexology Uncensored: The Documents of Sexual Science*, ed. Lucy Bland and Laura Doan (Chicago: University of Chicago Press, 1998), 51.

60. See, e.g., Emanuel Kanter, *Amazons, a Marxian Study* (Chicago: Charles H. Kerr, 1926).

61. Charlotte Wolff, *Love Between Women* (New York: St. Martin's Press, 1971), 82.

62. Renée Vivien, *Sapho: Traduction nouvelle avec le texte grec* (Paris: Lemere, 1903). Natalie Barney, *Cinq Petits Dialogues grecs* (Paris: Editions de la Plume, 1902).

63. This movement was later dubbed "Sapho 1900." See Joan DeJean, *Fictions of Sappho, 1546–1937* (Chicago: University of Chicago Press, 1989).

64. Barney, *Cinq Petits Dialogues grecs*, vii–viii; cited and translated in DeJean, *Fictions of Sappho*, 280, 354. "Alors l'Inconnue, la persuasive et la redoutable, la terrible et la douce, me dit: Si tu m'aimes, tu oublieras ta famille et ton mari et ton pays et tes enfants et tu viendras vivre avec moi. / Si tu m'aimes, tu quitteras tout ce que tu chéris, et les lieux où tu te souviens . . . et tes souvenirs et tes espoirs ne seront qu'un désir vers moi. . . . / Et je lui répondis en sanglotant: Je t'aime."

65. Barney is one of several prominent lesbian expatriate *salonières* animating early twentieth-century Parisian culture. Gertrude Stein, Winaretta Singer (princesse de Polignac), and "the triumvirate" (Ann Morgan, Elizabeth Marbury, and Elsie de Wolfe) opened their homes to artists, musicians, writers, critics, and patrons on a regular basis.

66. Jacques Depaulis, *Ida Rubinstein: Une Inconnue jadis célèbre* (Paris: Librairie Honoré Champion, 1995), 216.

67. The classical vernacular employed by homosexual advocates from Oscar Wilde to André Gide located these authors within an elite literary tradition in which homoeroticism had played a dignified and indeed instrumental role.

68. Barnes, foreword to *Ladies Almanack*, n.p.

69. Marcel Proust, *À la Recherche du temps perdu* (Paris: Gallimard/Pléiade, 1989), 4:107–108.

70. Eon de Beaumont (the Chevalier d'Eon), a French diplomat to Russia in the service of Louis XVI who reportedly cross-dressed as a woman for the purposes of espionage, incarnated the link between travesty and treachery that continued to resonate, in Barney's era, in political scandals such as Germany's Eulenberg affair. Philipp zu Eulenberg was a ranking diplomat close to Kaiser Wilhelm. Eulenberg's affair with the officer Kuno von Moltke, and the cross-dressing soirées of their "Liebenberg Round Table" (which included the kaiser himself),

provoked a scandal that undermined Kaiser Wilhelm's regime. The quotation is from Barnes, foreword to *Ladies Almanack*, n.p.

71. The memoir, originally written in French and self-published in Paris in 1929, has now been published in an English edition. Natalie Clifford Barney, *Adventures of the Mind*, trans. John Spalding Gatton (New York: New York University Press, 1992). The book documents Barney's life as a cultural hostess and, most significantly, the creation of the Académie des Femmes, founded by Barney in 1927 as a feminist alternative to the all-male Académie Française. It was not until 1980, eight years after Barney's death, that the Académie Française finally admitted a woman—Marguerite Yourcenar—into its ranks.

72. Ibid., 26.

73. Walter Benjamin, "Paris, Capital of the Nineteenth Century," in *Reflections: Essays, Aphorisms, Autobiographical Writings*, ed. Peter Demetz, trans. Edmund Jephcott (New York: Schocken, 1978), 156.

74. Radclyffe Hall, *The Well of Loneliness* (1928; reprint, New York: Avon Books, 1981), 356. Hall's description reminds us that Paris, during the inaugural years of Barney's salon, was quite literally a no-man's land—the able-bodied men having deserted the city, in a manner of speaking, for the front. The visual (as well, of course, as the economic and cultural) impact of this evacuation must not be underestimated. Some, like Hall, found the spectacle depressing; others, like Barney, found it exhilarating.

75. Karla Jay, *The Amazon and the Page: Natalie Clifford Barney and Renée Vivien* (Bloomington: Indiana University Press, 1988), 108.

76. H.D., *Paint It Today* (New York: New York University Press, 1992), 18.

77. Natalie Barney, *Traits et portraits* (Paris: Mercure de France, 1963), 31. "Pour apporter quelque chose, il faut venir d'ailleurs."

78. Barney, *Adventures of the Mind*, 180.

79. Sandra M. Gilbert and Susan Gubar, "'She Meant What I Said': Lesbian Double Talk," in *No-Man's Land: The Place of the Woman Writer in the Twentieth Century* (New Haven: Yale University Press, 1989), 219.

80. George Wickes, *The Amazon of Letters: The Life and Loves of Natalie Barney* (New York: Putnam's, 1976), 44.

81. Barnes, foreword to *Ladies Almanack*, n.p.

CHAPTER 2. ROMAINE BROOKS

The epigraph is from Natalie Barney, *The One Who Is Legion* (Orono: National Poetry Foundation, University of Maine, 1987), 159.

1. Mireille Havet, *Journal, 1918–1919* (Paris: Editions Claire Paulhan, 2003), 73: "dans le mystère un peu inquiétant et très pervers de son grand salon noir, blanc, cru, et vermillon, avec les coussins d'or, les laques, les miroirs, le tapis à carreaux et la grande cheminée: seule nature où flamboie un rude feu que rien n'a pu asservir et qui jaillit, éclairant l'admirable, hermétique visage de notre hôtesse, son sourire triste d'enfant navré, et son regard autoritaire et ardent qui caresse et questionne."

2. Albert Flament, cited in Blandine Chavanne and Bruno Gaudichon, eds., *Romaine Brooks* (Poitiers: Musée de la Ville de Poitiers et de la Société d'Antiquaires de l'Ouest, 1987), 157. "'Un portrait psychologique'! . . . Dans la psyché à trois faces, j'aperçois le visage réel de Mrs. Brooks qui vient de se frotter avec cette poudre ocre qu'elle aime tant et qui rit comme un enfant. Et je regarde de

nouveau cet autre visage sévère et blême, cet être invisible à nos yeux, qu'elle a livré là, sur la toile . . . , ce promeneur solitaire, au large des habitations dévastées."

3. See, e.g., Joe Lucchesi, "'The Dandy in Me': Romaine Brooks's 1923 Portraits," in *Dandies: Fashion and Finesse in Art and Culture*, ed. Susan Fillin-Yeh, 153–184 (New York: New York University Press, 2001); Bridget Elliott, "Performing the Picture or Painting the Other: Romaine Brooks, Gluck, and the Question of Decadence in 1923," in *Women Artists and Modernism*, ed. Katy Deepwell, 70–82 (Manchester, UK: Manchester University Press, 1989); and Bridget Elliott and Jo-Ann Wallace, *Women Artists and Writers: Modernist (Im)Positionings* (London: Routledge, 1994).

4. Elliott and Wallace, *Women Artists and Writers*, 51.

5. Regarding representations of the New Woman considered in late nineteenth-century portraiture and criticism, see Debora L. Silverman, *Art Nouveau in Fin-de-Siècle France: Politics, Psychology, and Style* (Berkeley and Los Angeles: University of California Press, 1989).

6. Camille Mauclair, "La Femme devant les peintres modernes," *La Nouvelle Revue*, 2d ser., 1 (1899): 212–213, cited ibid., 69.

7. Louis Vauxcelles, *L'Histoire générale de l'art français de la révolution à nos jours* (Paris: Librairie de France, 1922), 2:320; cited in Gill Perry, *Women Artists and the Parisian Avant-Garde: Modernism and "Feminine" Art, 1900 to the Late 1920s* (Manchester, UK: Manchester University Press, 1995), 8.

8. *Passe-temps honnête* was exhibited at the Galerie Bernheim in Paris in 1921 and reproduced in Bernheim's catalogue no. 7, August 1921; the painting was also reproduced in *La Vie Artistique*, 15 March 1922. Van Dongen's 1914 *Portrait de la marquise Casati* (who was portrayed by Brooks ca. 1920) launched his successful career as a society painter.

9. Perry, *Women Artists and the Parisian Avant-Garde*, 16.

10. Guglielmo Ferrero, "Woman's Sphere in Art," *New Review*, November 1893, cited in Lucy Bland and Laura Doan, eds., *Sexology Uncensored: The Documents of Sexual Science* (Chicago: University of Chicago Press, 1998), 23.

11. Femmes Artistes Modernes (F.A.M.), founded by Marie-Anne Camx-Zoegger, organized exhibitions from 1930 through 1938. F.A.M. stressed the professionalism of its membership. Suzanne Valadon, Tamara de Lempicka, and Marie Laurencin numbered among *les sociétaires* who exhibited in the context of its annual shows, which often opened with retrospectives reconstructing a history for women professionals in the arts; the Salon of 1934, for example, opened with a retrospective celebrating the work of Camille Claudel and Marie Bracquemond.

12. Guillaume Apollinaire, "Les Peintresses, chroniques d'art," *Le Petit Bleu*, 5 April 1912, n.p.

13. Montesquiou, "Cambrioleurs d'ames," *Le Figaro*, May 1910, unpaginated clipping conserved in Brooks's press book, Research Material on Romaine Brooks: Scrapbook, ca. 1910–1935, Archives of American Art (AAA), Smithsonian, reel no. 5134.

14. Brooks cited this excerpt from Montesquiou's article "Cambrioleurs d'ames" in her memoirs, "No Pleasant Memories," unpublished manuscript, ca. 1930, 220; also conserved in the AAA, Smithsonian. "Par ce temps d'amateurisme débridé, la qualité de ses travaux la classe parmi ceux dont la production sérieuse, sévère, amère même, parfaitement destinée aux clients du succès facile, n'a rien à voir (oh! Mais rien du tout!) avec le groupe mondain annuellement rassemblé sur de vagues cimaises et de téméraires plinthes par Monsieur F.S." The title of

Montesquiou's article has often been mistranscribed as "Cambrioleur [in the singular] d'ames," leading to its mistranslation as "thief of souls." As conceived by Montesquiou, it was not the artist but the portraits that stole the souls of the sitters. This distinction is significant in that it speaks to what Walter Benjamin describes as the "aura" of the original artwork: an object that has the characteristics of a subject.

15. Louis Vauxcelles, Arsène Alexandre, Claude Roger Marx, Guillaume Apollinaire, and Albert Flament, cited in *Romaine Brooks: Portraits, tableaux, dessins* (Paris: Braun et Cie., 1952), 48–52.

16. Vauxcelles, *Gil Blas*, 14 May 1910, excerpted in *Brooks: Portrait, tableaux, dessins*, 48–49.

17. E.S., "Art," *Commentator*, 21 June 1911, 75.

18. For an in-depth reading of Brooks's nudes, see Joe Lucchesi, "'An Apparition in a Black Flowing Cloak': Romaine Brooks's Portraits of Ida Rubinstein," in *Amazons in the Drawing Room: The Art of Romaine Brooks*, by Whitney Chadwick, with an essay by Joe Lucchesi (Berkeley and Los Angeles: University of California Press; Washington, DC: National Museum of Women in the Arts, 2000), 73–87.

19. Barney to Brooks, undated letter , Fonds Natalie Clifford Barney, Bibliothèque Littéraire Jacques Doucet (BLJD), Paris, NCB.C2.2996, 38–39. I am indebted to François Chapon for facilitating the consultation and citation of this material.

20. Claude Roger-Marx, "Personnages d'une époque," unreferenced clipping, conserved in Brooks's press book, Research Material on Romaine Brooks: Scrapbook, ca. 1910–1935, AAA, Smithsonian, reel no. 5134. "Ce chapeau haut de forme qui surplombe un visage féminin, ces mains gantées, ce costume viril rappellent certaines descriptions les plus effrontées de *À la Recherche du temps perdu*, tandis que la tristesse que l'artiste a donnée à son regard fait rêver aux héroïnes si tendrement décrites par Colette dans *Ces Plaisirs*."

21. Roger-Marx, cited in *Romaine Brooks: Portraits, tableaux, dessins*, 52.

22. Translated as "Life Passes by without Me" (1910); alternately titled *Au Balcon*. The English critic John Usher, in his comments on the subject of this painting, noted, "It is almost as if [the sitter] had been intentionally selected from a type diametrically opposed to the painter's own character" (*International Studio*, February 1926, 49).

23. In a remark cited by Brooks in the monograph, Apollinaire notes that her portrait subjects impress themselves on the viewer's mind like "silhouettes resembling memories." Guillaume Apollinaire, in *Romaine Brooks: Portraits, tableaux, dessins*, 48.

24. Concerning the spacialization of gender in nineteenth-century painting, see Griselda Pollock, "Modernity and the Spaces of Femininity," in *The Expanding Discourse: Feminism and Art History*, ed. Norma Broude and Mary D. Garrard, 244–267 (New York: Harper Collins, 1992).

25. Walter Benjamin, "Paris, Capital of the Nineteenth Century," in *Reflections: Essays, Aphorisms, Autobiographical Writings*, ed. Peter Demetz, trans. Edmund Jephcott (New York: Schocken Books, 1978), 156.

26. Ibid., 150

27. Ibid., 156.

28. Elisabeth de Gramont, introduction to *Romaine Brooks: Portraits, tableaux, dessins*, 4. "Indifférente aux honneurs et aux témoignages de reconnaissance, elle aspire à rester partout étrangère."

29. Baudelaire, cited in Walter Benjamin, *Charles Baudelaire: A Lyric Poet in the Era of High Capitalism*, trans. Harry Zohn (London: Verso, 1997), 55.

30. Gramont, introduction to *Romaine Brooks: Portraits, tableaux, dessins*, 4. "Affranchie des coteries et des êtres en général, elle se plait seulement à observer autour d'elle et à retenir au passage les particularités de chacun."

31. Vauxcelles, cited in *Romaine Brooks: Portraits, tableaux, dessins*, 49.

32. Benjamin, *Charles Baudelaire*, 146–147. "To perceive the aura of an object we look at means to invest it with the ability to look at us in return" (148).

33. For an extended analysis of the psychic formations that intertwine desire, loss, and aesthetic fulfillment, see Ellen Handler Spitz, *Image and Insight* (New York: Columbia University Press, 1991).

34. This is the ribbon of the Legion of Honor that Brooks earned for her fund-raising initiatives in conjunction with the exhibition and publication of the patriotic 1914 painting *La France croisée* (paired with a verse signed Gabriel D'Annunzio).

35. As the social critic Thorstein Veblen noted in his 1899 *Theory of the Leisure Class*, a gentleman's glove suggests that "the wearer cannot . . . bear a hand in any employment that is directly and immediately of any human use." Thorstein Veblen, *The Theory of the Leisure Class: An Economic Study of Institutions* (New York: B. W. Huebach, 1919), 170–171.

36. Rhonda K. Garelick, *Rising Star: Dandyism, Gender, and Performance in the Fin de Siècle* (Princeton: Princeton University Press, 1998), 23.

37. As Jules Barbey d'Aurevilly noted in his 1843 essay "Du Dandysme et de George Brummell" — a foundational text on dandyism buttressed by Honoré de Balzac's earlier "Traité de la vie élégante" (1830) and Baudelaire's later "Le Peintre de la vie moderne" (1863): "Le dandy est femme par certain côtés." Jules Barbey d'Aurevilly, "Du Dandysme et de George Brummell," in *Oeuvres romanesques complètes* (Paris: Gallimard, 1966), 2:710.

38. Garelick, *Rising Star*, 19.

39. M.R., "À l'Instar," *Fémina*, July 1924, 31–32. "Le haut de form de Brummel [*sic*]"; the accompanying text describes: "Ce que la mode féminine a pris à la mode masculine . . . Ou les progrès du féminisme."

40. Marius-Ary Leblond, "Les Peintres de la femme nouvelle," *La Revue* 39 (1901): 278, 283.

41. The following reviews are among those associating Brooks with Whistler: unattributed review, "Romaine Brooks Shows Portraits Here," *Art News* 24, 7 (21 November 1925): 3; Gustave Kahn, "Romaine Brooks," *L'Art et les Artistes* 7, 39 (May 1923): 307–308.

42. Montesquiou, "Cambrioleurs d'ames," unpaginated clipping.

43. Gabriel D'Annunzio, cited in "Her Painting a Sensation: Miss Brooks Receives the Praises of Thousands in Paris," *Washington Post*, 4 April 1914.

44. "Une Exposition d'artistes américains au Luxembourg," *L'Art et les Artistes* 3 (November 1919): 135.

45. She even signed her work with a winged cipher derived, like Whistler's hallmark butterfly, from her monogram.

46. Barney to Brooks, letter ca. 1920, Fonds Natalie Clifford Barney, BLJD, Paris, NCB.C2 2996,1-35/231: "ne rien ne trouve place qui n'ait d'abord sans signification par rapport à l'ensemble."

47. Montesquiou, "Cambrioleurs d'ames," unpaginated clipping.

48. Brooks, "No Pleasant Memories," 210–211.

49. Ibid., 205.

50. Barney wrote of Brooks's hypersensitivity: "Her eye, developed to the point that it cannot tolerate bright colors, once caused her to eject from her studio

another society woman who had tactlessly arrived dressed in garish green." Natalie Clifford Barney. *Adventures of the Mind,* trans. John Spalding Gatton (New York: New York University Press, 1992), 181. This memoir was written by Barney in French and originally self-published as *Aventures de l'esprit* (Paris: Emile-Paul Frères, 1929).

51. Roger-Marx, in *Romaine Brooks: Portraits, tableaux, dessins,* 50. The reference to Debussy links Brooks with a composer who had collaborated in several controversial initiatives in the total-art realm of the ballet theater—notably, the Russian Ballet's *L'Après-midi d'un faune* and *Jeux.* Both productions provoked debate on artistic as well as moral grounds. Debussy, what is more, was appreciated by Barney and Brooks's circle for a piece that he composed as an homage to the Sapphic poetry of Pierre Louÿs, *Les Chansons de Bilitis.*

52. For instance, Andrea Weiss claims that "unlike Eileen Gray, who was influenced by the geometry of Cubism and of the Dutch De Stijl group, Romaine did not care for artistic trends and painted as though the twentieth century and its many artistic shake-ups were not occurring around her. As time went on, she was increasingly discredited for being outmoded and out of touch." Andrea Weiss, *Paris Was a Woman: Portraits from the Left Bank* (San Francisco: HarperSanFrancisco, 1995), 110.

53. Albert Flament, in *Le Trottoir roulant,* excerpted in *Romaine Brooks: Portraits, tableaux, dessins,* 51. "Une femme que le goût de son temps n'a pas su réduire à l'esclavage; en empruntant au passé et au présent, elle a su former une chose—son logis—encore jamais réalisée et qui complète l'un des talents féminins les plus originaux de ce temps." Louis Vauxcelles, in *Excelsior,* 21 May 1931, cited in the same context, described Brooks's work as "inclassable."

54. "To judge by the self-portraits at the Alpine Club Gallery, Mill Street, Miss Romaine Brooks closely resembles her pictures in spirit and appearance. An air and aspect of decadence pervades most of them. General hopelessness and ashen-grey tones give one a feeling of waning life, of extinct passion, of decaying lilies, that suggests the poetry of Baudelaire, Verlaine, or Mallarmé." "The Decadent School," unreferenced clipping, Research Material on Romaine Brooks: Scrapbook, ca. 1910–1935, AAA, Smithsonian, microfilm roll no. 5134.

55. Brooks, "No Pleasant Memories." The artist's social and geographical itineraries intersected with Wilde's in various ways. For instance, Wilde's niece Dolly Wilde shared Barney's bed off and on for decades, according to Shari Benstock, *Women of the Left Bank: Paris, 1900–1940* (Austin: University of Texas Press, 1986), 180. Wilde frequently attended Barney's Friday salons at 20 rue Jacob masquerading as her uncle. Barney herself revered Wilde and emulated him as a writer. See Natalie Clifford Barney, "First Adventure: Oscar Wilde in the United States," in *Adventures of the Mind,* 31. Barney also entertained a brief engagement to Wilde's lover, Alfred Douglas. See Karla Jay, introduction to *A Perilous Advantage: The Best of Natalie Clifford Barney,* ed. and trans. Anna Livia (Norwich, VT: New Victoria Publishers, 1992). vi–viii.

56. A. T. Fitzroy [Rose Allatini], cited in Philip Hoare, *Oscar Wilde's Last Stand: Decadence, Conspiracy, and the Most Outrageous Trial of the Century* (New York: Arcade Publishing, 1997), 189. The novel, which tells the story of a homosexual artist and pacifist who is imprisoned for his beliefs, paints a candid portrait of same-sex relationships, both male and female. The book was banned shortly after its publication in 1918.

57. Henri Frantz, "L'Exposition des oeuvres de Mme Romaine Brooks," 1911,

unreferenced clipping, Research Material on Romaine Brooks: Scrapbook, ca. 1910–1935, AAA, Smithsonian, microfilm roll no. 5134.

58. Oscar Wilde, cited in James Abbott McNeill Whistler, *The Gentle Art of Making Enemies* (New York: Dover, 1967), 163. Gramont, introduction to *Romaine Brooks: Portraits, tableaux, dessins*, 4.

59. Many of Wilde's dandy-aesthete contemporaries, homosexual or not, took shelter in France in the wake of his trials. Aubrey Beardsley, for instance, migrated across the channel. Alfred Douglas took cover in France, converted to Catholicism, and married. The Decadent poet John Gray (allegedly the prototype for Wilde's Dorian Gray) and his lover, the sexual theorist André Raffalovich, also cooled their heels on the Continent and converted to Catholicism. Gray, in fact, took the vows of priesthood. Raffalovich, whom Beardsley addressed as "Mentor," later converted Beardsley to Catholicism. (Max Nordau, the author of *Entartung* [Degeneration]), had by then identified Catholicism as "the most frequent and most distinctive stigmata of the degenerate." Max Nordau, *Degeneration* (New York: Appleton, 1895), 111. Wilde himself was granted asylum in France after his release from prison. His name continued to provoke controversy, interest, and sometimes sympathy in France for decades after his death in Paris in 1900. His remains were ceremoniously moved from Bagneux to Paris's Père Lachaise cemetery when the funerary monument by Jacob Epstein was completed in 1909. As late as 1933, Gallimard (one of Paris's largest mainstream publishers) released a French edition of an English best seller, *Le Procès d'Oscar Wilde*, by Hillary Pacq (translated by Maurice Bec).

60. Joan Acocella, "The Reception of Diaghilev's Ballets Russes by Artists and Intellectuals in Paris and London, 1909–1914," Ph.D. dissertation, Rutgers University, 1984, 359.

61. In a letter to his colleague and designer Alexandre Benois written in 1897, Diaghilev acknowledged that "from the age of sixteen onwards" his "packaging" and other "eccentricities" had caused him "many complicated and dramatic moments (*once* an almost *tragic* moment)." He complained about the violence and persistence of public attacks on his "vacuous outward appearance" and his "foppishness." He confided his "deep belief that this phase will pass, if my life is crowned with success. Heavens above, it is success and only success that saves us and supersedes everything else." Public appreciation of Diaghilev had indeed started to shift, he noted. "Society has already begun to go on about 'this really decent man, très bien habillé, just like a foreigner'—and those are the same people who scoffed at my chic elegance." Sergei Diaghilev to Alexandre Benois, letter dated April 1897, published in I. S. Zil'bershtein and V. A. Samkov, eds., *Sergei Diaghilev i russkoe iskusstvo* [Sergei Diaghilev and Russian art], trans. and with commentary by John E. Bowlt, "Sergei Diaghilev's Early Writings," in *The Ballets Russes and Its World*, ed. Lynn Garafola and Nancy Van Norman Baer (New Haven: Yale University Press, 1999), 51–52.

62. Lynn Garafola, *Diaghilev's Ballets Russes* (Oxford: Oxford University Press, 1989), 340.

63. Ibid., 373.

64. Ibid., 363.

65. In a letter dated 7 December 1923, postmarked Kensington SW7, Brooks discusses an exchange of portraits to which she had agreed with Gluck. "Have begun Peter's portrait; well in already. But she wants me to pose too, rather a bore but can't get out of it. You would like her but she would not attract you in any

way, she doesn't me either. No mystery or allure. But I think the portrait will be amusing and a pity not to do." Fonds Natalie Clifford Barney, BLJD, Paris, NCB.C2.2445, 50–56. The reference to Gluck's appearance at the theater is from Diana Souhami, *Gluck: 1895–1978; Her Biography* (London: Pandora, 1988), 52.

66. Michael Baker, *Our Three Selves: The Life of Radclyffe Hall* (New York: William Morrow, 1985), 170.

67. Bryher's papers, preserved at the Beinecke Rare Book and Manuscript Library at Yale University, include the decade-long exchange of letters with Ellis.

68. The following excerpt from Ellis's germinal 1897 study *Sexual Inversion* represents the observations of one of the most progressive early twentieth-century sexologists on the exterior symptoms, if not the psycho-sexual preconditions, of lesbianism: "There is a very pronounced tendency among sexually inverted women to adopt male attire when practicable. . . . There is [also] nearly always a disdain for the petty feminine artifices of the toilet. Even when this is not obvious there are all sorts of instinctive gestures and habits which may suggest to female acquaintances the remark that such a person 'ought to have been a man.'" Havelock Ellis and John Addington Symonds, *Sexual Inversion* (New York: Arno Press, 1975; orig. published 1897), 95–96. Ellis, in later works, notably *The Psychology of Sex* (1933), problematized characterizations of the homosexual as a freakishly hybrid "third sex"; further observation and reflection had convinced him that the frontiers of gender and sexual identity were uncertain and that there were many possible stopping points between the poles of male and female.

69. Walter Benjamin, *The Arcades Project*, trans. Howard Eiland and Kevin MacLaughlin (Cambridge: MIT Press, 1989), 8.

70. Cassandra L. Langer, "Fashion, Character and Sexual Politics in Some of Romaine Brooks' Lesbian Portraits," *Art Criticism* 1, 3 (1981): 30.

71. Brooks to Barney, postmarked London, dated 5 June 1923, Fonds Natalie Clifford Barney, BLJD, Paris, NCB.C2.2445, 50–56.

72. Under the 1801 law, women wishing to wear trousers in public were required to apply for a police permit. For detailed discussion of the role that cross-dressing played in the definition and gendering of perversion in turn-of-the-century Western medical discourse, see Jann Matlock, "Masquerading Women, Pathologized Men: Cross-Dressing, Fetishism, and the Theory of Perversion, 1882–1935," in *Fetishism as Cultural Discourse*, ed. Emily Apter (Ithaca: Cornell University Press, 1993), 31–61. See also George Chauncey, Jr., "From Sexual Inversion to Homosexuality: The Changing Medical Conceptualization of Female 'Deviance,'" in *Passion and Power: Sexuality in History*, ed. Kathy Peiss and Christina Simmons (Philadelphia: Temple University Press, 1989), 87–117.

73. J. C. Holl, review of the Salon des Indépendants, 8 April 1925, unreferenced clipping, Research Material on Romaine Brooks, Scrapbook, ca. 1910–1935, AAA, Smithsonian, microfilm reel no. 5135. "Romaine Brooks, esprit fin, reste troublante par la conception de ses modèles choisis dans une faune élégante mais terriblement équivoque."

74. Barney, poem enclosed in a letter addressed to Brooks ca. 1920, Fonds Natalie Clifford Barney, BLJD, Paris, NCB.C2 2996, 1-35/231. The poem reads: "ils / arrivent comme la destinée, sans cause, / sans raison, sans égard, sans prétexte, ils / sont là, avec la rapidité de l'éclair, / trop terribles, trop soudains, trop / convaincants, trop 'autres' pour etre / meme un objet de haine."

75. Alvan F. Sanforn, "American Artists on the Firing Line," *Boston Evening Transcript*, undated, unpaginated clipping, Research Material on Romaine Brooks, Scrapbook, ca. 1910–1935, AAA, Smithsonian, microfilm reel no. 5135.

76. Barney, *Adventures of the Mind*, 180.

77. Whistler attributed the following remark on this subject to Wilde: "Popularity is the only insult that has not yet been offered to Mr. Whistler." Whistler, *Gentle Art of Making Enemies*, 99.

78. An undated letter from Barney to Brooks (ca.1918–1920) mentions Barney's efforts to expedite the award. Fonds Natalie Clifford Barney, BLJD, Paris, NCB.C2.2996,1-35/231.

79. The writer Germaine Beaumont (Colette's assistant) wrote, for instance, a glowing review of Brooks's work after the publication of the monograph, as did Yvon Bizardel. Both were encouraged by Barney. Germaine Beaumont, "Visages," unreferenced clipping dated 24–30 July 1953; Yvon Bizardel, "Romaine Brooks ou le regard retrouvé," unreferenced clipping; both from Fonds Natalie Clifford Barney, BLJD, Paris, NCB.C2.2445,476(3).

80. Brooks's independent income afforded her many luxuries as a painter. She almost never accepted commissions, for instance, and would not agree to execute a portrait unless the sitter inspired her; she rarely sold her paintings, retaining them instead in her personal collection. This distaste for the commercial aspect of professionalism corresponds with a Romantic notion of genius that Brooks shared with aesthete comrades and mentors such as D'Annunzio, Whistler, and Wilde. On her behalf, as a result, Barney was in a position to offer virtually the entire oeuvre to a single institution. Barney used the monograph as a promotional tool in this campaign, sending it to ambassadors, museum directors, curators, board members, anyone whom she felt could advance the cause. In 1966, Barney wrote to the U.S. ambassador to Great Britain, David Bruce (a family friend), alerting him that Paris's Musée National d'Art Moderne and Petit Palais had already spoken for a number of Brooks's portraits of the most "celebrated people of 'la belle époque.'" She urged the ambassador to influence the Smithsonian's director and senior curator, with whom she had been in negotiation for years, to come to a decision about possible acquisitions soon, while Brooks's collection still remained relatively intact.

81. Romaine Brooks to Natalie Barney, 14 June 1952, Fonds Natalie Clifford Barney, BLJD, Paris, NCB.C2.2445, 240–250.

82. Barney also pressured the Smithsonian to publish Brooks's autobiography, "No Pleasant Memories." Brooks intended to illustrate the book with drawings executed explicitly for that purpose, as well as photographs of her portraits; her 1923 self-portrait would have served, once again, as the cover image.

83. Marie Murat, *La Vie amoureuse de Christine de Suède, la reine androgyne*. (Paris: Flammarion, 1930).

84. Edward Carpenter, *The Intermediate Sex: A Study of Some Transitional Types of Men and Women* (London: George Allen and Unwin, 1908), 34. Susan Sontag, "Notes on Camp," in *Against Interpretation* (New York: Anchor/Doubleday, 1986), 290, embroiders on this notion of an homosexual "aristocracy of taste."

85. Gramont, introduction to *Romaine Brooks: Portraits, tableaux, dessins*, 4. "Ces Portraits pourraient bien être les derniers témoins de nos contemporains."

86. Natalie Clifford Barney, *Souvenirs indiscrets* (Paris: Flammarion, 1960), 23.

CHAPTER 3. "NARCISSUS AND NARCISSUS"

The epigraph is from Claude Cahun and Marcel Moore, *Aveux non avenus* (Paris: Editions du Carrefour), 1930. "Feminism is already in the fairy tales."

1. Claude Cahun, "L'Idée-maîtresse," *La Gerbe* 28 (January 1921): 205; and

29 (February 1921): 240. "Et mon Idée-maîtresse . . . 'the love that dare not speak its name' fut l'âme unique de ce corps sans défaut, mon être idéal. . . . L'Idée se multiplia . . . et s'élargit immensément. Elle se coucha, nuage d'or léger, tout autour de mon ciel; et je connus que je n'avais plus rien à craindre d'elle. Je suis en elle; elle est en moi; et je la poursuivrai à jamais, sans la perdre de vue. Mon Idée chère, vaste comme l'horizon, sera la couronne indestructible de tous mes actes, l'auréole de toutes mes âmes."

2. Ibid., 205

3. Cahun refers to her "exécrable manie de citation" in a letter to Adrienne Monnier, 23 July 1926, Bibliothèque Littéraire Jacques Doucet (BLJD), Paris, MS 8718, B' I 11. "Les Jeux uraniens," for instance, a text produced by Cahun (and Moore?) ca. 1914, plays, in a uranian (queer) way, with and off citations of significance to uranian readers. Citations from works by Plato, Verlaine, Alfred Douglas, Gide, Rimbaud, Shakespeare, Whitman, and Wilde, among others, shape the text of "Jeux uraniens." The quotes, set off as handwritten headers within the typewritten manuscript, serve a generative function. They literally provide the pretexts for the narrator's reflections, expressed as an interior dialogue between the lover and the beloved. It is tempting to speculate that Moore, who had the habit of collecting citations, may herself have selected the quotes and laid them down like challenges for her lover to gloss. Cahun adopted the title word *uranien* (uranian in English) from writings by the German homosexual rights advocate Karl Ulrichs in which he defends the third sex. Ulrichs, in turn, had borrowed the term from Plato. Ulrichs employed *uranian* in lieu of more clinical terms such as *invert* or *homosexual*. Ulrichs's notion of the third sex provided a basis of reflection for influential members of the scientific community such as the German homosexual rights movement leader Magnus Hirschfeld, André Raffalovich (author of *Uranisme et unisexualité*) in France, and Edward Carpenter in England. Cahun's "Les Jeux uraniens," which assumes the literary form of an epistle, also presents a long declaration (and defense) of same-sex desire and friendship. There are certain parallels between "Les Jeux uraniens" and Gide's *Corydon* (also largely composed before the 1914 war but not published until 1924). In both cases, the direct form of address, for instance, collapses the distinction between the utterances of the narrator and those of the author.

4. Barthes touches on the photography's proximity to theatricality, in Roland Barthes, *Camera Lucida: Reflections on Photography*, trans. Richard Howard (New York: Hill and Wang, 1981), 31–32. Claude Cahun's "self-portraiture" has provoked a spate of feminist scholarship in recent years. Since her rehabilitation in the 1990s as an important contributor to the surrealist movement, Cahun's photographic "self-portraits" have figured prominently in several major exhibitions, most notably the 1995 Musée d'Art Moderne de la Ville de Paris exhibition. Cahun's biographer, François Leperlier, curated this exhibition and produced a catalogue raisonnée titled *Claude Cahun, photographe* for the occasion. Most subsequent scholarship draws heavily on Leperlier's path-breaking research and tends to reflect his emphasis on Cahun as an underappreciated genius, a unique feminine force within the surrealist movement of the pre–World War II period. Leperlier, whose focus is more literary than visual, does not emphasize the role that Malherbe/Moore undeniably played in the coproduction of the photographic, if not the literary, oeuvre. Subsequently, a growing number of scholars have begun to consider the significance of Moore's collaboration. Abigail Solomon-Godeau produced a catalogue essay titled "The Equivocal 'I': Claude Cahun as Lesbian

Subject," in *Inverted Odysseys: Claude Cahun, Maya Deren, Cindy Sherman*, ed. Shelley Rice (Cambridge: MIT Press, 1999), which raised the question. Laura Cottingham in her essay written slightly later, "Considering Claude Cahun," comments that many of the photographs in question "were most likely produced in collaboration with Malherbe, as they seem technically impossible to have been staged and rendered without . . . assistance." Laura Cottingham, "Considering Claude Cahun," *Seeing through the Seventies: Essays on Feminism and Art* (Amsterdam: G+B Arts International, Gordon and Breach, 2000), 198. Marsha Meskimmon, in *Women Making Art: History, Subjectivity, Aesthetics* (London: Routledge, 2002), fully embraces the collaborative nature of the venture, as does Jennifer Shaw, in "Singular Plural: Collaborative Self-Images in Claude Cahun's *Aveux non avenus*," in *The Modern Woman Revisited: Paris Between the Wars*, ed. Whitney Chadwick and Tirza True Latimer (New Brunswick: Rutgers University Press, 2003). My own contributions to this collection take the collaboration as a given.

5. Among the various pieces of evidence that led me to adopt this position, I cite Cahun's numerous references to "our" photographic efforts. See, e.g., Claude Cahun to Charles-Henri Barbier, 21 September 1952, cited in François Leperlier, "L'Oeil en scène," in the introduction to *Claude Cahun* (Paris: Nathan/HER, 1999), n.p. "Il nous reste d'avant-guerre . . . d'assez belles photographies. Belles? Si j'en puis juger par la diversité des gens qui les ont admirées . . . des inconnus lorsqu'elles furent exposées chez des libraires . . . et par l'appréciation de quelques-uns qui les virent chez nous. Parmi ceux-ci, des gens les moins esthètes à des professionnels tels que Man Ray. D'autre part, récemment, un jeune anglais, professionel aussi . . . , nous posant des questions sur 'innovation' (!) technique (!) . . . à propos de nos essais d'amateurs datant des plus d'un quart de siècle."

6. Golda M. Goldman, "Who's Who Abroad: Lucie Schwob," *Chicago Tribune*, European ed., 23 December 1929, 4.

7. Golda M. Goldman, "Who's Who Abroad: Suzanne Moore," *Chicago Tribune*, European ed., 18 December 1929, 4.

8. Cahun described her encounter with Moore in 1909 as "une rencontre foudroyante," a lightning-bolt encounter. Francois Leperlier, "Claude Cahun: La Gravité des apparences," in *Le Rêve d'une ville: Nantes et le surréalisme*, ed. Henry-Claude Cousseau (Nantes: Musée des Beaux-Arts de Nantes, 1995), 263. In 1917, Cahun's father, Maurice Schwob, married Moore's mother, Marie-Eugènie Rondet Malherbe, entwining the lovers in a familial relationship.

9. Subsequent rolls of film shot by Moore repeatedly feature an empty scene, a horizon line unbroken by the figure of her lover.

10. Claude Cahun, "Les Jeux uraniens," unpublished ms., ca. 1914, Jersey Heritage Trust (JHT) Archives, St. Helier, Channel Island of Jersey, 34.

11. Michael Camille, "The Abject Gaze and the Homosexual Body: Flandrin's *Figure d'étude*," in *Gay and Lesbian Studies in Art History*, ed. Whitney Davis (New York: Harrington Park/Haworth Press, 1994), 164.

12. Ibid.

13. Susan Suleiman has described the work of women within the surrealist movement as "double-voiced," articulating both a "muted" and a "dominant" cultural register. Mikhail Bakhtin's notion of internal dialogism, in which a word or term is "polemically related to another, previous term that is absent but inferred by the response," structures her analysis. This tool lends itself equally well to an investigation of the photographs produced by Cahun and Moore. In

many of these photographs, the dominant (male, heterosexual) image or theme and muted (female, lesbian) response coexist. Susan Rubin Suleiman, *Subversive Intent: Gender, Politics, and the Avant-Garde* (Cambridge: Harvard University Press, 1990), 27.

14. Armand Dayot, *L'Image de la femme* (Paris: Hachette, 1899).

15. Cahun's great uncle Léon Cahun (whose name she adopted) presided over Paris's Bibliothèque Mazarine; his historical novels earned him the recognition of the Académie Française. Her uncle Marcel Schwob, a supporter of Oscar Wilde, achieved prominence in symbolist circles internationally. Her father, Maurice Schwob, owned and operated the daily newspaper *Phare de la Loire* of Nantes. Schwob also published an influential monthly cultural revue, *La Gerbe,* and a weekly supplement to the *Phare,* titled *Le Journal Littéraire.* The latter served for a time as the "mailbox of the surrealist movement," featuring in its columns contributions from Jacques Viot, Jacques Vaché, and André Breton, all of whom had ties to Nantes. See Patrice Allain, "Sous les Masques du fard: Moore, Claude Cahun et quelques autres," in "Autour de Marcel Schwob: Les "croisades" d'une famille républicaine à travers 50 ans de presse nantaise," *Nouvelle Revue Nantaise* 3 (1997): 115–133.

16. Cahun's article "La *Salomé* d'Oscar Wilde: Le procès Billing et les 47,000 pervertis du 'livre noir,'" *Mercure de France* 128 (July/August 1918): 69–80, for instance, fired off a double-barreled protest against homophobia by defending two artists, the homosexual icon Oscar Wilde and his lesbian interpreter Maud Allan, who had been attacked in the English courts on moral grounds. The editor of *Mercure,* Rachilde, published a defense of Wilde, and of France's relatively enlightened position regarding homosexuality, in the same issue: Rachilde, "Oscar Wilde et lui," *Mercure de France,* 128 (July/August 1918): 60–68. For detailed accounts of the Billing trial, see Philip Hoare, *Oscar Wilde's Last Stand: Decadence, Conspiracy, and the Most Outrageous Trial of the Century* (New York: Arcade, 1997); and Lucy Bland, "Trial by Sexology? Maud Allan, *Salomé* and the 'Cult of the Clitoris' Case," in *Sexology in Culture: Labeling Bodies and Desires,* ed. Lucy Bland and Laura Doan (Chicago: University of Chicago Press, 1998), 183–198.

Marcel Schwob, was a cofounder of *Mercure* and frequently contributed to the journal himself. The magazine's editors welcomed his niece's submissions. Her contributions to *Mercure* included several pieces expressing feminist and homophile perspectives, including an ironic tour de force called "Héroines." The collection gives voice to "the real" women behind the myths: "Eve, la trop crédule," "Dalila, femme entre les femmes," "Judith, la sadique," "Hélène, la rebelle," "Sapho, l'incomprise," "Marguerite, soeur incestueuse," and "Salomé, la sceptique" (dedicated to Wilde), *Mercure de France* (February 1925): 622–643. *Le Journal Littéraire* 45 (28 February 1925) contained two more pieces, titled "Sophie, la symboliste" and "La Belle." The manuscripts of "L'Allumeuse," "Marie," "Cendrillon," "L'Epouse essentielle," "Salmacis," and "Celui qui n'est pas un héros," which were never published during Cahun's lifetime, are preserved in the JHT Archives, St. Helier. The book version, illustrated by Moore, that Cahun envisioned never materialized.

17. The literary vignettes comprising *Vues et visions* first appeared without Moore's illustrations in *Mercure de France* 406 (16 May 1914). *Vues et visions* was published as a separate volume in 1919 by Georges Crès et Cie.

18. Claude Cahun, dedication, *Vues et visions* (Paris: Editions Georges Crès et

Cie., 1919). "À Marcel Moore: Je te dédie ces proses puériles / afin que l'ensemble du livre / t'appartienne et qu'ainsi / tes dessins nous fassent / pardonner mon texte."

19. E.g., John Addington Symonds, *Studies of Greek Poets* (1873) and "A Problem in Greek Ethics" (1897); Walter Pater, *Greek Studies: A Series of Essays* (1910) and *Plato and Platonism: A Series of Lectures* (1910); and Edward Carpenter, *Intermediate Types among Primitive Folks* (1919).

20. Fonds Maison des Amis des Livres, Adrienne Monnier/Maurice Saillet, Institut Mémoire de l'Édition Contemporaine (IMEC), Paris, ADR2.R7-03. Régistre: Inscription à la biliothèque, livres empruntés. The entry reads: "Lucie Schwob *(No 117)/15 Décembre 1918/Déc 17, Du Dandysme 7 50* [Barbey d'Aurevilly] */– –, Parallelement* [Verlaine] *4 50/* Janvier 10, *Le Banquet de Platon 3 00/Avril 2, Le Prométhée mal enchainé ed. or. 15/– –, Chemin de Crois*—Claudel *2 50.*"

21. Pierre Louÿs, *Les Chansons de Bilitis* (Paris: Librairie de l'Art Indépendant, 1895), n.p. "Ce petit livre d'amour antique est dédié respectueusement aux jeunes filles de la société future."

22. For instance, in the 1950s Dell Martin and Phyllis Lyon named the first lesbian advocacy organization in the United States the Daughters of Bilitis. Claude Cahun, "Sapho, l'incomprise," *Mercure de France* (February 1925): 622–643.

23. Cahun, *Vues et visions*, 94: "vers l'inconnue, à tâtons dans l'obscurité."

24. Ibid., 94. "Est-ce le ciel, est-ce la mer, est-ce la mort, est-ce . . . ? on ne sait pas. . . .Vers la clarté blanche, seule espérance, unique fin de cette nuit obscure, le long du chemin sombre à peine indiqué par les feux verts qui vacillent, deux ombres s'avancent, enlacées."

25. Ibid., 95. "Deux formes blanches passent et s'éloignent, confondues dans une brume dorée. Elles s'en vont vers la ville, dont les toits scintillent aux premiers rayons de l'aurore, elles s'en vont plus loin peut-être, vers l'inconnue, dans la lumière et dans la joie."

26. Ibid. "À l'horizon, une vague lumière rose. Est-ce le soleil levant, est-ce un Eros sans flèches, une vie nouvelle, est-ce . . . ? on ne sait pas."

27. Address book of Cahun/Moore, JHT Archives, St. Helier.

28. Virginia Woolf, *Orlando: A Biography* (London: Hogarth Press, 1928).

29. Virginia Woolf, *The Letters of Virginia Woolf: 1923–1928*, vol. 3, ed. Nigel Nicolson and Joanne Trautmann (New York: Harcourt, 1978), 429.

30. For instance, Man Ray, in *Self-Portrait*, the autobiography he began writing in 1951, laced the opening chapters of his life story with anecdotes of childhood precocity that worked to naturalize his vocation as a creative genius. "Looking back, I cannot help admiring the diversity of my curiosity, and of my inventiveness," he wrote. "I was really another Leonardo da Vinci." Man Ray, *Self-Portrait*, (New York: Bulfinch Press, 1998), 15. As Ernst Kris and Otto Kurz have demonstrated, since the publication in the 1550s of Giorgio Vasari's compendium *Lives of the Most Eminent Painters, Sculptors and Architects*, the biographies of canonical Western artists from Giotto to Picasso have shared remarkably similar childhood chapters; the anecdotes unfailingly authenticate the artist's status by constructing genius as an in-born condition. Ernst Kris and Otto Kurz, introduction to *Legend, Myth, and Magic in the Image of the Artist* (New Haven: Yale University Press, 1979), 1–12.

31. Roland Barthes, "Death of the Author," in *Image, Music, Text*, trans. Stephen Heath (New York: Hill and Wang, 1977), 143.

32. Here it would be useful to reconsider, and in slightly different terms, the question of the pseudonym. If the proper name speaks to specific social relations

within patriarchal societies, notably underlying kinship structures, the artist's name functions on an additional register; it serves, as Michel Foucault in his 1969 essay "What Is an Author?" points out, as a "means of classification," a kind of brand name. Michel Foucault, "What Is an Author?" in *Language, Counter-Memory, Practice: Selected Essays and Interviews*, ed. Donald Bouchard (Ithaca: Cornell University Press, 1977), 123. The author's name is not entirely a function of its bearer's civil status nor a product of fiction; it spans, as Foucault notes, "the breach, among the discontinuities, which give rise to new groups of discourse and their singular mode of existence" (23).

33. Merry A. Foresta, in her foreword to Man Ray's memoir *Self-Portrait*, reports that the artist assembled a self-commemorative album in 1934, creating a bronze self-portrait bust especially for the cover photograph. He described the project as "a sort of propaganda" with the self at the center "as the commodity to sell" (10).

34. Henri Bergson, cited in Cahun, "Jeux uraniens," 14. "La négation diffère donc de l'affirmation proprement dite en ce qu'elle est une affirmation du second degré."

35. Goldman, "Who's Who Abroad: Lucie Schwob," 4.

36. Lucie Schwob to Adrienne Monnier, Paris, 2 July 1926, IMEC, Caen.

37. Ibid. "Mais il est des jours où je souffre tant de cet isolement, dont ma nature surtout mais aussi toute sorte de circonstances sont cause, que . . . "

38. Ibid. "Vous m'avez dit d'écrire une confession parce que vous savez bien que c'est actuellement la seule tâche littéraire qui puisse m'apparaître tout d'abord réalisable, où je me sente à l'aise, me permettant une prise directe, un contact avec la vie concrète, avec les faits. . . . Mais je crois avoir bien compris de quelle façon, sous quelle forme vous entendiez cette confession (en somme: sans tricherie d'aucune sorte)."

39. Lucie Schwob to Adrienne Monnier, Nantes, 23 July 1926, BLJD, Paris. "N'ayez pas grand espoir."

40. Ibid. "D'ailleurs, quoi que je fasse, jamais je ne pourrai éviter vos objections, trop profondes, qui s'adressent à l'essence même de mon tempérament."

41. "Confidences au miroir," an open-ended essay begun by Cahun ca.1945 and dedicated to Suzanne Malherbe, was published only recently in François Leperlier, *Claude Cahun, écrits* (Paris: Jean-Michel Place, 2002). Cahun published her meditations on various subjects in revues such as *La Gerbe* and *Philosophie*.

42. Barthes, "Death of the Author," 143.

43. Jean-Jacques Rousseau, *Les Confessions* (Paris: Garnier-Flammarion, 1968), 1:43. "Je forme une entreprise qui n'eut jamais d'exemple et dont l'exécution n'aura point d'imitateur. Je veux montrer à mes semblables un homme dans toute la vérité de la nature; et cet homme ce sera moi. Moi seul. Je sens mon coeur et je connais les hommes. Je ne suis fait comme aucun de ceux que j'ai vus; j'ose croire n'être comme aucun de ceux qui existent. Si je ne vaux pas mieux, au moins je suis autre. Si la nature a bien ou mal fait de briser le moule dans lequel elle m'a jeté, c'est ce dont on ne peut juger qu'après m'avoir lu." Despite Rousseau's self-designation as initiator of the autobiographical enterprise, we should note that nearly two centuries earlier, in 1580, Michel de Montaigne set precisely the same task for himself; in a note to the reader that prefaces his autobiography, he writes: "Je veus qu'on m'y voie en ma façon simple, naturelle, et ordinaire, sans contention et artifice: car c'est moy que je peins. . . . Ainsi, lecteur, je suis moy-mesmes

la matière de mon livre" (I would like to be seen simply as I am, natural, and ordinary, without contention and artifice: because it is I whom I paint. . . . In this way, reader, I am myself the material out of which my book is made). Michel de Montaigne, "Au Lecteur," in *Essais* (Paris: Gallimard/Pléiade, 1950), n.p. Rousseau virtually cites Montaigne in the preface and introductory paragraphs of his own autobiography: "Voici le seul portrait d'homme, peint exactement d'apès nature et dans toute sa vérité, qui existe et qu probablement existera jamais" (Here is the only portrait of a man painted exactly after nature and absolutely true in every way that exists and probably ever will exist) (preface to *Confessions*, n.p.).

44. It is tempting to speculate that one of the voices may indeed be that of Moore. Patrice Allain, in "Sous les Masques du fard," points to similarities of style that complicate any certain attribution to Cahun of certain published texts (among them, *Vues et visions*). However, it is clearly the mobility and indeterminacy of the subject position that matters here—and emphatically not the attribution of authorship or identification of fictional characters with biographical counterparts.

45. Cahun and Moore were involved for several years during the 1920s in the Théâtre Esotérique, founded by Berthe d'Yd and Paul Castan. Here Cahun occasionally performed and Moore designed costumes and sets. In this context, they grew close to an exotic dancer, an American expatriate named Beatrice Wanger, whose stage name was Nadja (like the heroine of André Breton's later novel of the same name). The company produced "dramatic tableaux that made one dream, because of the preciousness and refinement of the palette, of Oscar Wilde's Salomé." Unreferenced clipping, dated 29 December 1923, Bibliothèque de l'Arsenal, Paris, RT 3993 SR97/1984,1923.

During this period, Cahun successfully auditioned before Georges and Ludmilla Pitoëff but was unable to keep pace with the demands of the company due to fragile health. In 1929, Cahun joined Pierre Albert-Birot's company Le Plateau, where she performed as Satan ("Le Diable") in Albert-Birot's adaptation of a twelfth-century mystery play, *Les Mystères d'Adam*, in March 1929. Cahun earned critical praise for her role as Blue Beard's wife (the character named Elle) in Albert-Birot's play *Barbe bleue*. She also performed in *Banlieu*, which was not as well received. Moore apparently did not produce costumes or sets for Le Plateau but documented several of Albert-Birot's productions photographically, including those in which Cahun performed. Albert-Birot mapped out a research program for new modes of dramatic expression in the theater's "Programme-Revue," *Le Plateau*. Cahun presented excerpts from *Aveux non avenus* in this publication, in which Moore's portraits of the members of the company also appeared.

Albert-Birot's theater Le Plateau (the name evokes the "naked stage," theater at its essence) survived for only one season but left a mark, nonetheless, upon the history of modern theater. The troupe lent impetus to the era's most radical trends, incorporating the ideas of theorists such as Brecht (the alienation effect) and E. G. Craig (the shift of dramatic emphasis away from the actor). With Apollinaire, Albert-Birot envisioned a theater in the round in which the members of the audience, acknowledged and activated as participants in the interpretive process, occupied the center of the theatrical arena. He shared with Apollinaire and other members of the Parisian avant-garde an interest in puppet theater as a locus of cultural renewal. (Albert-Birot supported two associations—Les Amis de la Marionnette and l'Association de Nos Marionettes—whose members included

Apollinaire, Philippe Soupault, Ivan Goll, Joseph Delteil, Jean Lurçat, Juan Gris, Marc Chagall, and Maeterlinck, among others.) Although his own early ambitions for exploiting body puppetry outstripped his technical capacities and means, he urged his cast members to void themselves of individual character, acting instead as human marionettes in the service of the poetic text.

I am obliged to Arlette Albert-Birot for sharing her insights and writings about Pierre Albert-Birot's theatrical activities with me.

46. Cahun, "Jeux uraniens," 29. "Mais ce qui me plait surtout dans ton entreprise incomplète et close, ce sont les places que tu as su laisser vides."

47. Leigh Gilmore, "An Anatomy of Absence," *Genders* 26 (1997): 237.

48. Terry Castle, *The Apparitional Lesbian: Female Homosexuality and Modern Culture* (New York: Columbia University Press, 1993), explores absence as signifier of the lesbian subject.

49. Barthes, in "Death of the Author," describes this kind of modern text, which reduces the all-knowing author to a humble scribe, as a "tissue of quotations" (146).

50. Claude Cahun and Marcel Moore, *Aveux non avenus* (Paris: Editions du Carrefour, 1930), 119. "Je recopie cet exercice (que mon partenaire écrivait en temps voulu et de ma propre main) pour montrer comment nous cherchons à délimiter nos personnages."

51. Jennifer Shaw's essay "Singular Plural: Collaborative Self-Images in Claude Cahun's *Aveux non avenus*" considers in depth the questions of authorship and originality that this body of work raises.

52. In "Death of the Author," Barthes calls our attention to works of modern literature that problematize the author's role as the originator of the text. He notes that Marcel Proust, for example, rather than basing the narrative of *À la Recherche du temps perdu* on his life (as convention would have it), "made his very life a work for which his own book was a model" (144). Barthes tracks the "desacrilization" of the author from Balzac, through the decadent school, up to the advent of the surrealist movement. He draws out the continuities between decadent Symbolism and Surrealism, the two outsiders of high Modernism, and two movements with which Cahun and Moore identified closely.

53. Suleiman, *Subversive Intent*, 14.

54. As Judith Butler has argued, "If it is already true that 'lesbians' and 'gay men' have been traditionally designated as impossible identities, errors of classification, unnatural disasters within juridico-medical discourses, or what amounts to the same, the very paradigm of what calls to be classified, regulated, and controlled, then perhaps these sites of disruption, error, confusion and trouble can be the very rallying points for a certain resistance to classification and to identity as such." Butler, "Imitation and Gender Insubordination," in *Inside/Outside: Lesbian Theories, Gay Theories*, ed. Diana Fuss (New York: Routledge, 1991), 13–31. Cahun and Moore theorized lesbianism, similarly, as a position of "noncooperation with God" (*Aveux non avenus*, 39).

55. Cahun and Moore, *Aveux non avenus*, 215. "Chaque fois qu'on invente une phrase, il serait prudent de la retourner pour voir si elle est bonne."

56. Ibid. "C'est plus facile que la preuve par neuf."

57. Michel Foucault, *The History of Sexuality*, vol. 1, *An Introduction*, trans. Robert Hurley (New York: Vintage Books, 1990), 64.

58. Henri Michaux sometimes accompanied Cahun, as several of his letters indicate. I thank Mireille Cardot for sharing Michaux's letters with me.

59. Robert Folkenflik, "The Self as Other," in *The Culture of Autobiography: Constructions of Self-Representation*, ed. Robert Folkenflik (Stanford: Stanford University Press, 1993), 234.

60. Advice columnist Lynn E. Linton, in *Modern Women* (1889), cited in Bram Dijkstra, *Idols of Perversity: Fantasies of Feminine Evil in Fin-de-Siècle Culture* (New York: Oxford University Press, 1986), 135.

61. Cahun and Moore, *Aveux non avenus*, 38. "Le mythe de Narcisse est partout. Il nous hante."

62. I discuss another example, Antoine Magaud's 1885 painting *A Kiss in the Glass,* at some length in Tirza True Latimer, "Looking Like a Lesbian: Portraiture and Sexual Politics in 1920s Paris," in Chadwick and Latimer, *Modern Woman Revisited*, 135–136.

63. "Editorial on the publication of Havelock Ellis's *Sexual Inversion*," *Lancet*, 1896, as cited in Lucy Bland and Laura Doan, eds., *Sexology Uncensored: The Documents of Sexual Science* (Chicago: University of Chicago Press, 1998), 51–52.

64. Havelock Ellis, *La Femme dans la société*, vol. 1, *L'Hygiène sociale, études de psychologie sociale*, trans. Lucy Schwob (Paris: Mercure de France, 1929). This work was published in English in the context of the author's multivolumed *Study of Social Psychology*. Cahun's French translation of the second volume of *La Femme dans la société* was never published. In a letter to Adrienne Monnier dated 1926, Cahun emphasizes the centrality of Ellis's work to her intellectual development.

65. Havelock Ellis, "Auto-Erotism, a Psychological Study," cited in Dijkstra, *Idols of Perversity*, 145. If the mirror plays a more or less symbolic role in Ellis's texts, his contemporary Otto Rank paints a more literal picture of feminine narcissism. He records a case study of a "narcissistic" woman who "would sometimes feel sexual excitement when seated before a mirror doing her hair." Cited in Dijkstra, *Idols of Perversity*, 146.

66. Cahun and Moore, *Aveux non avenus*, 38. "L'invention du metal poli est d'une claire étymologie narcissienne."

67. Sigmund Freud, "On Narcissism: An Introduction" (1914), in *The Standard Edition*, trans. and ed. James Strachey (London: Hogarth Press, 1957), 14:89. Freud's characterization of homosexuality owes a measure of its credibility to the complicity of homosexuals. Even before the publication of Freud's essay on narcissism, Narcissus had a history within male homosexual subcultures: Nijinsky's 1911 ballet *Narcisse*, for instance, enjoyed cult status within Paris's homosexual high society; Jean Cocteau, exploiting this subcultural cliché, episodically adopted the pen name "Narcisse" during the 1920s.

68. Havelock Ellis, *Sexual Inversion* (London: Wilson and MacMillan, 1897), 87–88.

69. Ibid. Ellis's attempt to account for lesbians who exhibit no masculine characteristics or proclivities goes beyond the territory explored by sexologists such as Richard von Krafft-Ebing, who sees lesbianism as a sort of psychic by-product of biological masculinity; for Krafft-Ebing, too, the lesbian may be readily identified by her physical manliness. The congenital model (figuring homosexuality as an inborn disposition, not a matter of criminal or sinful conduct) legitimated homophile pleas for tolerance and was widely embraced by early twentieth-century homosexual advocates (from sexologists like Magnus Hirschfeld to novelists like Radclyffe Hall). The element of choice, however, had more profound political implications. The fact that feminism is so often characterized as "leading to"

lesbianism, in both pro- and antifeminist writings of the period, affirms the disruptive potential of the free-will, or sexual-preference, model.

70. A "mirror with a memory" refers to the fact that the daguerreotype reflected back, off of its silvery surface, an uncannily precise image of the sitter; both the exactitude of the resemblance and the mirrorlike quality of the photographic plate made the mirror an apt analogy. Oliver Wendell Holmes, Sr., reportedly coined the phrase "mirror with a memory." The longer quotation is from a letter dated 20 September 1920, cited in Cahun and Moore, *Aveux non avenus*, 13. "Nos deux têtes (ah! que nos cheveux s'emmêlent indébrouillablement) se penchèrent sur une photographie. Portrait de l'un ou de l'autre, nos deux narcissismes s'y noyant, c'était l'impossible réalisé en un miroir magique. L'échange, la superposition, la fusion des désirs. L'unité de l'image obtenu par l'amitié étroite des deux corps—aux besoins qu'ils envoient leurs âmes au diable!"

71. Cahun and Moore, *Aveux non avenus*, 9. "Narcissisme? Certes. C'est ma meilleure tendance."

72. "Let us recognize," Richard Meyer has urged in a similar vein, "the individual's need not only to inhabit the space of identity but also, and even simultaneously, to get the hell out of there." Richard Meyer, "Identity," in *Critical Terms for Art History*, ed. Robert S. Nelson and Richard Schiff (Chicago: University of Chicago Press, 2003), 356.

73. Cahun and Moore, *Aveux non avenus*, 39.

74. Peggy Phelan, *Unmarked: The Politics of Performance* (New York: Routledge, 1993), 16.

75. Sue-Ellen Case, in "Meditations on the Patriarchal Pythagorean Pratfall and the Lesbian Siamese Two-Step," argues that the "lesbian body, defined by its desire, is always two bodies." Case, "Meditations," in *Choreographing History*, ed. Susan Leigh Foster (Bloomington: Indiana University Press, 1995), 198.

76. Mary Ann Doane, *Femmes Fatales: Feminism, Film Theory, Psychoanalysis* (New York: Routledge, 1991), 47.

77. Leperlier, "L'Oeil en scène," n.p.

78. Cahun and Moore, *Aveux non avenus*, 66. "Moments les plus heureux de toute votre vie? . . . Le rêve. Imaginer que je suis autre. Me jouer mon rôle préféré."

79. The collage medium, which signifies by appropriating and displacing found elements, adheres to the Freudian principles of "dream work." In dream work, unarticulated and/or unspeakable (repressed) memories re-present themselves in some disguised form in order to escape the attention of the conscious mind's censor. The texts of Freud elucidating this and other mechanisms that permit the unconscious to circumvent the interdictions of consciousness inspired attempts by Cahun and Moore's circle to formalize dream theory in surrealist practices such as collage, found poetry, automatic writing, and in various photographic and cinematic procedures such as multiple exposure, splicing negatives, dodging, solarization, time lapse and strobe photography, the use of distorting lenses, cinematic crash cutting, and over- and undercranking the movie camera.

80. Cahun, "Jeux uraniens," 73. "Parce que je vois le monde à travers toi, il ne faut pas m'en croire plus mauvais observateur. Tu ne m'as pas fermé ton âme, tu ne m'as pas refusé l'usage de ton regard clair. . . . Tes yeux, loin de troubler ma vue, lui sont des lunettes correctrices."

81. Both Cahun and Moore spoke English fluently. English puns, among other forms of wordplay, enliven the pages of *Aveux non avenus*.

82. Cahun and Moore, *Aveux non avenus*, 229–230.

Libéré de l'anneau (cette prison, l'orbite), peut-être le globe de l'oeil se met-
trait à tourner . . . Il évoluerait dans le ciel, se peuplerait de mes créatures,
adorable monde!
 Il s'est assez vu. Ne s'appartient plus. On l'a détourné de son cours.
Cette amertume qui l'attachait étroitement à soi s'est modérée. Aucune
intimité possible entre nous. Le voilà pris dans sa vie nouvelle, englué dans
ce goût pluriel des réalités—transitoires, accessoires. Toute concentration
s'est dispersée dans la curiostité de connaître, de changer l'inconnaissable,
l'inchangeable monde, dans la volonté d'agir (ne fût-ce que sur soi), dans le
souci de se mêler à tout. (lui qui se démêlait d'autrui si exclusivement!)—
Devenir au lieu d'être. Il se sent aliéné. Autant dire: vendu.
 Il faut en finir.
 Frapper en plein visage, en plein centre de l'âme, au coeur de l'oeil—du
seul qui compte (mon oeil droit, de naissance, est un miroir sans tain.) Frap-
per au plus visible: en plein noir de la pupille dilatée. Et pour ne pas rater
son coup, devant la glace grossissante. . . .
 C'est presque fait déjà. En somme, il ne reste plus que le bout crispé du
doigt, la gueule ronde prête à hurler quand bondira la balle—et le but, la
proie, la peur, le cercle d'ombre s'élargissant. . . .
 Pour la première fois, les belles petites images convexes, les enluminures
de l'oeil, les miniatures innocentes du monde, les faibles représentants de
l'espace, les reflets, ont cessé d'être. Ce que je vois là-dedans: cet abom-
inable trou qui saigne, vient du temps, de moi, de l'intérieur.
 Une main retombe, molle.
 L'intensité, la honte, pouvaient suffire: s'il n'est pas mort, il n'en vaut
guère mieux. L'oeil droit dédaigné, rageur, jette son encre sympathique—et
l'oeil gauche renonçant à soi-même, à la pourpre, aux prodiges, n'ose enfin
se regarder.

83. Phelan, *Unmarked*, 33.
84. Cahun and Moore, *Aveux non avenus*, 235.
85. Rousseau, *Confessions*, 1:44. If "Moi-seul" describes the fully enfranchised
subject of patriarchal discourse (with its monotheistic God, its hierarchical logic,
its single vanishing point), "Moi-meme (faute de mieux)" represents fleeting posi-
tions held, "for want of something better," by the disenfranchised.
86. Cahun and Moore, *Aveux non avenus*, 230. "Le cercle d'ombre s'élargissant."
87. Rosalind Krauss, "Corpus Delicti," in *L'Amour Fou: Photography and
Surrealism,* by Rosalind Krauss and Jane Livingston (New York: Abbeville Press;
Washington, DC.: Corcoran Gallery, 1985), 95.
88. Cahun and Moore, *Aveux non avenus*, 229. "Devenir au lieu d'être."
89. Butler, "Imitation and Gender Insubordination," 16.
90. Cahun, "Jeux uraniens," 83. "Ainsi tu vis, posant ton empreinte sur mes
actes pour les faire admirer."
91. The hand bears the following arithmetic equation: "Dieux × Dieux / Dieux
= Moi = Dieux" (God times God divided by God equals Me equals God). Cahun
and Moore, *Aveux non avenus*, 34.
92. Ibid. "Entre mille tâtonnements, qu'une seule fois j'ai mis le doigt sur Dieu,
(au fond du coeur et j'aurai beau m'en défendre) me voilà passé prophète."

93. Ibid., 35. "Il y a trop de tout."

94. Ibid. "Si un cube n'entre pas dans ma construction, je le supprime. Un à un je les retire tous. . . . Je me fais raser les cheveux, arracher les dents, les seins — tout ce qui gène ou impatiente mon regard — l'estomac, les ovaires, le cerveau conscient et enkysté."

95. Ibid., 147.

96. Ibid., 176. "Brouiller les cartes. Masculin? féminin? mais ça dépend des cas. Neutre est le seul genre qui me convienne toujours. S'il existait dans notre langue on n'observerait pas ce flottement de ma pensée."

97. Barthes, "Death of the Author," 144.

98. Cahun and Moore, *Aveux non avenus*, 235. "Me faire un autre vocabulaire, éclaircir le tain du miroir, cligner de l'oeil, me flouer . . . corriger mes fautes et recopier mes actes, me diviser pour me vaincre, me multiplier pour m'en imposer . . . ça n'y peut rien changer."

99. Cahun's Jewish identity might also be viewed, like this six-pointed star, as a cultural label tied around her neck, one partially eclipsed by the secularity of her background and her own representational choices.

100. Cahun and Moore, *Aveux non avenus*, 58. "Devant son miroir . . . touchée de la grace. . . . Elle consent à se reconnaitre. Et l'illusion qu'elle crée pour elle-même s'étend à quelques autres."

101. Sandra M. Gilbert and Susan Gubar, "'She Meant What I Said': Lesbian Double Talk," in *No-Man's Land: The Place of the Woman Writer in the Twentieth Century* (New Haven: Yale University Press, 1989), 222. Gilbert and Gubar focus on the creative relationship of Gertrude Stein and Alice Toklas, among others.

102. Elisabeth de Gramont, introduction to *Romaine Brooks: Portraits, tableaux, dessins* (Paris: Braun et Cie., 1952), 4. "Indifférente aux honneurs et aux témoignages de reconnaissance, elle aspire à rester partout étrangère."

103. Gilbert and Gubar, "'She Meant What I Said,'" 22.

104. Revelation 21:1. I thank James Leventhal for calling my attention to the full citation.

105. Cahun and Moore, *Aveux non avenus*, 117. "SINGULIER PLURIEL / Nous. / 'Rien ne peut nous séparer.'"

CHAPTER 4. SUZY SOLIDOR AND HER LIKES

The epigraph by Paul Valéry, composed for Solidor, is translated "What reason have you to blame me? / I love as I please / whom it pleases me to love."

1. The Parisian chanteuse posed for some 250 portraits over the course of a performance career that spanned three decades. The collection grew, from its inception in the early 1920s, to include no less than a hundred portraits during the period under consideration in this chapter, the decades between the wars. Solidor donated forty portraits, representative of the collection, to the Château-Musée, Haut-de-Cagnes, the fortress village to which Solidor retired in 1960 and where she operated her last club, Chez Suzy. The Château-Musée acquired a number of additional portraits by posthumous donation and made several purchases (including Solidor's press books and some of her furniture) at auction. The auctioneer at the Galerie Robiony, 50 r. Gioffredo, Nice, passed close to two hundred paintings from the collection under his gavel on 6–7 July 1983.

2. Suzy Solidor, cited in Jacques Robert, "Avec cent quinze tableaux et un chien né d'un lion et d'une chèvre, Suzy Solidor va faire le tour du monde," *Paris*

Matin, 7 November 1947, unpaginated press clipping, Bibliothèque de l'Arsenal (BA), Paris, RT 10750.

3. Ibid., n.p.

4. G. Rouland, cited in Karine Jay, "Suzy Solidor (1900–1983): Portrait(s) d'une artiste à la frange dorée de l'art," master's thesis, Université Jean Moulin, Lyon III, 1996, 61b. Solidor's portraits bear the signatures of artists from Greece, Russia, Germany, Portugal, Japan, England, Spain, Belgium, Holland, Austria, Canada, Poland, the United States, Venezuela, and Italy, as well as France.

5. For an elaboration of this notion, see Donald Preziosi, "Collecting/Museums," in *Critical Terms for Art History*, ed. Robert S. Nelson and Richard Shiff (Chicago: University of Chicago Press, 2003), 409.

6. Robert Surcouf (1773–1827) began his seafaring career as a slave trader. In 1795 he launched a series of campaigns (which amounted to state-financed piracy) targeting the English merchant marine fleet in the Indian Ocean. His triumphs as a corsair made him a popular hero in France and one of the most hunted men in English maritime history. The British crown offered a sizable reward for his capture or death. In 1802, having narrowly evaded the bounty hunters, he returned to Saint-Malo with a cargo valued at two million francs. In 1815, after conducting yet another spectacular campaign in the Indian Ocean, he turned to relatively legitimate commercial ventures. Whether or not Surcouf's distant descendant actually sired Suzy Solidor has never been proven or officially acknowledged. Solidor's claim was vehemently denied by the family but not (according to the testimony of several people in Solidor's entourage) by her alleged father, who frequented the club (once Solidor's fame was established) and even contributed a drawing of his own to her portrait collection.

7. Suzy Solidor, "Suzy Solidor révèle son étrange destin de femme sans hommes," *Confessions* 1, 3 (December 1936): 22. The biographical narrative I recount here draws on Solidor's sensationalized autobiographical article for Joseph Kessel's popular magazine *Confessions*, which I introduce, as with Brooks's memoirs "No Pleasant Memories" and Cahun and Moore's *Aveux non avenus*, as a form of self-representation, not an evidentiary document. Certain aspects of the tale she tells, though—such as her military exploits—are verifiable. Karine Jay, in her thesis, "Suzy Solidor: Portrait(s) d'une artiste à la frange dorée de l'art," documents Solidor's career as an ambulance driver, for instance, and reproduces a photograph of Solidor in uniform.

8. Suzy Solidor, *Deux Cents Peintres, un modèle* (Paris: Nef de Paris, n.d.), n.p. "Cette femme, près de laquelle je vivais, a fait de la petite Bretonne inculte que j'étais un Parisienne."

9. Solidor, "Solidor révèle son étrange destin," 24. "Elle me sculptait, ajoutant quelque chose à son oeuvre chaque jour."

10. Ibid., 23. "Quant à moi, je garde trop de reconnaissance à Mademoiselle, j'ai en vérité trouvé trop de plaisir à notre vie commune pour crier au scandale, au rapt, ou à la perversion. Tout ce que je puis dire, c'est que je n'étais pas une tribade-née."

11. Ibid. "Mademoiselle composait avec patience l'atmosphère propice à mon initiation. Les livres mis à ma disposition célébrient tous le cultre saphique. Femmes, de Verlaine, voisinait avec les oeuvres de Renée Vivien."

12. Jacques Robert, untitled clipping, 1930s, BA, Paris, microfilm RO16340. "Elle vie là, parmi des manuscrits de Pierre Louÿs et de Valéry, vantant la beauté des amours de Bilitis ou de Chlöe."

13. Solidor, "Suzy Solidor révèle son étrange destin," 24. To celebrate the tenth anniversary of their "marriage," Bremond d'Ars presented Solidor with *Le Livre d'amour*, a volume of verses and engravings created uniquely for Solidor and signed by the "most of the artists of our era."

14. Ibid. "Elle fit faire mon portrait, presque toujours nue, par une quantité de peintres, tels que Domergue, Van Dongen, Marie Laurencin, Vertès, Foujita, Kisling . . . j'en passe et des meilleurs. Sa chambre en était tapissée."

15. Ibid. "C'était la grande époque de Deauville où Mademoiselle, tous les ans, menait grand train, tenait table ouverte. Elle m'y exhibait avec un sorte de rage ostentatoire."

16. "A bastard is an infringement of all the rules," Violette Leduc asserts in her memoir *La Bâtarde*; the originary infringement of illegitimacy—irreconcilable—imposes a kind of template on the life of the bastard from cradle to grave, according to Leduc. Although Leduc suffered acutely from the stigmatizing conditions of her birth, Solidor made the most of her bastard status. She reclaimed infringement (of every imaginable sort) as her legitimate purview. Violette Leduc, *La Bâtarde*, trans. Derek Coltman (1964; reprint, New York: Farrar, Straus and Giroux, 1979), 44.

17. Cited by Jacques Primack, in an insert to *Suzy Solidor, la fille aux cheveux de lin: 1933–1939*, Chansonophone recording 121, n.d. "Nos enfants n'ont pas l'habitude de s'habiller avec trois rubis dont deux sur la poitrine ou de s'exhiber avec un maillot en écailles ou en filet de pêcheur."

18. In the twelfth century, the town introduced a law of asylum, making it an attractive shelter for the fortunes of pirates, corsairs, and smugglers.

19. In 1934, when Solidor became the first chanteuse televised in France, the TV appearance did not widen her audience—only a few dozen French households owned television sets. However, the event attracted extensive coverage in the press. Pioneering television as a performance venue reinforced Solidor's public identification with the signs and conditions of modernity. M. H. Berger, "La Télévision en est aujourd'hui au point ou était la T.S.F. en 1922 lors des premières émissions radiola: Les impressions de Suzy Solidor, première chanteuse de music-hall 'télévisionnée' par les P.T.T.," *Excelsior*, 6 June 1934, unpaginated press clipping, BA, Paris, microfilm RO16340.

20. Unreferenced clipping, Solidor press book, Chateau-Musée Archives (C-M Archives), Cagnes-sur-Mer.

21. Suzy Solidor, *Fil d'or* (Paris: Editions de France, 1940), 102–103. "Tu navigueras là où la mer est la plus sévère, la plus dure aux marins. Combats avec elle, chaque jour de ta vie. Triomphe, ce sera ton honneur et ta rédemption."

22. Suzy Solidor, "Les Feux de la rampe," part 3, radio broadcast, 1 October 1971, Radio-France (RF) Archives, Paris, 200V 1127.

23. One was Lucienne Boyer, who worked her way up from popular music halls to increasingly exclusive venues and finally opened her own nightclub in 1930; it closed later that year. In Montparnasse, the duo Pills and Tabet operated *Chez Elle* with more success. Finally, in 1938, Agnès Capri opened Capricorne in an upscale locale between the Palais Royal and the Opéra (just around the corner from Solidor's La Vie Parisienne).

24. Susan Stewart, in her chapter on the "objects of desire," explores the role that collecting plays in the creation of presence, absence, and milieu. See Susan Stewart, *On Longing: Narratives of the Miniature, the Gigantic, the Souvenir, the Collection* (Durham, NC: Duke University Press, 1993), 157.

25. Solidor, *Deux Cents Peintres*, n.p.: "une Parisienne qui aurait gardé tous les défauts et les qualités de sa race."

26. Albert E. Gallatin compiled a list of representations of Whistler, *Portraits and Caricatures of James McNeill Whistler: An Iconography*, in 1913 that identified some four hundred works.

27. Abigail Solomon-Godeau, "The Legs of the Countess," in *Fetishism as Cultural Discourse*, ed. Emily Apter and William Pietz (Ithaca: Cornell University Press, 1993), 268–269. If the question of feminine agency remained vexed for women of Solidor's generation, the debate had at least been ushered into a more public arena by artists such as Brooks, Cahun and Moore, and Solidor herself.

28. With respect to the star system emerging in the early twentieth century, see Richard Dyer, *Heavenly Bodies: Film Stars and Society* (London: Macmillan, 1987).

29. Goldwyn broke new ground in 1925 by establishing a permanent in-house photography department; this gave the studio absolute control over an actor's image. Distinct genres emerged, each requiring a specialist: the film still on location, the glamorous studio portrait, the product endorsement photo, the casual shot off the set.

30. A 1934 photograph by Jean Morel, which I did not succeed in obtaining permission to reproduce despite the determined efforts of Tom Gitterman (Tom Gitterman Gallery, New York), shows the star's face hovering like a logo over her name amid a field of neon lights and specterlike reflections.

31. Louise Brooks, cited in Robert Dance and Bruce Robertson, introduction to *Ruth Harriet Louise and Hollywood Glamour Photography* (Berkeley and Los Angeles: University of California Press/Santa Barbara Museum of Art, 2002), n.p.

32. Roland Barthes, "The Face of Garbo," in *A Barthes Reader*, ed. Susan Sontag (New York: Hill and Wang), 83–84.

33. *Portrait of Mlle S. avec le chien Pacha appartenant à Mlle de Bremond d'Ars*, for instance, was reproduced as a full-page illustration in the *Catalogue officiel illustré* of the Société Nationale des Beaux-Arts Salon in 1926. Lempicka's portrait, exhibited at the 1933 Salon des Indépendants, was reproduced in several journals.

34. "Un Bel Atelier moderne," *actualités féminines* (women in the news, news for women), newsreel, Pathé, 1932.

35. Jean-Gabriel Domergue identified himself as the "inventor of the pin-up." Marie Wallet, "Jean-Gabriel Domergue," in *1918–1958: La Côte d'azur et la modernité* (Paris: Réunion des Musées Nationaux, 1997), 210.

36. René Guetta, unreferenced press book clipping, ca. 1940, C-M Archives, Cagnes-sur-Mer. "Je l'admire comme femme et comme artiste—et je ne dois pas être seul, puisque cent peintres—les uns plus connus que les autres—exécutèrent son portrait. Ils pendaient tous aux murs, ces portraits de Foujita, de Marie Laurencin, de Domergue, de Van Dongen, de Trucmuche ou de Machinskoff et si on a le bonheur d'être ivre-mort, on en voit mille, deux mille qui tourbillonnent follement devant les yeux. . . . Mais la Suzy Soloidor en chair et en os faisait pâlir cette collection d'oeuvre d'art."

37. "Un Quart d'heure avec Suzy Solidor," part 2, radio broadcast, 7 April 1948, RF Archives, Paris, NS3108. "Chaque soir, mes amis les peintres venaient me voir, à la fois pour me dire bonjour mais aussi pour constater que leur portrait était bien en place."

38. Ibid. "Des journalistes, bientôt, les accompagnèrent, probablement satisfaits d'effectuer des reportages sur le tout."

39. Cocteau's illustrations for Jean Genet's homoerotic novel *Querelle* (1948) earned Genet a fine and a jail sentence for "offence against public decency."

40. Marius-Ary Leblond, "Mariette Lydis," *La Vie*, 15 July 1928, unpaginated clipping, Fonds Bouglé, Bibliothèque Historique de la Ville de Paris. Regarding an exhibition of forty paintings and illustrations at the Galerie Trémois, Leblond wrote: "La suavité dans la torture. Le monde de la souffrance et de la volupté s'ouvre. Une grande artiste, avec le lyrisme fatal de Sapho . . . nous conduit dans cet enfer: Le Suicide, Criminelles. . . . tous les vices, toutes les horreurs s'y dépeignent, entre autres le supplice de la caresse, avec une sobriété hallucinante de lignes convulsés, de passivité abimée, de douleur qui approche l'extase. . . . La femme de Vienne, devenant libre comme l'homme dans l'Europe sans règle et sans foi, verse fatalement à la curiostité de l'extrême; elle prend l'intensité pour la passion, et elle prête à l'artificiel toute la sève de sang de la nature."

41. Regarding an exhibition of Edzard's work at the gallery Durand-Ruel, the critic Marcel Sauvage observed: "voici toutes les fleurs noires du romantisme qui est le fond même de l'âme allemande." Marcel Sauvage, "Un Peintre allemand à Paris," *L'Art Vivant* 83 (June 1928): 471. The Pascin reference is from a clipping preserved in the municipal archives of Cagnes-sur-Mer.

42. *Petit Marseillais*, 15 April 1936, unreferenced clipping, Solidor press book, C-M Archives, Cagnes-sur-Mer.

43. Solidor reproduced Zinoviev's portrait in *Deux Cents Peintres*. Pierre Barlatier described Solidor as follows: "brillant comme un soleil noir. Elle avait l'air réelement d'une figure de proue, d'une de ces statues de bois, longue et mince, amoureusement patinée par la lumière et les embruns et où traînaient encore un peu d'or à la chevelure, un peu de rose aux joues et aux lèvres, un peu de bleu aux yeux." Barlatier, excerpt from a review reprinted in *Donation Suzy Solidor* (Cagnes-sur-Mer: Château-Musée, 1973), n.p.

44. "Quand Suzy Solidor devient romancière," 29 April 1939, unreferenced press clipping, BA, Paris, microfilm RO16340.

45. "Ouvre tes jambes, prends mes flancs / Dans ces rondeurs blanches et lisses / Ouvre tes deux genoux tremblants, ouvre tes cuisses / Ouvre tout ce qu'on peut ouvrir / Dans les chauds trésors de ton ventre / J'inonderai sans me tarir l'abîme où j'entre."

46. "Je suis un vieux garçon dit Suzy Solidor: 'Quand j'ai un cauchemar je rêve que je me marie,'" *Samedi Soir*, 25 December 1948, unpaginated clipping, Solidor press book, C-M Archives, Cagnes-sur-Mer. "Suzy Solidor n'a jamais caché la passion vigoureuse et tendre qu'elle éprouvait pour les créatures de son sexe. . . . Les enfants charmantes qui chantaient dans son cabaret étaient toutes ses 'petites alliées.'"

47. Lemaire contributed in a number of ways to the intimate ambiance of the club; she circulated among the tables, chatting up the clientele, and she primed the audience for Solidor's appearances by performing "warm-up" sets that she had rehearsed with the vedette. Interview, Doris Lemaire, Cagnes-sur Mer, April 2001.

48. "Dany Dauberson Nouvelle Suzy Solidor," *Radar*, 6 March 1949, unpaginated clipping, Solidor press book, C-M Archives, Cagnes-sur-Mer.

49. When asked to which political party she adhered, Solidor responded: "De la Solidorité Féminine!" Unreferenced press clipping dated 1952, Solidor press book, C-M Archives, Cagnes-sur-Mer.

50. "Je Suis un Vieux Garçon dit Suzy Solidor," n.p. "Quand je mange du foie

gras et que j'ai un cauchemar, dit elle, je rêve que je me marie. D'ailleurs, je suis un vieux garçon."

51. "On Ferme chez Suzy Solidor," *Marianne*, July 1938, unpaginated press clipping, Solidor press book, C-M Archives, Cagnes-sur-Mer. "Là-bas je chanterai, je visiterai le Temple de Lesbos avec ferveur, en pélerin."

52. Léon Treich, "Notes parisiennes: Les mémoires de Suzy Solidor," *Le Soir*, 23 July 1966, unpaginated press clipping, BA, Paris, microfilm RO16340. "Ces histoires ne m'enlèveront pas un ami. De même que les adversaires du nu sont les femmes mal faites, les médisants sont des refoulés qu j'ai écartés de ma chambre!"

53. The tea dances were announced on flyer for La Vie Parisienne, ca. 1937, C-M Archives, Cagnes-sur-Mer.

54. Maurice Barbezet, director of the firm Packard, succeeded Bremond d'Ars as Solidor's protector in 1929. He set her up as an antique dealer in the boutique La Grande Mademoiselle and undoubtedly helped finance the opening of the club La Vie Parisienne. In the late 1930s, Solidor had an affair with Jean Mermoz, the legendary aviator, whose love letters she incorporated into her recitations at the club in the wake of the flyer's highly publicized disappearance. A sign of the rising conservatism of these times, Solidor's exploitation of this romantic episode marks a momentary shift in a self-promotional strategy that had heretofore privileged lesbian liaisons.

55. Jean Servière, "Sur la voix de Suzy Solidor," *Je Suis Partant*, 13 December 1941, unpaginated clipping, Solidor press book, C-M Archives, Cagnes-sur-Mer. "Sans Confessions et une auréole de mauvais aloi, il n'y aurait pas autant de monde rue Sainte-Anne." Solidor's "confessions" appeared in the first issue of the magazine, along with those of Colette and Joseph Kessel, the editor of the magazine.

56. René Guetta, unreferenced clipping, Solidor press book, C-M Archives, Cagnes-sur-Mer. "Elle parlait à ses clients comme à des amis puisque tous ses clients étaient ses amis. Elle allait, elle venait, dans la pénombre. . . . Et dans la petite pièce, intime comme un boudoir, je me sentais heureux, attendri, plein d'indulgence pour les autres et pour moi-même!"

57. Charles Zalber, cited in Jay, "Suzy Solidor," 78.

58. Servière, "Sur la Voix de Suzy Solidor," n.p.

59. E.g., Marguerite Monot, who also composed for Piaf.

60. "Le plus joli bateau du monde / Et le plus finement gréé, / C'est le joli corps de ma blonde / Ayant la souplesse de l'onde / Et je la gouverne à mon gré."

61. "Les Portraits de Suzy," *À Paris*, 10 March 1933, unpaginated clipping, Solidor press book, C-M Archives, Cagnes-sur-Mer.

62. This was the first of three publications (*Quarante Peintres, un modèle*; *Cent Peintres, un modèle*; *Deux Cents Peintres, un modèle*); these catalogues preserve traces of the collection, now mainly dispersed.

63. Joseph Kessel, in Solidor, *Deux Cents Peintres*, n.p. "Des murs la regardent les quarante portraits qu'elle a inspirés à quarante peintres de toutes les écoles, de toutes les races, de tous les pays. Quarante visages, qui sont à elle, confrontent le véritable, le vivant qui en même temps leur ressemble et les défie."

64. "Portraits de Suzy." "J'ai l'impression . . . que je me déplace devant des miroirs déformants et pour n'être pas trop dépaysée je m'éfforce toujours de ressembler à mon dernier portrait."

65. "La Mémoire de Suzy Solidor," radio broadcast, produced by Nadine Nimier, 15 August 1978, RF Archives, Paris, 78C3095A72. "Quand je les vois,

comme ça, à côté de moi, ce n'est pas moi que je vois, c'est tous les artistes: je revois Kisling, je revois Foujita, et tous les copains."

66. Jean Cocteau, in Suzy Solidor, *Quarante Peintres, un modèle* (Paris: Pierre Morel, ca. 1938); Cocteau, cited by Michel Sineux, record jacket text, *Suzy Solidor Anthology: L'Amiguité faite chanteuse*, n.d.

67. "Partir avant le Jour," the theme song of the 1938 film *Images of Paris*, was composed by Ted Grouya, who performed the duet with Solidor on a recording released the same year.

68. Jay, "Suzy Solidor," 73. Yvonne George, who performed at Cocteau's haunt, Le Boeuf sur le Toit, had ties to the club's lesbian and male homosexual coteries.

69. Unreferenced press clipping, Solidor press book, C-M Archives, Cagnes-sur-Mer. "C'est non seulement une réalisation émouvante, mais c'est aussi un 'test' précieux qui permet de contrôler l'artificiel, le 'chique' des fausses chansons de marins actuellement à la mode et dont Mme Suzy Solidor incarne, avec d'ailleurs un incontestable talent, le genre déplorablement faux."

70. Sylvie, "Les Confidences de Suzy Solidor," unpaginated, undated clipping, Solidor press book, C-M Archives, Cagnes-sur-Mer. "'Je passe mes vacances à bord d'un voilier. J'y prépare des chansons. En pleine atmosphere. Et à la rentrée . . . ,' les mots semblaient suspendus aux lèvres de Suzy Solidor. J'attends: 'Le cabaret me reprend. Le cinema aussi, maintenant. Ce dernier m'a mise en goût avec La Garçonne. Il est question pour moi d'un second film où je jouerai le rôle d'une femme voguant seule à travers l'océan. Toujours la mer.'"

71. If Solidor could claim be the "most portraitured woman of her era," she could also claim the distinction of being one of the era's most caricatured. The art of caricature, as Wendy Reaves has shown, enjoyed its heyday in the 1920s and 1930s; very much associated with *la mode* and *la moderne*, the development of this form of portraiture kept pace with the development of the modern cult of celebrity (which was, according to Walter Winchel, "more a matter of press than of prestige"). See Wendy Reaves, *Celebrity Caricature in America* (New Haven: Yale University Press, 1998).

72. My translation is a loose one. The original text of the refrain follows: "N'espère pas m'attacher au rivage / Ma barque folle suit le flot / Je poursuis l'éternel mirage / Qui fait rêver les matelots. / A travers marées et rafales / D'un pôle à l'autre sans frayeur / Je vais où nul n'a fait escale; / Je cherche l'île du bonheur."

73. Solidor, *Fil d'or*, 186.

74. The author Albert T'Serstevens was known for travel narratives such as *Voyages aux îles de l'Amérique* (1931) and maritime novels such as *Les Corsaires du roi* (1924); he also composed the lyrics for Solidor's hit "La Maison des marins."

75. T'Serstevens, in Solidor, *Quarante Peintres*, n.p. "Elle est faite pour chanter ces chansons de marins, qui portent en elles la nostalgie du lointain, qui ont l'odeur de l'iode, de la saumure et du doudron. Elle me fait penser, non pas à une femme, mais un jeune matelot de Saint-Malo qui garde dans les yeux le bleu de la mer, et sur tout son visage long et maigre, le lyrisme des grands voyages."

76. Solidor, "Suzy Solidor révèle son étrange destin," 23. "One cannot reproach a fish for not being a bird."

77. Ibid., 25. "Comment serais-je responsable d'une confusion qui, aujourd'hui, tantôt me jette sur la rude épaule tutélaire d'un homme, tantôt veut que je prenne contre mon flanc à jamais stérile, que je caresse et que j'apaise une jeune

et faible créature, dont je ne sais plus très bien parfois si elle est mon amie ou mon enfant."

78. Bernard Talmey, cited in Dijkstra, *Idols of Perversity*, 153.

79. Otto Weininger, *Sex and Character* (1903; reprint, London: William Heinemann, 1906), 198. The Italian criminologist Cesare Lombroso (also widely read in France in the early twentieth century) maintained that "all women fall into the same category, whereas each man is an individual unto himself; the physiognomy of the former conforms to a generalized standard; that of the latter is in each case unique." Cesare Lombroso and G. Ferrero, *La Femme criminelle et la prostituée*, trans. Louise Meille, as cited in Joan Wallach Scott, *Only Paradoxes to Offer: French Feminists and the Rights of Man* (Cambridge: Harvard University Press, 1996), 10.

80. Herman Melville, in tales such as *White Jacket* and, of course, *Moby Dick*, painted an enduring picture of the homosocial seafaring life. If Melville's work was only belatedly translated into French, stories of the sea by established authors such as T'Serstevens, Roditi, Cocteau, and Genet reached wide audiences.

81. Gilles Barbedette and Michel Carassou, *Paris Gay 1925* (Paris: Presses de la Renaissance, 1981), 80–81.

82. Jean Cocteau, *Professional Secrets*, trans. Robert Phelps (New York: Farrar, Straus and Giroux, 1970), 119–120.

83. Ibid., 120.

84. The couplet "Le ciel est bleu / La mer est verte / Laisse un peu ta braguette ouverte" survives in the collective memory of Paris's gay male communities to this day, although its point of origin has long since been forgotten.

85. For an analysis of the gay cultural implications of early twentieth-century ballet, see my essay, Latimer, "Balletomania: A Sexual Disorder?" in *GLQ: A Journal of Lesbian and Gay Studies* 5, 2 (1999): 173–197.

86. Pierre Barlatier, "Vedettes d'hier: Elles ne sont pas oubliées," *Le Soir*, 1 July 1965, unpaginated clipping, BA, Paris, microfilm RO16340.

87. Ibid., n.p.

88. Ibid. "On s'arrachait les aquarelles de Dignimont représentant, avec vigueur et sans vaine sensiblerie, des marins dans des bars louches." Dignimont, known for this kind of genre painting, also produced a portrait of Solidor.

89. "La Chanson de la belle pirate," 1936. "J'ai senti vibrer en mon âme / l'appel du large et des dangers / et quittant mes habits de femme / sur un trois mât je m'engageais / puis je fis serment sous la lune / d'être chevalier de fortune."

CONCLUSION

The epigraph is from François Leperlier, *Claude Cahun, écrits* (Paris: Jean Michel Place, 2002), 629–630. "They were forced, at the end of the day, to condemn us without believing in our existance. . . . As if with regret."

1. Natalie Barney to Djuna Barnes, 13 January 1963; Djuna Barnes to Natalie Barney, 16 October 1963; Barnes Archives, McKeldin Library, University of Maryland, College Park.

2. Jean Chalon published an article titled "Natalie Barney" (*Connaissance des Arts*, November 1965, 82–87) and began work on his biography, *Chère Natalie Barney: Portrait d'une séductrice* (Paris: Stock, 1976). François Chapon, curator of Barney's papers, published a collection of writings the same year: *Autour de Natalie Clifford Barney* (Paris: Université de Paris, 1976). These initiatives

introduced lesbians of the new generation to Barney and her entourage and raised awareness of their cultural and sexual-cultural significance as pathbreaking predecessors.

3. A few of this community's prominent citizens did their best to maintain footholds in the chosen homeland. Sylvia Beach, for instance, remained in Paris; Janet Flanner went home, but only to return to Europe as a war correspondent.

4. Faÿ, a Harvard University graduate and professor of American history in the French university system, had promoted Stein's writings in France, translating *The Autobiography of Alice B. Toklas* and assisting in the production of the French version of *The Making of Americans*. Before the war, Faÿ, a member of the gay male circle that revolved around Stein and Toklas, had been a regular visitor to their Paris household. After the war, from his exile in Switzerland, he wrote a memoir called *Les Précieux*, valorizing his role as the wartime protector of Stein and Toklas. For an introductory exploration of this complex and (for Stein and Toklas) compromising relationship, see Janet Malcolm, "Gertrude Stein's War: The Years in Occupied France," *New Yorker*, 2 June 2003, 59–81. Malcolm draws on a fascinating and thoroughly documented essay penned jointly by Edward M. Burns and Ulla E. Dydo, "Gertrude Stein: September 1942 to September 1944," published as an appendix to the collection edited by these two scholars, *The Letters of Gertrude Stein and Thornton Wilder* (New Haven: Yale University Press, 1996).

5. All the citations in this paragraph are drawn from Romaine Brooks, "A War Interlude" or "On the Hill of Florence during the War," unpublished, unpaginated manuscript, ca. 1940–1945, Archives of American Art, Smithsonian, Washington, DC. Brooks did not subject her anti-Semitism to scrutiny, despite the significance of her personal relationships with Jewish men and women—most notably, Ida Rubinstein and Carle Dreyfus. Dreyfus, Barney's brother-in-law and a curator of the Louvre, rescued Brooks's paintings from her Paris studio in advance of the German Occupation and hid them in a safe location until the city's liberation. Barney, who was half Jewish herself, also embraced positions that we would not hesitate to identify today as anti-Semitic. In 1941 she wrote an essay, for instance, advocating a territorial solution to Europe's "Jewish problem." "La Question juive et la terre promise" urged Jews to evacuate Europe and found a new homeland upon their ancient holy lands. Fonds Natalie Clifford Barney, Bibliothèque Littéraire Jacques Doucet, Paris, NCB.Ms86. During the final months of the war, Brooks and Barney huddled in the basement of a neighbor as Allied bombs hammered Tuscany. The Germans had set up antiaircraft artillery guns in Brooks's garden and requisitioned the first floor of the villa as a command post. Brooks and Barney returned to this home early one morning, as the Allies advanced, and found, to their dissatisfaction, that "no room had been made ready for us: the ground-floor evacuated by the Germans during the night was uninhabitable and our bedrooms were covered with fallen plaster caused by the detonations. No one had thought to order the little maid to clean up a room." Brooks, "War Interlude."

6. Claude Cahun, "Le Muet dans la mêlée" (1948), in François Leperlier, *Claude Cahun, écrits* (Paris: Jean Michel Place, 2002), 627, 629–630. "La Gestapo chercha quatre ans en vain. Si nous avions pu vivre parées contre toute perquisition, si soudaine fut-elle, ils n'auraient jamais cru, malgré leurs informateurs, qu'il s'agissait de nous. Même toutes preuves en mains ils n'en croyaient pas leurs yeux. Ils restaient persuadés que nous ne pouvions être plus que des comparses, complices de . . . X. Pour obtenir qu'ils cessent de nous interroger au sujet de nos affiliations

hypothéthiques avec . . . X, ou avec l'Intelligence Service (!!!), il nous fallut leur démontrer que nous etions pleinement conscientes et capables de nos 'crimes.' Un peu de patience—de part et d'autre—y suffit. . . . Constatant que nous étions des femmes, ces êtres inférieurs . . . ; que nous avions à Jersey la réputation de bourgeoises paisibles, qu'il était impossible de nous faire passer . . . pour des 'terroristes'; que, lors de notre arrestation—devant témoins jersiais—nous n'avions fait aucune résistance; que vis-à-vis d'eux-mêmes, ce soir-là et au cours des interrogatoires, nous n'avions qu'une hostilité froide, exempte de toute violence émotive . . . ils y perdirent leur 'aryien': notre 'idéalisme' passait leur conception cynique de l'espèce humaine. Cela piquait ce qui malgré tout subsistait en eux de curiosité psychologique. . . . À Jersey, ils durent, en fin de compte, nous condamner sans croire à notre existence. En quelque sorte. Comme à regret." In addition to these memoirs, evidence of the couple's actions—the propaganda tracts they posted on barracks doors by night, the notes they wrote and slipped into soldiers' shirt pockets—has been preserved by the Jersey Heritage Trust. Letters (to Breton, to Charles Henri-Barbier) describing their activities in some detail also survive in private collections and public archives.

7. Suzanne Malherbe, "Sentenced to Death by Island Nazis: The Story of Two Gallant Frenchwomen," *Jersey Post*, 14 July 1945, unpaginated clipping, Jersey Heritage Trust Archives.

8. Inscription by Claude Cahun on the back of a photo, shot by Moore in 1940, that pictures Cahun and her domestic employee Edna posing with a barque, *Defender Jersey*. They had hidden the illegal boat from the Germans at the request of the local fishermen. "Il nous reste pas mal de films . . . nous en avions tant qu'ils se seront lassé de les détuire . . . mais je n'ai jamais eu le temps ni le courage de vérifier exactement ce qui reste—sachant que mes préferés manquent."

9. Cited in Jacques Robert, "Avec cent quinze tableaux et un chien né d'un lion et d'une chèvre, Suzy Solidor va faire le tour du monde," *Paris Matin*, 7 November 1947, unpaginated press clipping, Bibliothèque de l'Arsenal, Paris, RT 10750. "Recevoir le client, c'est mon business!"

10. Ibid. "Mais que c'est elle qui l'a lancée en France, en des temps où cette Lily ne pouvait que faire figure d'espionne."

11. Solidor, cited in "Je suis un vieux garçon dit Suzy Solidor: 'Quand j'ai un cauchemar je rêve que je me marie,'" *Samedi Soir*, 25 December 1948, unpaginated clipping, Solidor press book, C-M Archives, Cagnes-sur-Mer.

12. Herbert Lottman, *L'Epuration* (Paris: Fayard, 1986), 440.

13. Karine Jay, "Suzy Solidor (1900–1983): Portrait(s) d'une artiste à la frange dorée de l'art," master's thesis, Université Jean Moulin, Lyon III, 1996, 150.

14. Robert, "Avec cent quinze tableaux," n.p. "Sa 'Vie Parisienne'. . . , durant quatre ans, était véritablement devenue la 'Vie hitlérienne.'"

15. Michael Ann Holly, "Mourning and Method," *Art Bulletin*, December 2002, 664.

16. In taking this approach, I follow the lead of pathbreaking scholars from T. J. Clark to Griselda Pollock who see modernity as a particularly visual paradigm.

17. Anne Middleton Wagner, *Three Artists (Three Women): Modernism and the Art of Hesse, Krasner, and O'Keeffe* (Berkeley and Los Angeles: University of California Press, 1996), 287.

18. Teresa de Lauretis, "Sexual Indifference and Lesbian Representation," *Theatre Journal* 40, 2 (May 1988): 171.

SELECTED BIBLIOGRAPHY

Abbott, Berenice. *A Guide to Better Photography*. New York: Crown Publishers, 1941.

Acton, Harold. *Memoirs of an Aesthete*. London: Hamish Hamilton, 1984.

Alexandre, Arsène. "Exposition américaine du Luxembourg." *Le Figaro*, 20 October 1919.

Allain, Patrice. "Sous les Masques du fard: Moore, Claude Cahun et quelques autres." In "Autour de Marcel Schwob: Les "croisades" d'une famille républicaine à travers 50 ans de presse nantaise." *Nouvelle Revue Nantaise* 3 (1997): 115–133.

Allen, Carolyn. *Following Djuna: Women Lovers and the Erotics of Loss*. Bloomington: Indiana University Press, 1996.

Apter, Emily. "Acting Out Orientalism: Sapphic Theatricality in Turn-of-the-Century Paris." In *Performance and Cultural Politics*, ed. Elin Diamond. New York: Routledge, 1996.

Baker, Michael. *Our Three Selves: The Life of Radclyffe Hall*. New York: William Morrow, 1985.

Barbedette, Gilles, and Michel Carassou. *Paris Gay 1925*. Paris: Presse de la Renaissance, 1981.

Barbey d'Aurevilly, Jules. "Du Dandysme et de George Brummell." In *Oeuvres romanesques complètes*, vol. 2. Paris: Gallimard, 1966.

Bard, Christine. *Les Femmes dans la société française au 20ième siècle*. Paris: Armand Colin, 2001.

———. *Les Garçonnes: Modes et fantasmes des années folles*. Paris: Flammarion, 1998.

———, ed. *Un Siècle d'antiféminisme*. Paris: Fayard, 1999.

Barkan, Eazar, and Ronald Bush, eds. *Prehistories of the Future: Primitivist Culture and Modernism*. Stanford: Stanford University Press, 1995.

Barnes, Djuna. *Ladies Almanack*. New York: New York University Press, 1992. (Originally published in 1928.)

———. Unpublished letters and papers. Rare Books Collection, McKeldin Library, University of Maryland, College Park.

Barney, Natalie Clifford. *Adventures of the Mind*. Trans. John Spalding Gatton. New York: New York University Press, 1992.

——. *Aventures de l'esprit*. Paris: Emile-Paul Frères, 1929.

——. *Eparpillements*. Paris: Sansot, 1910.

——. "Memoirs of a European American." Unpublished memoirs. Fonds Natalie Clifford Barney, Bibliothèque Littéraire Jacques Doucet, Paris.

——. *The One Who Is Legion or A.D.'s Afterlife*. London: E. Partridge, Ltd., 1930.

——. *Pensées d'une amazone*. Paris: Emile-Paul, 1929.

——. *A Perilous Advantage: The Best of Natalie Clifford Barney*. Ed. and trans. Anna Livia. Norwich, VT: New Victoria Publishers, 1992.

——. *Poems et poèmes, autres alliances*. New York: Doran and Co., 1920.

——. *Souvenirs indiscrets*. Paris: Flammarion, 1960.

——. *Traits et portraits*. Paris: Mercure de France, 1963.

——. Unpublished letters and papers. Beinecke Rare Book and Manuscript Library, Yale University, New Haven.

——. Unpublished letters and papers. Fonds Natalie Clifford Barney, Bibliothèque Littéraire Jacques Doucet, Paris.

Barthes, Roland. *Camera Lucida: Reflections on Photography*. Trans. Richard Howard. New York: Hill and Wang, 1981.

——. "Death of the Author." In *Image, Music, Text*, trans. Stephen Heath. New York: Hill and Wang, 1977.

——. "The Face of Garbo." In *A Barthes Reader*, ed. Susan Sontag. New York: Hill and Wang, 1996.

——. *A Lover's Discourse: Fragments*. Trans. Richard Howard. New York: Hill and Wang, 1998.

Baudelaire, Charles. *Oeuvres complètes*. Paris: Gallimard, 1961.

——. *The Painter of Modern Life, and Other Essays*. Ed. and trans. Jonathan Mayne. London: Phaidon, 1964.

Beach, Sylvia. *Shakespeare and Company*. New York: Harcourt, Brace, 1956.

Belton, Robert J. *The Beribboned Bomb: The Image of Woman in Male Surrealist Art*. Calgary: University of Calgary Press, 1995.

——. "Speaking with Forked Tongues: 'Male' Discourse in 'Female' Surrealism?" In *Surrealism and Women*, ed. Mary Ann Caws, Rudolf E. Kuenzli, and Gwen Raaberg. Cambridge: MIT Press, 1995.

Benjamin, Walter. *The Arcades Project*. Trans. Howard Eiland and Kevin MacLaughlin. Cambridge: MIT Press, 1989.

——. *Charles Baudelaire: A Lyric Poet in the Era of High Capitalism*. Trans. Harry Zohn. London: Verso, 1997.

——. *Illuminations*. With an introduction and ed. Hannah Arendt, trans. Harry Zohn. New York: Schocken Books, 1969.

——. *Reflections: Essays, Aphorisms, Autobiographical Writings*. Ed. Peter Demetz, trans. Edmund Jephcott. New York: Schocken, 1978.

——. "Short History of Photography" (1917). In *Classic Essays on Photography*, ed. Alan Trachtenberg. New Haven: Leete's Island Books, 1989.

Benstock, Shari. "Paris Lesbianism and the Politics of Reaction, 1900–1940." In *Hidden from History: Reclaiming the Gay and Lesbian Past*, ed. Martin Duberman, Martha Vicinus, and George Chauncey, Jr. New York: Meridian, 1989.

——. *Women of the Left Bank: Paris, 1900–1940*. Austin: University of Texas Press, 1986.

Berg, Nanda van den. "Claude Cahun: La Révolution individuelle d'une surréaliste méconnue." *Avant-Garde*, no. 7 (July 1990): 71–92.

Berger, Harry, Jr. "Fictions of the Pose: Facing the Gaze in Early Modern Portraiture." *Representations* 46 (Spring 1994): 87–120.

Bersani, Leo. *Homos*. Cambridge: Harvard University Press, 1995.

Bhabha, Homi K. *The Location of Culture*. London : Routledge, 1994.

Blake, Jody. *Le Tumulte Noir: Modernist Art and Popular Entertainment in Jazz-Age Paris, 1900–1930*. University Park: Pennsylvania State University Press, 1999.

Bland, Lucy, and Laura Doan, eds. *Sexology in Culture: Labeling Bodies and Desires*. Chicago: University of Chicago Press, 1998.

———, eds. *Sexology Uncensored: The Documents of Sexual Science*. Chicago: University of Chicago Press, 1998.

Blessing, Jennifer. "Resisting Determination: An Introduction to the Work of Claude Cahun, Surrealist Artist and Writer." *Found Object* 1, 1 (1993): 68–78.

———, ed. *A Rrose is a Rrose is a Rrose: Gender Performance in Photography*. New York: Guggenheim Museum, 1997.

Boucher, François, Anne d'Eugny, and René Coursaget, eds. *Au Temps de Baudelaire, Guys, et Nadar*. Paris: Editions du Chêne, 1945.

Bourcier, Marie-Hélène. *Queer Zones: Politques des identities sexuelles, des representations et des saviors*. Paris: Editions Balland, 2001.

Bourget, Paul. *Outre-mer (notes sur l'Amérique)*. Paris: Alphonse Lemerre, ca. 1894.

Breeskin, Adelyn D. *Romaine Brooks*. Washington, DC: National Museum of American Art/Smithsonian Institution Press, 1986.

Bremond d'Ars, Yvonne de. *C'est arrivé en plein Paris: Passionnante aventure d'antiquaire*. Paris: Henri Lefebvre, 1957.

Brilliant, Richard. *Portraiture*. Cambridge: Harvard University Press, 1991.

Brooks, Romaine. "No Pleasant Memories." Unpublished manuscript, ca. 1930. Archives of American Art, Smithsonian, Washington DC.

———. Research materials on Romaine Brooks. Archives of American Art, Smithsonian, Washington, DC.

———. *Romaine Brooks*. Exhibition catalogue. London: Alpine Club Gallery, 1925.

———. *Romaine Brooks*. Exhibition catalogue. New York: Wildenstein Galleries, 1925.

———. *Romaine Brooks: Portraits, tableaux, dessins*. Paris: Braun et Cie., 1952.

———. "A War Interlude" or "On the Hill of Florence during the War." Unpublished manuscript, ca. 1940–1945. Archives of American Art, Smithsonian, Washington DC.

Broude, Norma, and Mary D. Garrard. "Introduction: The Expanding Discourse." In *The Expanding Discourse: Feminism and Art History*, ed. Norma Broude and Mary D. Garrard. New York: Harper Collins, 1992.

Bryher [Winifred Ellerman]. Unpublished letters and papers. Beinecke Rare Book and Manuscript Library, Yale University, New Haven.

Bryson, Norman. *Vision and Painting: The Logic of the Gaze*. New Haven: Yale University Press, 1983.

Norman Bryson, Michael Ann Holly, and Keith Moxey, eds. *Visual Culture: Images and Interpretations*. Hanover, NH: University Press of New England, 1994.

Buchloh, Benjamin H. "Figures of Authority, Ciphers of Regression: Notes on the Return of Representation in European Painting." *October* 34 (Spring 1981): 39–69.

Butler, Judith. *Bodies That Matter: On the Discursive Limits of "Sex."* London : Routledge, 1993.

——. *Gender Trouble: Feminism and the Subversion of Identity.* London : Routledge, 1990.

——. "Imitation and Gender Insubordination." In *Inside/Out: Lesbian Theories, Gay Theories*, ed. Diana Fuss. New York: Routledge, 1991.

——. "Melancholy Gender—Refused Identification." *Psychoanalytic Dialogues* 5, 2 (1995): 165–180.

Cahun, Claude. "Au Diable." *Le Plateau* 2 (May–June 1929): 5–6.

——. "Aux Amis des livres." *La Gerbe* 5 (February 1919): 147–148.

——. "Carnaval en chamber." *Ligne de Coeur* 4 (March 1926): 47–50.

——. "Héroines." Manuscript, ca. 1924. Jersey Heritage Trust Archives, St. Helier, Channel Island of Jersey.

——. "Héroines." *Mercure de France* 639 (1 February 1925): 623–643.

——. "L'Idée-maîtresse." *La Gerbe* 28 (January 1921): 202–205.

——. "L'Idée-maîtresse." *La Gerbe* 29 (February 1921): 237–240.

——. "L'Idée-maîtresse." *La Gerbe* 30 (March 1921).

——. "L'Idée-maîtresse." *La Gerbe* 31 (April 1921).

——. "Les Jeux uraniens." Unpublished manuscript, ca. 1914. Jersey Heritage Trust Archives, St. Helier, Channel Island of Jersey.

——. "Réponse à l'inquête de la revue *Inversions*." *L'Amitié* 1 (April 1925).

——. "*La Salomé* d'Oscar Wilde: Le procès Billing et les 47,000 pervertis du 'livre noir.'" *Mercure de France* 128 (July/August 1918): 69–80.

Cahun, Claude, and Marcel Moore. *Aveux non avenus.* Paris: Editions du Carrefour, 1930.

——. Miscellaneous unpublished papers, photographs, and negatives. Jersey Heritage Trust Archives, St. Helier, Channel Island of Jersey.

——. *Vues et visions.* Paris: Editions Georges Crès et Cie., 1919.

Camille, Michael. "The Abject Gaze and the Homosexual Body: Flandrin's *Figure d'Etude*." In *Gay and Lesbian Studies in Art History*, ed. Whitney Davis. New York: Harrington Park/Haworth Press, 1994.

Carlston, Erin G. *Thinking Fascism: Sapphic Modernism and Fascist Modernity.* Stanford: Stanford University Press, 1998.

Carpenter, Edward. *The Intermediate Sex: A Study of Some Transitional Types of Men and Women.* London: George Allen and Unwin, 1908.

Carpenter, Humphrey. *Geniuses Together: American Writers in Paris in the 1920s.* London: Unwin Hyman, 1987.

Case, Sue-Ellen. "Meditations on the Patriarchal Pythagorean Pratfall and the Lesbian Siamese Two-Step." In *Choreographing History*, ed. Susan Leigh Foster. Bloomington: Indiana University Press, 1995.

Castle, Terry. *The Apparitional Lesbian: Female Homosexuality and Modern Culture.* New York: Columbia University Press, 1993.

——. *Noël Coward and Radclyffe Hall, Kindred Spirits.* New York: Columbia University Press, 1996.

Caws, Mary Ann. "Ladies Shot and Painted: Female Embodiment in Surrealist Art." In *The Female Body in Western Culture: Contemporary Perspectives*, ed. Susan Rubin Suleiman, 262–287. Cambridge: Harvard University Press, 1985.

———. *The Surrealist Look: An Erotics of Encounter*. Cambridge: MIT Press, 1997.

Chadwick, Whitney. *Amazons in the Drawing Room: The Art of Romaine Brooks*. With an essay by Joe Lucchesi. Berkeley and Los Angeles: University of California Press; Washington, DC: National Museum of Women in the Arts, 2000.

———. "An Infinite Play of Empty Mirrors: Women, Surrealism, and Self-Representation." In *Mirror Images: Women, Surrealism, and Self-Representation*, ed. Whitney Chadwick. Cambridge: MIT Press, 1998.

———. *Women, Art, and Society*. London: Thames and Hudson, 1990.

———. *Women Artists and the Surrealist Movement*. New York: Thames and Hudson, 1985.

Chadwick, Whitney, and Isabelle de Courtivron, eds. *Significant Others: Creative and Intimate Partnerships*. London: Thames and Hudson, 1993.

Chadwick, Whitney, and Tirza True Latimer, eds. *The Modern Woman Revisited: Paris Between the Wars*. New Brunswick: Rutgers University Press, 2003.

Chalon, Jean. *Chère Natalie Barney: Portrait d'une séductrice*. Paris: Stock, 1976.

Chauncey, George, Jr. "From Sexual Inversion to Homosexuality: The Changing Medical Conception of Female 'Deviance.'" In *Passion and Power: Sexuality in History*, ed. Kathy Peiss and Christina Simmons. Philadelphia: Temple University Press, 1989.

———. *Gay New York: Gender, Urban Culture, and the Making of the Gay Male World, 1890–1940*. New York: Basic Books, Harper Collins, 1994.

Chavanne, Blandine, and Bruno Gaudichon, eds. *Romaine Brooks*. Poitiers: Musée de la Ville de Poitiers et de la Société d'Antiquaires de l'Ouest, 1987.

Cheetham, Mark, Michael Ann Holly, and Keith Moxey, eds. *The Subjects of Art History: Historical Objects in Contemporary Perspectives*. Cambridge: Cambridge University Press, 1998.

Choisy, Maryse. "Dames seules," *Le Rire* (special issue on *dames seules*), 21 May 1932.

———. *Dames seules*. With drawings by Marcel Vertès. Paris: Cahiers Gai/Kitsch/Camp, 1993. (Reprint of the special issue of *Le Rire*, 21 May 1932.)

Clark, T. J. *Farewell to an Idea: Episodes from a History of Modernism*. New Haven: Yale University Press, 1999.

———. *The Painting of Modern Life: Manet and His Followers*. New York: Alfred Knopf, 1984.

Cleyrergue, Berthe. *Berthe ou un demi-siècle auprès de l'Amazonne*. Paris: Editions Tièrce, 1980.

Cline, Sally. *Radclyffe Hall: A Woman Called John*. Woodstock, NY: Overlook Press, 1997.

Cocteau, Jean. *Past Tense: The Cocteau Diaries*. Trans. Richard Howard. San Diego: Harcourt Brace Jovanovich, 1987.

———. *Professional Secrets*. Trans. Robert Phelps. New York: Farrar, Straus, and Giroux, 1970.

Cohen, Ed. "Posing the Question: Wilde, Wit, and the Ways of Man." In *Performance and Cultural Politics, ed*. Elin Diamond. New York: Routledge, 1996.

Colette, Sidonie-Gabrielle. *The Pure and the Impure*. Trans. Edith Daly. New York: Farrar and Rinehart, 1933.

Corn, Wanda M. *The Great American Thing: Modern Art and National Identity, 1915–1935*. Berkeley and Los Angeles: University of California Press, 1999.

———. "Identity, Modernism, and the American Artist after World War I: Gerald

Murphy and *Américanisme*." In *Nationalism in the Visual Arts*, ed. Richard Etlin. Washington, DC: National Gallery of Art, 1991.

Cossart, Michael de. *The Food of Love: Princess Edmond de Polignac (1865–1943) and Her Salon*. London: Hamish Hamilton, 1978.

Cottingham, Laura. "Considering Claude Cahun," In *Seeing through the Seventies: Essays on Feminism and Art*. Amsterdam: G+B Arts International, Gordon and Breach, 2000.

Cousseau, Henry-Claude, ed. *Le Rêve d'une ville: Nantes et le surréalisme*. Nantes and Paris: Musées des Beaux-Arts de Nantes, Réunion des Musées Nationaux, 1994.

Cowley, Malcolm. *Exile's Return: A Literary Odyssey of the 1920s*. New York: Viking, 1951.

Crary, Jonathan. *Techniques of the Observer: On Vision and Modernity in the Nineteenth Century*. Cambridge: MIT Press, 1996.

Damisch, Hubert. *The Origin of Perspective*. Trans. John Goodman. Cambridge: MIT Press, 1994.

Dance, Robert, and Bruce Robertson. *Ruth Harriet Louise and Hollywood Glamour Photography*. Berkeley and Los Angeles: University of California Press/Santa Barbara Museum of Art, 2002.

Dayot, Armand. *L'Image de la femme*. Paris: Hachette, 1899.

Dean, Carolyn J. "Claude Cahun's Double." *Yale French Studies* 90 (1996): 71–92.

———. *The Self and Its Pleasures: Bataille, Lacan, and the History of the Decentered Subject*. Ithaca: Cornell University Press, 1992.

Deepwell, Katy. "Uncanny Resemblances." *Women's Art Magazine* 62 (January–February 1995): 17–19.

———, ed. *Women Artists and Modernism*. Manchester, UK: Manchester University Press, 1998.

DeJean, Joan. *Fictions of Sappho, 1546–1937*. Chicago: University of Chicago Press, 1989.

Delarue-Mardrus, Lucie. *L'Amérique chez elle*. Paris: Editions Albert, 1933.

D'Emilio, John, and Estelle B. Freedman. *Intimate Matters: A History of Sexuality in America*. New York: Harper and Row, 1988.

Denker, Eric. *In Pursuit of the Butterfly: Portraits of James McNeill Whistler*. Washington, DC: National Portrait Gallery, 1995.

Derrida, Jacques. *Writing and Difference*. Trans. Alan Bass. Chicago: University of Chicago Press, 1978.

Dhavernas, Odile. "L'Inscription des femmes dans le droit: Enjeux et perspectives." In *Le Féminisme et ses enjeux*. Paris: Centre Fédéral FEN, 1988.

Diamond, Elin, ed. *Performance and Cultural Politics*. New York: Routledge, 1996.

Doan, Laura. *Fashioning Sapphism: The Origins of Modern English Lesbian Culture*. New York: Columbia University Press, 2001.

Doane, Mary Ann. *Femmes Fatales: Feminism, Film Theory, Psychoanalysis*. New York: Routledge, 1991.

Dollimore, Jonathan. "Different Desires: Subjectivity and Transgression in Wilde and Gide." In *The Lesbian and Gay Studies Reader*, ed. Henry Abelove, Michèle Aina Barale, and David M. Halperin. New York: Routledge, 1993.

Drouin, Henri. *Femmes damnées*. Paris: NRF/Gallimard, 1929.

Drucker, Johanna. *Theorizing Modernism: Visual Art and the Critical Tradition.* New York: Columbia University Press, 1994.

Duberman, Martin, Martha Vicinus, and George Chauncey, Jr., eds. *Hidden from History: Reclaiming the Gay and Lesbian Past.* New York: Meridan, 1989.

Dulac, Germaine. *Ecrits sur le cinéma (1919–1937).* Paris: Editions Paris Expérimental, 1994.

Dussaule, Georges. *Donation Solidor, 1973.* Cagnes-Sur-Mer: Chateau-Musée, 1973.

Dyer, Richard. *Heavenly Bodies: Film Stars and Society.* London: MacMillan, 1987.

——. *Now You See It: Studies on Lesbian and Gay Film.* London: Routledge, 1991.

——. *Stars.* London: British Film Institute, 1979.

——. *White.* London: Routledge, 1997.

Eilel, Carol S., ed. *Purism in Paris, 1918–1925: L'Esprit Nouveau.* New York: Abrams, 2001.

Elliott, Bridget. "Performing the Picture or Painting the Other: Romaine Brooks, Gluck, and the Question of Decadence in 1923." In *Women Artists and Modernism,* ed. Katy Deepwell. Manchester, UK: Manchester University Press, 1998.

Elliott, Bridget, and Janice Helland, eds. *Women Artists and the Decorative Arts 1880–1935: The Gender of Ornament.* Aldershot, UK, and Burlington, VT: Ashgate, 2002.

Elliott, Bridget, and Jo-Ann Wallace. *Women Artists and Writers: Modernist (Im)postionings.* London: Routledge, 1994.

Ellis, Havelock. *La Femme dans la société,* vol. 1 *L'Hygiène sociale, études de psychologie sociale.* Trans. Lucy Schwob. Paris: Mercure de France, 1929.

Ellis, Havelock, and John Addington Symonds. *Sexual Inversion.* New York: Arno Press, 1975. (Originally published 1897.)

Ellmann, Richard. *Oscar Wilde.* New York: Random House, 1988.

Eribon, Didier. *Une Morale du minoritaire: Variations sur un thème de Jean Genet.* Paris: Fayard, 2001.

——. *Réflexions sur la question gay.* Paris: Fayard, 1999.

Faderman, Lillian. *Odd Girls Out and Twilight Lovers: A History of Lesbian Life in the Twentieth Century.* New York: Penguin, 1991.

——. *Surpassing the Love of Men: Romantic Friendship and Love Between Women.* New York: William Morrow, 1981.

Fillin-Yeh, Susan, ed. *Dandies: Finesse in Art and Culture.* New York: New York University Press, 2001.

——. "Dandies, Marginality and Modernism: Georgia O'Keeffe, Marcel Duchamp and Other Cross-Dressers." *Oxford Art Journal* 18 (1995): 33–44.

Fitch, Noel Riley. *Sylvia Beach and the Lost Generation: A History of Literary Paris in the Twenties and Thirties.* New York: Norton, 1983.

Flanner, Janet. *Paris Was Yesterday, 1925–1939.* New York: Viking Press, 1972.

Folkenflik, Robert. "The Self as Other." In *The Culture of Autobiography: Constructions of Self-Representation,* ed. Robert Folkenflik. Stanford: Stanford University Press, 1993.

Ford, Hugh. *Published in Paris: A Literary Chronicle of Paris in the 1920s and 1930s.* New York: Collier, 1988.

Foster, Hal. "L'Amour Faux." *Art in America* 1 (January 1986): 116–129.

——. *Compulsive Beauty*. Cambridge: MIT Press, 1993.

Foucault, Michel. *The History of Sexuality*, vol. 1, *An Introduction*. Trans. Robert Hurley. New York: Vintage Books, 1990. (Originally published in English 1978.)

——. "What Is an Author?" In *Language, Counter-Memory, Practice: Selected Essays and Interviews*, ed. Donald Bouchard. Ithaca: Cornell University Press, 1977.

Freud, Sigmund. "On Narcissism: An Introduction," In *The Standard Edition*, vol. 14, trans. and ed. James Strachey. London: Hogarth Press, 1955.

——. "The Psychogenesis of a Case of Homosexuality in a Woman" (1920). In *The Standard Edition*, vol. 17, trans. and ed. James Strachey. London: Hogarth Press, 1955.

——. "The Uncanny." In *The Standard Edition*, vol. 17, trans. and ed. James Strachey. London: Hogarth Press, 1955.

Gagnier, Regenia. *Idylls of the Marketplace: Oscar Wilde and the Victorian Public*. Stanford: Stanford University Press, 1986.

Garafola, Lynn. *Diaghilev's Ballets Russes*. Oxford: Oxford University Press, 1989.

Garafola, Lynn, and Nancy Van Norman Baer, eds. *The Ballets Russes and Its World*. New Haven: Yale University Press, 1999.

Garb, Tamar. *Sisters of the Brush: Women's Artistic Culture in Late Nineteenth-Century Paris*. New Haven: Yale University Press, 1994.

Garber, Marjorie. *Vested Interests: Cross-Dressing and Cultural Anxiety*. New York: Routledge, 1992.

Garelick, Rhonda K. *Rising Star: Dandyism, Gender, and Performance in the Fin de Siècle*. Princeton: Princeton University Press, 1998.

Gever, Martha. *Entertaining Lesbians: Celebrity, Sexuality, and Self-Invention*. New York: Routledge, 2003.

Gilbert, Sandra, and Susan Gubar. *No-Man's Land: The Place of the Woman Writer in the Twentieth Century*. New Haven: Yale University Press, 1989.

Gilmore, Leigh. "An Anatomy of Absence." *Genders* 26 (1997): 224–251.

Gledhill, Christine, ed. *Stardom: Industry of Desire*. London: Routledge, 1991.

Golan, Romy. *Modernity and Nostalgia: Art and Politics in France Between the Wars*. New Haven: Yale University Press, 1995.

Grahn, Judy. *Really Reading Gertrude Stein: A Selected Anthology with Essays by Judy Grahn*. Freedom, CA: Crossing Press, 1989.

Gramont, Elisabeth de. *Souvenirs du monde de 1890 à 1940*. Paris: Grasset, 1966.

Grosz, Elizabeth. *Space, Time, and Perversion*. New York: Routledge, 1995.

Gubar, Susan. "Blessings in Disguise: Cross-Dressing as Re-Dressing for Female Modernists," *Massachusetts Review* 22 (Autumn 1981): 477–508.

Guibert, Noëlle. *Portrait(s) de Sarah Bernhardt*. Paris: Bibliothèque Nationale de France, 2000.

Hall, Radclyffe. *The Well of Loneliness*. London: Cape, 1928.

Halperin, David M. "Is There a History of Sexuality?" In *The Lesbian and Gay Studies Reader*, ed. Henry Abelove, Michèle Aina Barale, and David M. Halperin. New York: Routledge, 1993.

Harris, Steven. "Coup d'oeil." *Oxford Art Journal* 24, 1 (2001): 89–112.

Havet, Mireille. *Journal, 1918–1919*. Paris: Editions Claire Paulhan, 2003.

H.D. [Hilda Doolittle]. *Paint It Today*. New York: New York University Press, 1992.

Higonnet, Anne. *Berthe Morisot's Images of Women*. Cambridge: Harvard University Press, 1992.

——. "Secluded Vision: Images of Feminine Experience in Nineteenth-Century Europe." In *Expanding the Discourse: Feminism and Art History*, ed. Norma Broude and Mary D. Garrard. New York: Harper Collins, 1992.

Higgonet, Margaret, Jane Jenson, Sonya Michel, and Margaret Weitz, eds. *Behind the Lines: Gender and the Two World Wars*. New Haven: Yale University Press, 1987.

Hoare, Philip. *Oscar Wilde's Last Stand: Decadence, Conspiracy, and the Most Outrageous Trial of the Century*. New York: Arcade, 1997.

Irigaray, Luce. *This Sex Which Is Not One*. Trans. Catherine Porter with Carolyn Burke. Ithaca: Cornell University Press, 1985.

Jagose, Annamarie. *Inconsequence: Lesbian Representation and the Logic of Sequence*. Ithaca: Cornell University Press, 2002.

Jay, Karine. "Suzy Solidor (1900–1983): Portrait(s) d'une artiste à la frange dorée de l'art." Master's thesis. Université Jean Moulin, Lyon III, 1996.

Jay, Karla. *The Amazon and the Page: Natalie Clifford Barney and Renée Vivien*. Bloomington: Indiana University Press, 1988.

——. Introduction to *A Perilous Advantage: The Best of Natalie Clifford Barney*. Ed. and trans. Anna Livia. Norwich, VT: New Victoria Publishers, 1992.

Jones, Amelia. "'Clothes Make the Man': The Male Artist as a Performative Function." *Oxford Art Journal* 18, 2 (1995): 18–32.

Jones, Caroline A. "The Sex of the Machine: Mechanomorphic Art, New Women, and Francis Picabia's Neurasthenic Cure." In *Picturing Science, Producing Art*, ed. Caroline A. Jones and Peter Galison. New York: Routledge, 1998.

Kahn, Gustave. "Romaine Brooks." *L'Art et les Artistes* 37 (May 1923): 307–314.

Katz, Jonathan Ned. *The Invention of Heterosexuality*. New York: Penguin, 1996.

Koerner, Joseph Leo. *The Moment of Self-Portraiture in German Renaissance Art*. Chicago: University of Chicago Press, 1993.

Kozloff, Max. "Portraiture and Performance." In *Face Value: American Portrait*. Paris: Flammarion, 1995.

Krauss, Rosalind E. *Bachelors*. Cambridge: MIT Press, 1999.

——. *The Originality of the Avant-Garde and Other Modernist Myths*. Cambridge: MIT Press, 1985.

——. *The Picasso Papers*. New York: Farrar, Straus and Giroux, 1998.

Krauss, Rosalind, and Jane Livingston. *L'Amour Fou: Photography and Surrealism*. New York: Abbeville Press; Washington, DC: Corcoran Gallery, 1985.

Kris, Ernst. "Problems of Literary Criticism: Aesthetic Ambiguity." In *Psychoanalytic Explorations in Art*. New York: Schocken, 1952.

Lacan, Jacques. "The Mirror Stage as Formative of the Function of the I." In *Ecrits: A Selection*, trans. Alan Sheridan. New York: Norton, 1977.

——. "Of the Gaze: The Line and Light." In *The Four Fundamental Concepts of Psycho-Analysis*, ed. Jacques-Alain Miller, trans. Alan Sheridan. New York: W. W. Norton, 1977.

Langer, Sandra L. "Fashion, Character and Sexual Politics in Some [of] Romaine Brooks' Lesbian Portraits," *Art Criticism* 1, 3 (1981): 25–40.

La Porte, Jean. "Romaine Brooks interprète de la sensibilité internationale." *Vogue* (Paris), 1 June 1925, 34, 76.

Lasalle, Honor. "The Sightless Woman in Surrealist Photography." *Afterimage* 15, 5 (December 1987): 4–5.

Lasalle, Honor, and Abigail Solomon-Godeau. "Surrealist Confession: Claude Cahun's Photomontages," *Afterimage* 19 (March 1992): 10–13.

Lauretis, Teresa de. *Alice Doesn't: Feminism, Semiotics, Cinema.* Bloomington: Indiana University Press, 1984.

——. "Sexual Indifference and Lesbian Representation." In *The Lesbian and Gay Studies Reader*, ed. Henry Abelove, Michèle Aina Barale, and David M. Halperin. New York: Routledge, 1993.

——. *Technologies of Gender.* Bloomington: Indiana University Press, 1987.

Leblond, Marius-Ary. "Les Peintres de la femme nouvelle." *La Revue* 39 (1901): 275–276, 289–290.

Lebovici, Elisabeth, and Catherine Gonnard. "How Could They Say I?" In *Claude Cahun.* Valencia: Institut Valencià d'Art Modern, 2001.

Leduc, Violette. *La Bâtarde.* Trans. Derek Coltman. New York: Farrar, Straus and Giroux, 1979.

Lempke, Sieglinde. *Primitivist Modernism: Black Culture and the Origins of Transatlantic Modernism.* Oxford: Oxford University Press, 1998.

Lentengre, Marie-Louise. *Pierre Albert-Birot.* Paris: Jean-Michel Place, 1993.

Leperlier, François. "L'Assomption de Claude Cahun." In *La Femme s'entête*, ed. Georgiana M. M. Colvile and Katharine Conley. Paris: Collection Peine Marge/Lachenal et Ritter, 1998.

——. *Claude Cahun: L'Ecart et la métamorphose.* Paris: Jean Michel Place, 1992.

——. *Claude Cahun, écrits.* Paris: Jean Michel Place, 2002.

——. *Claude Cahun, photographe.* Paris: Jean Michel Place, 1995.

Leperlier, François, and David Bate. *Mise en Scène: Claude Cahun, Tacita Dean, Virginia Nimarkoh.* London: Institute of Contemporary Art, 1994.

Lewis, Reina. *Gendering Orientalism: Race Femininity and Representation.* New York: Routledge, 1996.

Lewis, Reina, and Katrina Rolley. "Ad(dressing) the Dyke: Lesbian Looks and Lesbians Looking." In *Outlooks: Lesbian and Gay Sexualities and Visual Cultures*, ed. Peter Horne and Reina Lewis. London: Routledge, 1996.

Lichtenstein, Therese. "A Mutable Mirror: Claude Cahun." *Art Forum* 30 (April 1992): 64–67.

Loke, Margarett. "The Dressed-Up Surrealist." *Art News* 90, 10 (December 1991): 17.

Lottman, Herbert. *L'Epuration.* Paris: Fayard, 1986.

Louÿs, Pierre. *Les Chansons de Bilitis.* Paris: Librairie de l'Art Indépendant, 1895.

Lubar, Robert S. "Unmasking Pablo's Gertrude: Queer Desire and the Subject of Portraiture." *Art Bulletin* 79, 1 (March 1997): 56–84.

Lucchesi, Joe. "'The Dandy in Me': Romaine Brooks's 1923 Portraits." In *Dandies: Fashion and Finesse in Art and Culture*, ed. Susan Fillin-Yeh. New York: New York University Press, 2001.

MacDougall, Allan Ross. "Painters, Dancers, Authors in Paris." *Arts and Decoration* (New York) 23, 2 (June 1925): 27, 74.

Mackenzie, Compton. *Extraordinary Women.* London: Martin Secker, 1929.

Man Ray. *Self-Portrait.* New York: Bulfinch Press, 1998.

Marbury, Elisabeth. *My Crystal Ball: Reminiscences.* New York: Boni and Liveright, 1923.

Marcus, Jane. "Sapphistory: The Woolf and *The Well.*" In *Lesbian Texts and*

Contexts, ed. Karla Jay and Joanne Glasgow. New York: New York University Press, 1990.

Marek, Jayne. "Bryher and *Close Up*, 1927–1933." *H.D. Newsletter* 3, 2 (1990): 27–37.

———. *Women Editing Modernism: "Little" Magazines and Literary History*. Lexington: University Press of Kentucky, 1995.

Matlock, Jann. "Masquerading Women, Pathologized Men: Cross-Dressing, Fetishism, and the Theory of Perversion, 1882–1935." In *Fetishism as Cultural Discourse*, ed. Emily Apter and William Pietz. Ithaca: Cornell University Press, 1993.

McAlmon, Robert. *Being Geniuses Together, 1920–1930*. San Francisco: North Point Press, 1984.

McCauley, Elizabeth Anne. *A. A. E. Disdéri and the Carte de Visite Portrait Photograph*. New Haven: Yale University Press, 1985.

McKay, Claude. *A Long Way from Home*. New York: L. Furman, 1937.

Meyer, Richard. *Outlaw Representation: Censorship and Homosexuality in Twentieth-Century American Art*. Oxford : Oxford University Press, 2002.

———. "Robert Mapplethorpe and the Discipline of Photography." In *The Lesbian and Gay Studies Reader*, ed. Henry Abelove, Michèle Aina Barale, and David M. Halperin. New York: Routledge, 1993.

Moers, Ellen. *The Dandy: Brummell to Beerbohm*. London: Secker and Warburg, 1960.

Monahan, Laurie, J. "Radical Transformations: Claude Cahun and the Masquerade of Womanliness." In *Inside the Visible: An Elliptical Traverse of Twentieth Century Art in, of, and from the Feminine*, ed. M. Catherine de Zegher. Cambridge: MIT Press, 1996.

Monnier, Adrienne. Papers. Fonds Adrienne Monnier, Institut Mémoires de l'Édition Contemporaine (I.M.E.C.), Paris and Caen.

———. *The Very Rich Hours of Adrienne Monnier: An Intimate Portrait of the Literary and Artistic Life in Paris Between the Wars*. With an introduction and trans. Richard McDougall. New York: Charles Scribner's Sons, 1976.

Montaigne, Michel de. "Au Lecteur." In *Essais*. Paris: Gallimard, 1950.

Morand, Paul, Edouard MacAvoy, and Michel Desbrueres. "Romaine Brooks." *Bizarre* 46 (March 1968): 3–12.

Morris, Sharon. "The Androgynous Self: Höch and Cahun." In *The Bisexual Imaginary: Representation, Identity and Desire*, ed. Phoebe Davidson, Jo Eadie, Clare Hemmings, Ann Kaloski, and Merl Storr. London: Cassell, 1997.

Mulvey, Laura. "Visual Pleasure and Narrative Cinema." In *Film Theory and Criticism: Introductory Readings*, ed. Gerald Mast, Marshall Cohen, and Leo Braudy. New York: Oxford University Press, 1992.

Munhall, Edgar. *Whistler and Montesquiou: The Butterfly and the Bat*. Paris: Flammarion, 1995.

Murat, Laure. *Passage de l'Odéon*. Paris: Fayard, 2003.

Nead, Lynda. *The Female Nude: Art, Obscenity, and Sexuality*. London: Routledge, 1992.

Newton, Esther. "The Mythic Mannish Lesbian: Radclyffe Hall and the New Woman." *Signs* 9, 4 (Summer 1984): 557–575.

Nochlin, Linda. *Women, Art, and Power*. New York: Harper and Row, 1988.

Nordau, Max. *Degeneration*. New York: D. Appleton, 1895.

Ockman, Carol. *Ingres' Eroticized Bodies: Retracing the Serpentine Line*. New Haven: Yale University Press, 1995.

Owens, Craig. *Beyond Recognition: Representation, Power, and Culture*. Ed. Scott Bryson, Barbara Kruger, Lynne Tillman, and Jane Weinstock. Berkeley and Los Angeles: University of California Press, 1992.

——. "Posing." In *Difference: On Representation and Sexuality*, ed. Kate Linker. New York: New Museum of Contemporary Art, 1984.

Parker, Andrew, and Eve Kosofsky Sedgwick, eds. *Performativity and Performance*. New York: Routledge, 1994.

Perry, Gill. *Women Artists and the Parisian Avant-Garde: Modernism and "Feminine" Art, 1900 to the Late 1920s*. Manchester, UK: Manchester University Press, 1995.

Phelan, Peggy. *Unmarked: The Politics of Performance*. New York: Routledge, 1994.

Philips, Christopher. "To Imagine That I Am Another." *Art in America* 80 (July 1992): 92–93.

Pollock, Griselda. *Differencing the Canon: Feminist Desire and the Writing of Art's Histories*. London: Routledge, 1999.

——. "Modernity and the Spaces of Femininity." In *The Expanding Discourse: Feminism and Art History*, ed. Norma Broude and Mary D. Garrard. New York: Harper Collins, 1992.

——. *Vision and Difference: Femininity, Feminism and Histories of Art*. London: Routledge, 1988.

Querlin, Marise. *Femmes sans hommes: Choses vues*. Paris: Editions de France, 1931.

Rachilde. "Oscar Wilde et lui." *Mercure de France* 128 (July/August 1918): 59–68.

Rank, Otto. *The Double*. Trans. and ed. Harry Tucker, Jr. Chapel Hill: University of North Carolina Press, 1971.

Reaves, Wendy. *Celebrity Caricature in America*. New Haven: Yale University Press, 1998.

Reed, Christopher. "Making History: The Bloomsbury Group's Construction of Aesthetic and Sexual Identity." In *Gay and Lesbian Studies in Art History*, ed. Whitney Davis. New York: Harrington Park/Haworth Press, 1994.

——. "Re-Imaging Domesticity: The Bloomsbury Artists and the Victorian Avant-Garde." Ph.D. dissertation, Yale University, 1991.

Rich, Adrienne. "Compulsory Heterosexuality and Lesbian Existence." *Signs* 5, 4 (Summer 1980): 631–660.

Riviere, Joan. "Womanliness as a Masquerade." In *Formations of Fantasy*, ed. Victor Burgin, James Donald, and Cora Kaplan, 35–61. London: Routledge, 1989.

Roberts, Mary Louise. "Acting Up: Feminist Theatrics of Marguerite Durand." *French Historical Studies* 19, 4 (Fall 1996): 1103–1138.

——. *Civilization without Sexes: Reconstructing Gender in Postwar France, 1917–1927*. Chicago: University of Chicago Press, 1994.

——. *Disruptive Acts: The New Woman in Fin-de-Siècle France*. Chicago: University of Chicago Press, 2002.

Robinson, Paul. *Gay Lives: Homosexual Autobiography from John Addington Symonds to Paul Monette*. Chicago: University of Chicago Press, 1999.

Rodriguez, Suzanne. *Wild Heart: A Life*. New York: HarperCollins, 2002.

Roger-Marx, Claude. Introduction to *Tableaux par Romaine Brooks*. Paris: Galeries Durand-Ruel, 1910.

Rousseau, Jean-Jacques. *Les Confessions*. Paris: Garnier-Flammarion, 1968.

Rowe, Dorothy. "Women Artists and the Limits of Modernist Art History." *Art History* 23 (March 2000): 130–135.

Rubin, William. *Picasso and Portraiture: Representation and Transformation*. New York: Museum of Modern Art, 1996.

Sander, Gunther, and Ulrich Keller, eds. *August Sander; Citizens of the Twentieth Century: Portrait Photographs, 1892–1952*. Trans. Linda Keller. Cambridge: MIT Press, 1986.

Sawelson-Gorse, Naomi, ed. *Women in Dada: Essays on Sex, Gender, and Identity*. Cambridge: MIT Press, 1998.

Scott, Joan Wallach. *Gender and the Politics of History*. New York: Columbia University Press, 1988.

———. *Only Paradoxes to Offer: French Feminists and the Rights of Man*. Cambridge: Harvard University Press, 1996.

Secrest, Meryle. *Between Me and Life: A Biography of Romaine Brooks*. Garden City: Doubleday, 1974.

Sedgwick, Eve Kosofsky. *Epistemology of the Closet*. Berkeley and Los Angeles: University of California Press, 1990.

Sekula, Allan. "The Body and the Archive." *October* 39 (Winter 1986): 3–64.

Showalter, Elaine. *Sexual Anarchy: Gender and Culture at the Fin de Siècle*. New York: Viking, 1990.

Silver, Kenneth E. *Esprit de Corps: The Art of the Parisian Avant-Garde and the First World War, 1914–1925*. Princeton: Princeton University Press, 1989.

Sinfield, Alan. *The Wilde Century: Effeminacy, Oscar Wilde, and the Queer Moment*. New York: Columbia University Press, 1994.

Smith-Rosenberg, Carroll. "Discourses of Sexuality and Subjectivity: The New Woman, 1870–1936." In *Hidden from History: Reclaiming the Gay and Lesbian Past*, ed. Martin Duberman, Martha Vicinus, and George Chauncey, Jr. New York: Meridan, 1989.

———. *Disorderly Conduct: Visions of Gender in Victorian America*. New York: Oxford University Press, 1985.

———. "The New Woman and the New History." *Feminist Studies* 3 (Fall 1975): 185–198.

Sohn, Anne-Marie. "Entre deux guerres: Les Rôles féminins en France et en Angleterre." In *Histoire des femmes en occident: Le XXe siècle*, ed. Georges Duby and Michelle Perrot. Paris: Plon, 1992.

Solidor, Suzy. *Deux Cents Peintres, un modèle*. Paris: Nef de Paris, n.d. (ca. 1960).

———. *Fil d'or*. Paris: Editions de France, 1940.

———. Papers. Château-Musée Archives, Haut-de-Cagnes, Cagnes-sur-Mer.

———. *Quarante Peintres, un modèle*. Paris: Pierre Morel, n.d. (ca. 1938).

———. Radio broadcasts. Radio-France Archives, Paris.

———. "Suzy Solidor révèle son étrange destin de femme sans hommes." *Confessions* 1, 3 (December 1936): 21–25.

Solomon-Godeau, Abigail. "The Equivocal 'I': Claude Cahun as Lesbian Subject." In *Inverted Odysseys: Claude Cahun, Maya Deren, Cindy Sherman*, ed. Shelley Rice. Cambridge: MIT Press, 1999.

———. "The Legs of the Countess." In *Fetishism as Cultural Discourse*, ed. Emily Apter and William Pietz. Ithaca: Cornell University Press, 1993.

――. *Photography on the Dock: Essays on Photographic History, Institutions, and Practices*. Minneapolis: University of Minnesota Press, 1997.

Sontag, Susan. *Against Interpretation and Other Essays*. New York: Doubleday, 1986.

――. *On Photography*. New York: Doubleday, 1990.

Souhami, Diana. *Gluck: 1895–1978; Her Biography*. London: Pandora, 1988.

Steele, Valerie. *Paris Fashion: A Cultural History*. New York: Oxford University Press, 1988.

Stein, Gertrude. *The Autobiography of Alice B. Toklas*. 1933; reprint, New York: Vintage Books, 1961.

Stewart, Mary Lynn. *For Health and Beauty: Physical Culture For Frenchwomen, 1880s–1930s*. Baltimore: Johns Hopkins University Press, 2001.

Stewart, Susan. *On Longing: Narratives of the Miniature, the Gigantic, the Souvenir, the Collection*. Durham, NC: Duke University Press, 1993.

Stimpson, Catharine. "Zero Degree Deviancy: The Lesbian Novel in English." In *Writing and Sexual Difference*, ed. Elizabeth Abel, 243–259. Chicago: University of Chicago Press, 1982.

Suleiman, Susan. *Subversive Intent: Gender, Politics, and the Avant-Garde*. Cambridge: Harvard University Press, 1990.

Susman, Warren. "Pilgrimage to Paris: American Expatriation, 1920–1934." Ph.D. dissertation, University of Wisconsin, Madison, 1958.

Tamagne, Florence. *Histoire de l'homosexualité en Europe: Berlin, Londres, Paris, 1919–1939*. Paris: Editions du Seuil, 2000.

Terry, Jennifer. "Lesbians under the Medical Gaze: Scientists Search for Remarkable Sexual Differences." *Journal of Sex Research* 27, 3 (August): 317–340.

Texier, Catherine. "Analyse et recherche iconographique de l'oeuvre de Romaine Brooks." Thèse de 3eme cycle, Université de Paris, Départment d'Arts Plastiques, 1987.

Thébaud, Françoise, ed., in collaboration with Georges Duby and Michelle Perrot. *Histoire des femmes en occident: Le XXe siècle*. Paris: Plon, 1992.

Thurman, Judith. *Secrets of the Flesh: A Life of Colette*. New York: Alfred A. Knopf, 1999.

Tickner, Lisa. "Feminism, Art History, and Sexual Difference." *Genders* 3: 92–128.

Traub, Valerie. *The Renaissance of Lesbianism in Early Modern England*. Cambridge: Cambridge University Press, 2002.

Troubridge, Una Elena. *The Life and Death of Radclyffe Hall*. London: Hammond, Hammond and Co., Ltd., 1961.

Turner, Elisabeth Hutton. "The American Artistic Migration to Paris Between the Great War and the Great Depression." Ph.D. dissertation, University of Virginia, 1985.

Usher, John. "A True Painter of Personality." *International Studio*, February 1926, 46–50.

Vachet, Pierre. *L'Inquiétude sexuelle*. Paris: Grasset, 1927.

Wagner, Anne Middleton. *Three Artists (Three Women): Modernism and the Art of Hesse, Krasner, and O'Keeffe*. Berkeley and Los Angeles: University of California Press, 1996.

Walker, Lisa. *Looking Like What You Are: Sexual Style, Race, and Lesbian Identity*. New York: New York University Press, 2001.

Weeks, Jeffrey. *Sex, Politics and Society: The Regulation of Sexuality since 1800*. London: Longman, 1991.

Weinberg, Jonathan. *Speaking for Vice: Homosexuality in the Art of Charles Demuth, Marsden Hartley, and the First American Avant-Garde*. New Haven: Yale University Press, 1993.

Weininger, Otto. *Sex and Character*. 1903; reprint, London: William Heinemann, 1906.

Weiss, Andrea. *Paris Was a Woman: Portraits from the Left Bank*. San Francisco: HarperSanFrancisco, 1995.

Werner, Françoise. *Romaine Brooks*. Paris: Plon, 1990.

Weston, Kath. *Families We Choose: Lesbians, Gays, Kinship*. New York: Columbia University Press, 1991.

Whistler, James Abbott McNeill. *The Gentle Art of Making Enemies*. New York: Dover, 1967.

Wickes, George. *The Amazon of Letters: The Life and Loves of Natalie Barney*. New York: Putnam's, 1976.

Wilson, Elizabeth. *Adorned in Dreams: Fashion and Modernity*. Berkeley and Los Angeles: University of California Press, 1985.

Wittig, Monique. *The Straight Mind and Other Essays*. Boston: Beacon Press, 1992.

Wolfe, Elsie de. *After All*. New York: Harper and Brothers, 1930.

Woolf, Virginia. *The Letters of Virginia Woolf, 1923–1928*, vol. 3. Ed. Nigel Nicolson and Joanne Trautmann. New York: Harcourt, 1978.

———. *Orlando: A Biography*. London: Hogarth Press, 1928.

———. *A Room of One's Own*. 1929. San Diego: Harvest/Harcourt Brace Jovanovich, 1989.

———. *Three Guineas*. 1938. London: Penguin, 1977.

Zabriskie, Virginia, ed. *Paris in the Thirties: Surrealism and the Book*. Paris: Zabriskie Gallery, 1991.

Zegher, Catherine M. de, ed. *Inside the Visible: An Elliptical Traverse of Twentieth-Century Art in, of, and from the Feminine*. Cambridge: MIT Press, 1994.

Index

ABOUT THE AUTHOR

Tirza True Latimer earned her Ph.D. in art history at Stanford University. She has published work from a lesbian feminist perspective on a range of topics in the fields of art history and criticism, the decorative arts, and performance. Latimer lectures in art history, feminist studies, and gender studies at various San Francisco Bay Area institutions and is currently organizing an international exhibition on Claude Cahun and Marcel Moore.